GIRL HEAD

Girl Head

FEMINISM AND FILM MATERIALITY

Genevieve Yue

FORDHAM UNIVERSITY PRESS NEW YORK 2021

Library of Congress Control Number: 2020916856

Printed in the United States of America

23 22 21 5 4 3 2 1

First edition

for Anne Friedberg

Contents

Color plates follow page 84

Plates and Figures

Plates

Figures

GIRL HEAD

Introduction
The Body of Medusa

I was always aware that there was a hidden aspect of filmmaking that
was comparable to the hidden obsessions of people, that what you saw
on the screen was a censored or acceptable social image but that
something was hidden. I was thinking of what might happen if a
movie were run, and as you were watching the numbered countdown
leader, all of a sudden you saw something on the screen that you were
not expecting to see, not supposed to see, an image that existed on a
subliminal level in a lot of movies in the 1940s and 1950s, where there
were sexual implications of all sorts without your ever seeing a naked
woman in an erotic one-to-one relationship with the camera . . .
[For *A Movie*] my idea at the time . . . was that that image of the naked
woman was an image normally kept hidden but is there, an implicit
part of the movies.

—BRUCE CONNER[1]

We are used to thinking critically about cinematic images of women. In par-
ticular, feminist film studies has influentially and persistently foregrounded
the topic of representation—problematizing how (and whether) women are de-
picted onscreen. In the aftermath of groundbreaking works such as Claire
Johnston's "Women's Cinema as Counter-Cinema" (1973), Molly Haskell's
From Reverence to Rape (1974), and Laura Mulvey's "Visual Pleasure and Nar-
rative Cinema" (1975), feminist film theorists in the mid- to late 1970s began
an intensive and productive investigation into questions of gender and repre-
sentation. The emphasis on representation, inspired by Mulvey's notion of
women's "to-be-looked-at-ness," or the overt presentation of women's bodies

1

as sexually desirable objects, resulted in a reexamination of women onscreen as well as a recuperation of underrecognized female figures within film history.[2] Although much feminist inquiry has subsequently broadened to consider material, social, economic, and political structures, the field is still centrally concerned with issues of representation. As the editors of a 2018 survey of genealogies of feminist media studies in *Feminist Media Histories* affirm, the "fundamental questions of feminist media studies [are] . . . Who represents? and Who is represented?"[3]

This dominant approach in feminist analysis misses important historical developments that have occurred in sites of film production outside the scope of representation. A feminism oriented toward these other spaces offers an enlarged understanding of the often invisible social forces that shape supposedly "neutral" or "objective" technical processes. Such a feminism might tell us how anxieties about the social status of women are displaced onto the material dimension of film. And while materiality has been recently undergoing intense scrutiny in the humanities, and in film and media studies, the discourse on materiality has emphasized the specific materiality (immaterial or otherwise) of the digital vis-à-vis analog technologies. Despite this interest in materiality, not to mention the profound impact of feminist film analysis in other areas of film studies, gender has never been examined as an intrinsic and key theoretical aspect of film materiality. This is where *Girl Head* intervenes, and in doing so it constructs an alternative and subterranean history of film materiality as revealed through feminist analysis.

By investigating three sites of film materiality, this book offers a methodological intervention in feminist film analysis—moving inquiry away from representation, which looks at the image onscreen, and toward industrial and institutional processes which, though hidden from view, are no less gendered. I closely attend to spaces of technical film production, and, from there, ask the kinds of speculative questions normally found in textual analysis of films. Theoretical inquiry is grounded in granular archival research: I locate a gendered and bodily materiality across three historically situated sites of film production: the film laboratory, editing practices, and the film archive. In each, the woman's body plays an important role in the making of the film object, a role not confined to the representation of women. I track this body's often elusive movements in and through material practices. This will not be a linear history, because those movements often go underground for long stretches and reappear in curious new formations. My objects therefore encompass a wide variety of production contexts and films: inside Hollywood and on the fringes of the avant-garde, and spanning the earliest manifestations of what could be called cinema to their digital upending at the end of the twentieth century.

Additionally, I bring in individual films, especially experimental and feminist works, as important interlocutors in discussing the production practices that are the focus of each chapter.

Girl Head departs from the norm of feminist analysis in the objects it examines and the questions it raises. The China Girl, for example, is the kind of figure that falls outside the range of traditional feminist concerns. It is a reference image that has been used in film laboratories since the mid- to late 1920s to calibrate color, density, and ideal appearance for the film image. Although in more limited use today, it is still involved in analog and some digital film refining processes. In a China Girl image, a woman (despite the nomenclature, she is typically white, for reasons I will explain shortly) is posed, in close-up, in front of swatches of black, white, gray, and various reference colors. The China Girl may be an image of a woman, but its designated technical function is not to depict a person. The woman is a model and not an actor, and the filmstrip containing the China Girl is not a portrait or likeness of her. It is really not "about" her at all. Yet her body—the tone of her flesh—is integral to the final image that gets screened for an audience, a commercial output from which the reference image is carefully excluded. The China Girl is a challenge to a scholarly emphasis on representation because it presents a different relationship between the film image and gender than the one such an emphasis presumes. When working within a critical framework oriented toward representation, image and gender conveniently align: images of women produce meaning in films, and as Teresa de Lauretis and feminist film scholars have demonstrated, images of women organize a film's structure of meaning.[4] Yet because the China Girl is a type of image that exists solely as part of the technical apparatus of the film laboratory and is largely absent from the realm of representation, it interrupts the assumed congruity of image and gender. Although it does not participate directly in the affective, sensorial, and psychological dynamics of film spectatorship, it nevertheless has a profound effect on the look of every commercially produced film, "touching" everything a viewer sees, even if not in a way that can be readily recognized.

The China Girl is at the heart of this book but at the margins of film—literally, the head or tail leader of a reel. Sometimes called a "girl head," the China Girl appears within the material construction of film, and not at the level of the projected image (unless by an error in the projection booth, or as part of a deliberately reflexive strategy in experimental film). As I discuss in chapter 1, the China Girl has been an enduring, if mostly imperceptible, figure in film history. On a conceptual level, it exposes the gap between the surface appearance of a film and the complex orchestration of its materiality in terms of gender, labor, and industry. It is the opposite of the women who

appear onscreen: it is not a figure in film, but one used *for* film. In other words, it shows how the functioning of the film laboratory requires for it to be understood only as material, and never a person in the sense of its leading lady counterparts. The anonymity of China Girl models also indicates how the woman's vanishing into sheer materiality is necessary to the transformation of her into an instrument fundamental to the operation of the film laboratory.

In a lifetime of watching movies, it's likely that I had glimpsed dozens of such images before I fully recognized what I had been seeing. Any time a projectionist fails to switch over a film reel at the appointed time, allowing the end of the reel to run out, the canny moviegoer can catch a few frames of a China Girl. Whenever this happened, I failed to take notice. Even when I worked as a student projectionist, regularly rewinding reels, checking prints, and repairing broken splices, I never stopped to consider the women whose images passed through my hands.

It was not until I saw Morgan Fisher's *Standard Gauge* (1984), that I became aware of the China Girl figure. Fisher's film is organized as a kind of show-and-tell of various film scraps he had collected working in stock footage libraries and as an editor on low-budget features. Winding strips of 35 mm film over a lightbox, Fisher pauses on several examples of China Girls to comment on them. He explains their function in film laboratories, where they are crucial to calibrating a film's final appearance, especially the norms for skin tones. Little is known about their provenance: who the models were, and how, in the United States at least, these women came to be called "China Girls." Though Fisher describes the China Girl as a "figure who in some quarters is emblematic, almost, of film itself," the smiling women in the film leader remain largely enigmatic.

Curious about the China Girl, and finding little historical information about the figure, I began to speak to laboratory technicians. At DuArt, in New York, shortly before the closing of their film department, Steve Blakely showed me how the China Girl was used in the lab to gauge everything from the composition of chemical baths to the functioning of developing machines. In these many uses, the woman's face, in its ubiquity and repetition, seemed to disappear from the image. Blakely explained how a technician was trained to look at details *in* the image rather than the face itself. The owner of this particular face, I learned after some digging, was Lili Young, the then girlfriend (and later wife) of Bob Young, son of one of DuArt's founders. In the laboratory, Lili had become less a recognizable person than an image and, as a technical tool, *only* image. In contrast to the many faces that appear onscreen, that of a China Girl disappears twice over: first as a woman kept off-

screen, and second as a body transformed into material (numeric values for color, shading, density, and the like) and thereby instrumentalized in the film laboratory.

At this point, a note on terminology. Against the more genteel sound of "China Girl," "girl head" is bluntly vulgar in its suggestion of flesh and material. It is also a more straightforward term for what it describes. "China Girl," though more commonly used, embeds a history of misdirection. The term almost carelessly misnames its object, since the China Girl in the Hollywood film industry is almost always white, and rarely Chinese or Asian. There is a long tradition of deliberately miscasting women who are deemed *other*, whether racialized, sexualized, or more overtly monstrous, and thereby threatening to the implied male hero, artist, filmmaker, or technician. Such miscasting—everyone will have their "favorite" instance—mine is Anne Baxter as Nefretiri in *The Ten Commandments* (1956)—is a familiar problem of cinematic representation. The term *China Girl* misleadingly conjures up such a "character," instead of a crudely functional body, as if to recruit the reference image into the film proper. We should resist narrativizing the China Girl as a kind of secret little movie. Throughout this book, I use the term *China Girl* for the sake of recognizability, even if *girl head* more accurately describes the object. I do so under some protest, as *China Girl* is somehow more sanitizing, romanticizing, and more offensive, all at once. *Girl head*, meanwhile, lays bare the device, and perhaps for that reason it has not caught on as widely.

It would be easy to cast the China Girl as an emblem of the repressed eroticism of film. There is something inherently pornographic about a woman, conventionally attractive by design, who is elaborately posed but not meant to be so much as glimpsed by a viewer. It is telling that the "Lena," the equivalent reference image for digital image compression standards, is taken from a 1972 *Playboy* magazine cover. Such a repressed eroticism is suggested in Bruce Conner's remarks in the epigraph. Speaking in a post-screening discussion at the 1984 Flaherty Seminar, Conner is responding to a question about the sudden appearance of a woman rolling down her stocking in his found-footage classic *A Movie* (1958) (fig. 1). Without naming it specifically, Conner describes the way a viewer might encounter a China Girl, an image of a woman who is "kept hidden but is there." He affirms that this play of a woman's presence and absence is "an implicit part of the movies," and this suggests that there is a central libidinal logic that undergirds narrative film. This is a view maintained by many film theorists, including André Bazin: as he wrote in 1957, cinema's "eroticism is . . . a basic ingredient . . . a major, a specific, and even perhaps an essential one."[5] There is a prurient tinge to Conner's remarks: the woman that appears corresponds to "hidden obsessions" and an erotic logic under the

Figure 1. *A Movie* (Bruce Conner, 1958). Courtesy of Conner Family Trust.

Production Code where, because sex could only be implied, it had the effect of being seemingly everywhere. Conner's China Girl is not coincidentally engaged in a striptease, which, by withholding what is desired, the forbidden element, only increases the desire to see it.[6]

There is another way to read Conner's remark that a woman's body, present but concealed, is inherent to film. Apart from the trope of repressed eroticism discussed earlier, the instance of the China Girl alerts us to a deeper structure by which the things we seen in film rest on a foundation of what is unseen. In the case of the China Girl, the hidden element is the medium's materiality, and, as I contend, a gendered dimension that attends it.

As the China Girl shows, the set of technical and material conditions for the image onscreen *already* includes explicitly gendered bodies, before anyone even steps in front of the camera. This runs contrary to the expectation set up by representational analysis. The film production process is usually taken to sit safely apart from issues of representation, the gaze, or embodiment. It is an area governed by technicians, engineers, mechanics, clerks, and other professionals that would seem to adhere to objective, rational protocols. The China Girl is a non- or pre-representational image in the sense that the model is not playing a character or scene in any traditional sense of the profilmic. As a result, it imports gender into the film image before representation ever occurs. This book argues that the material aspects of the filmstrip *are* gendered, even if they do not immediately present that way. The China Girl provides a crucial link between the idealized appearance of bodies onscreen and the laboratory procedures and labor by which this ideal is maintained, namely through the concealment and literal debasement of the woman's body. Along with the other figures I examine in this book, it demonstrates that the material supports of film are less neutrally functional and more ideologically freighted than they otherwise appear.

Girl Head tracks the materializations of the *female body* in and through the nonrepresentational spaces of film production. This addresses an important epistemological point raised by Conner: how can we observe, much less learn anything about, the China Girl if it is so difficult to see? To move beyond the spaces of representation, as this book does, is in large part a conceptual intervention. I mentioned previously the limitation of a feminist critique predicated solely on representation, though, to be sure, much important feminist work in film studies addresses matters apart from representation: industry histories, semiotics, psychoanalysis, Marxist approaches to filmic mass production and consumption, and cultural studies work on female spectatorship and alternative public spheres.[7] Among these approaches, there persists a conceptual limitation where it concerns the status of the female body. While these scholars

have crucially broadened feminist film studies to include more than merely what is visible onscreen, one effect has been to cede the female body to the domain of the mimetic image as a topic confined to representational approaches. As I discuss shortly, insofar as a nonrepresentational focus of materialist histories of film and media is salutary, such approaches also do not admit of a specifically gendered and bodily materiality. *Girl Head*, by contrast, maintains a concept of materiality in which sexual and racial differences are intrinsically inscribed. This means that the female body is transformed—sometimes symbolically, sometimes also literally—into material to be used in film production practices. The motivations for and significant costs resulting from this process of materialization are addressed in the experimental and feminist works discussed in each chapter.

In areas both technical and theoretical, this book locates instances of the material exclusion of women's bodies from the images that appear onscreen. These various girl heads are figures that never disappear entirely, though they require some effort to be fully seen. Appearance, in this sense, is not only a matter of how one looks but the conditions by which an image can be seen. This book aims to restore a fuller picture of what film production beneath the surface appearance of representation has been. The emphasis is necessarily historical: it addresses a twentieth-century moment in which both the film medium and the category of woman were durable if culturally charged concepts in order to question anew the interrelationship between the two. In this way it also looks ahead to possibilities for a renegotiation of this relationship in a contemporary moment in which both terms have been profoundly destabilized, by digital media in the case of film and by queer and posthumanist approaches in the case of woman. In this way the woman's body is necessarily tethered to the technics of moving-image reproducibility, and throughout the sites of production examined in this book, we will continually encounter it as a nonmimetic, denigrated, and disavowed means of production at the heart of film materiality.

Materiality

The material processes of film production would seem to be neutral and apolitical. Against these presumptions, this book aims to demonstrate how an operative concept of gender has been embedded in a history of film materiality. This is to say that film material practices have been understood and manipulated according to social attitudes about gender.

I take *materiality* to mean the physical, tangible qualities of an object. With film objects, materiality designates the filmstrip plus the conditions and tech-

nical basis of production—including the complex institutional support for the shooting, developing, processing, exhibition, and storing of film artifacts. My use of materiality considers how a filmstrip is shaped by production processes that themselves have histories. My focus on production processes, meanwhile, is distinguished from production histories of films, which privilege human agents. A production history might sketch the biographies of the director and lead actors, include behind-the-scenes anecdotes from crew members, and survey trade publications for audience and critical reception. My approach, by contrast, emphasizes material forms and technical and industrial developments. A history of quality control methods in film laboratories does not exclude human agents, but counts the work of engineers, scientists, and laboratory technicians among the industrial conditions, broader cultural attitudes, and other factors that give these practices their particular shape. A production history, on the other hand, is interested in process only insofar as it produced the film in question. By contrast, I use materiality to signal an inquiry into process itself. Furthermore, because these processes are always evolving, what constitutes film materiality is also subject to change. This is especially pronounced in the technological transformations of the moving image brought about by digital cinematography, postproduction, exhibition, and storage. The film object is never stable and instead possesses its own history shaped by cultural, social, and technological factors. As I will show, gender is one such factor, and it is inseparable from the processes that go into the making of a film.

Generally speaking, materiality gets opposed to immateriality. In film studies, the latter frequently manifests in textual analyses that treat films solely as semiotic assemblages, or in methods that privilege cinema's more evanescent aspects, including the critique of the projection apparatus in Jean-Louis Comolli and Jean Narboni and conceptual works that emphasize the immaterial beam of light, as in Anthony McCall's "solid light sculptures." In the specific context of media studies, the immaterial is often described as or conflated with the virtual. Anne Friedberg provides a useful genealogy of the latter term, extending it beyond the contemporary association of the term with digital technologies, as with "virtual reality."[8] By tracing its meanings in sixteenth- and seventeenth-century optical research and late nineteenth-century philosophical discourse, she demonstrates how the virtual can represent materiality but not in exact correspondence:

> [T]he term "virtual" serves to distinguish between any representation
> or appearance (whether optically, technologically, or artisanally
> produced) that appears "functionally or effectively *but not formally*" of

the same materiality as what it represents. Virtual images have a materiality and a reality but of a different kind, a second-order materiality, liminally immaterial . . . the virtuality of the image does not imply direct mimesis, but a transfer—more like metaphor—from one plane of meaning and appearance to another.[9]

Among its various traits, Friedberg notes the virtual's "power of acting without the agency of matter."[10] The virtual is opposed to the material because it lacks physical substance. Friedberg speculates that Gilles Deleuze, in his influential philosophy of cinema, derived his own use of "virtuality" through his reading of the work of Henri Bergson, for whom *virtual* designates the immaterial quality of memory.[11] Meanwhile, the virtual generally looks like the material. It connotes representation as well as substitution, because the physical basis of materiality is absent. It is a "transfer . . . from one plane of meaning and appearance to another."[12] The virtual transposes the physical world onto the field of representation. A virtual image thereby conjures an absent presence by resembling it in another form.[13]

This notion of the virtual alerts us to how film materiality is distinct from other artistic media. In the case of sculpture, our experience of it as a work of art involves its total physical presence. The artwork is identical to the material it is composed of: bronze, marble, wax, and so on. The same is true of painting, music, and dance. In these media, the artwork's physical composition corresponds to the visual experience of the work: a bronze sculpture is and will appear to the viewer as a bronze cast. Yet with film, the moving image is not material but virtual, as Friedberg indicates. The materiality of the filmstrip does *not* resemble the image that is projected onscreen. A film reel, in the absence of a projector, is not yet a film. To lay a hand on the material being of, say, Rodin's *Monument to Balzac* (1898), just means touching the artwork itself. Meanwhile, the material being of, say, *The Wizard of Oz* (1939) will not be experienced as the artwork *The Wizard of Oz*. At most there is an indexical correspondence between the two. To use the language of Peircean semiotics, film material is non-iconic.[14] A complex translation is required to turn a film reel into a projected moving image, just as one cannot hold one's ear up to a vinyl record and hear music.

Theories of film realism already deploy their own concepts of materiality, and here I wish to distinguish my emphasis on the materiality of the filmstrip from those that are anchored in the mimetic capacities of the cinematographic camera. As I will discuss below, Siegfried Kracauer's theory of material evidence affirms the potency of the world as recorded by film. He argues that this anchoring in material reality is unique to film and places the viewer in

closer proximity than would be possible in other media forms. My focus is different; rather than reality *in* film (like Kracauer), I take up the reality *of* film material as it is organized in historically specific forms and processes.

The distinction between material filmstrip and immaterial image allows me to formulate a complication illustrated in the China Girl example. Though undoubtedly the China Girl is an image, it does not partake of the same visual and spectatorial economy as an image onscreen. Instead, the image of the China Girl model is itself a means of production. It is nonmimetic in that it does not look like anything proper to the film, and it is also nonrepresentational in that the China Girl image possesses no semantic value. It remains tethered to the filmstrip only as a vestige of an earlier photochemical analysis. It is not meant to signify anything beyond its use for quality control procedures, and yet in the unchanging convention of the image of a female face, it cannot help *but* signify.

Why is gender foregrounded in this figure's name and many manifestations? As I discuss in chapter 1, there is nothing that technically requires the China Girl to be a woman. Yet its appearance as such has been remarkably durable, even persisting in largely unaltered form during the tumultuous transition from analog to digital technologies and the transformed material basis of each. Film production cultures are developed and structured according to the broader social attitudes that circulate around them, and their frequently vernacular practices are often passively transmitted and thereby preserved. Film production practices, as they have constituted the specific materiality of film (an unusually malleable and manipulatable material), have been inseparable from gender and the notion of materiality built into our concept of gender.[15] Following detailed investigations of the book's three production sites, each chapter describes how film material is gendered according to the affordances of each site.

This gendering of film materiality occurs in two steps that can be distinguished in theory. First, I draw an analogy between the material of the woman's body and the material constitution of the filmstrip. The woman's image (typically her face) is allied with the immaterial image, then cut off from the material dimension of the filmstrip, related to the physical matter of the woman's body (her flesh). These separations, or what amounts to a conceptual decapitation, are formulated differently in each chapter, though they all involve a set of opposed pairs: face as distinct from flesh or head as separated from the rest of the body. In each of the book's areas of film production I locate a persistent axis that divides material-body from virtual-image.

Second, the material-body once severed is repressed or concealed in the expression of the virtual-image. The gendered material dimension thereby

disappears into the projected, immaterial one. Not only is the body-as-material engaged in production processes lopped off in favor of the image of the face produced and screened, but the sublimation of the woman's body corresponds to the *forgetting* of the image's subtending materiality. I show that gender has been structurally immanent in those processes of a film's construction where it seemed, whether through neglect or omission, to be bracketed.

Alfred Hitchcock offers an unlikely account of how to locate the body within film production as a technical process. In his extensive 1962 interview with François Truffaut, he recounted (via a female translator, Helen Scott, who herself vanishes from the interview transcript) a scene he had envisioned but never shot for *North by Northwest* (1959). In this striking scene, the protagonists are in an auto factory, and behind them a car is being assembled. The audience, who is paying attention to the foreground conversation, is shocked to see, just as the car is completed, a body tumble out.

> I wanted to have a long dialogue scene between Cary Grant and one
> of the factory workers as they walk along the assembly line. They
> might, for instance, be talking about one of the foremen. Behind them
> a car is being assembled, piece by piece. Finally, the car they've seen
> being put together from a simple nut and bolt is complete, with gas
> and oil, and all ready to drive off the line. The two men look at it and
> say, "Isn't it wonderful!" Then they open the door to the car and out
> drops a corpse![16]

I argue that this missing scene is analogous to the production of a film. Picture a film going through the steps of being constructed and assembled. Just as Hitchcock's car is built by joining "nut and bolt," so a film is put together shot by shot. Both the production of the car and this continuous chain of images roll out at an industrially standardized rate. The whole process is a transparent spectacle, laid out in a long take, and the audience marvels as much at the finished product as at the seamless background efficiency of the technical process. Like a magic trick, everything occurs in seemingly full view.

Then we discover a further trick, a horrible rabbit pulled out of the hat: a body falls out of the car, somehow unseen until now. Somewhere within the pristine efficiency of the industrial process, the body was incorporated without being noticed as part of the official, exhibited process. While we looked on, oblivious, the body was simultaneously *produced*—introduced as another component of the finished production; *hidden*—being the one part we never saw bolted on; and *left* outside—as an industrial accident, a remainder, or just human remains.

Hitchcock's unshot scene characterizes the process of film production as a staging of visible and invisible elements. For the purposes of our analogy, if we imagine a woman's body as the initially hidden and then revealed output of the industrial process, then film production might be seen as likewise ambivalently integrating and warding off the materiality of the female body. For, in the production sites I am investigating, the body that film production is predicated upon, both as something to be utilized as functional material and also concealed as unwanted remainder, has been a woman's. Rather than an accidental excess, it is an industrial material that was assembled along *with* the commercial product and simultaneously disassembled or undone—in Hitchcock's scene, murdered. Thus materialized, the woman's body is bound up in film's material infrastructure. But it cannot appear as a component like any other. Instead, it must be concealed. The only way it can even appear is when it crops up out of place, like the momentary flash of China Girl leader visible when a reel is left to run out, unattended.

Methodology

Girl Head examines three sites of film production: the film laboratory, editing practices, and the film archive. I scrutinize each area in close, technical detail, with particular attention given to the orchestration of film production practices as they have developed historically. From there, I shift to a more speculative register to conceptualize the role of gender in the articulation of film materiality at each site. Each chapter concludes with a consideration of experimental and feminist films that critique, reclaim, or otherwise reorganize the logic of film production at its most material level.

I consider film as a material artifact, grounded in and historically shaped by processes of development, printing, projection, and storage. In its emphasis on sites of film production, this project shares much in common with a historical materialist strain of feminist film analysis and production studies. The former dates to the 1970s, with studies by Annette Kuhn and AnnMarie Wolpe that located interpretive issues of "meaning production in textual analysis" within the "social and historical contexts" of film production, distribution, and exhibition.[17] Recent work on media history, by Caetlin Benson-Allott, Michèle Martin, Lisa Nakamura, Lorna Roth, and others has continued this approach, examining new objects (e.g., video or social media) within their institutional and infrastructural contexts.[18] The interdisciplinary field of production studies, especially the feminist scholarship of Julie D'Acci, Miranda J. Banks, Brooke Erin Duffy, and Elana Levine, has also taken up technical and historical

issues of production—describing "producers, their locations, industries, and products"—in film and media, with methods taken from the social sciences, especially sociology, anthropology, and communications.[19]

Such studies tend to partition materiality (technical or institutional processes and support) from gender (woman as cultural actor or mediatized subject) and only later reconnect them, if at all. My approach differs in that I locate the gendering of film materiality in the filmstrip itself, as part of its internal negotiations and mediations. I neither begin from nor drive toward the empirical woman of social relations, such as the many female screenwriters, directors, producers, actors, editors, casting directors, costume designers, script-girls, and other film industrial workers that would be central in a historical materialist study. Nor do I take gender to proceed from a separate space to interact with technical apparatuses or infrastructure. Instead, I show how film materiality is itself gendered, meaning that it is inscribed with the character and associations of women at all levels of a film's construction. The historical development of production practices shows that gender, as expressed through the uses of the woman's body and yoked to film materiality, was itself appropriated as a means of production.

My approach emphasizes the interaction between the material of film and its social and cultural determinations. This is what distinguishes it from recent feminist scholarship on "new materialism."[20] In departing from social and linguistic determinants, new materialism offers significant queer and feminist potential in recognizing that matter, especially the body, is not only "passive stuff . . . raw, brute, or inert," to be molded by culture.[21] Rather, "matter, nature, life, production, and reproduction" have a substantial reality apart from discourse and subjective conceptualization.[22] While this offers new spaces of inquiry to the body, rather than foreclosing it as a mere discursive construction, it is limiting for an analysis of a material *and* cultural artifact such as film. I approach cultural understandings of gender as effectively "baked into" the film, being inseparable determinants of film's materiality. I propose that the filmstrip can be read for instances or clues of this gendered dynamic. Hence, this study proceeds from the imbrication of the social with the technical. Whereas new materialism assigns matter a prior autonomy not subordinated to culture, I affirm that film materiality is necessarily constituted by the cultural sphere. With the China Girl, for instance, the image's use in quality control procedures to achieve the desired appearance for a film is deeply tied to the figure's knot of racial and sexual ideologies. The China Girl image's guise of an attractive white woman cannot be merely technical, nor can the figure be fully understood without considering its technical function in the film laboratory. As a device used to support a technical process, it marshals a sexist

ideal of subservient, still, and silent women to ground a technical process. In effect, the China Girl requires women to submit to the authority of a process that seems able to control and contain them. The materiality particular to film therefore cannot fully withdraw into the precultural vitalist flux of new materialism's definitions. Materiality is, rather, a stage upon which these cultural dynamics are enacted.

As a work about film materiality, *Girl Head* maintains an additional emphasis on the medium specificities of film as well as digital or "postcinematic" media. Again, contemporary avant-garde and moving-image art is instructive here, offering a crucial perspective on film at a moment of profound transformation, both in terms of its artistic and technological medium specificities. The idea and institution of film are becoming less stable for two reasons. First, in artistic terms, the medium of film is simultaneously being dissolved through digitized reproduction, hybridized in intermedial or mixed media work, and reified as sculptural objects or artifacts in the gallery. Second, film, along with many other technological media such as video, photography, and vinyl audio recordings, is undergoing a massive process of remediation, as all formats are translated, encoded, and broadly recirculated as compressed digital files. Experimental film affords a unique vantage to examine the changing historical configurations of film materiality and the shifting expressions of gender in and through the film object. Such works are not only explicitly critical of the production norms for film, but they also stage the material transformations of the moving image. Each chapter, then, tracks the shifting valences of the film "medium" in multiple configurations: historical, theoretical, and aesthetic.

The Disappearing Female Body

Girl Head's theoretical inquiry is organized around the motif of the disappearing female body, a symptom of the behind-the-scenes technical process where the woman's body is subtly and symbolically *materialized*. This body is converted into material for and incorporated into the film production process as a reference image not intended for viewing, as excess footage trimmed out to conceal the evidence of cinematographic trickery, and as the material remnants that motivate the construction of an archive. The motif of the vanishing woman that attends these nonrepresentational disappearances is more than analogy, but a sign of the production processes that are otherwise hidden.

I analyze this motif to clarify how this vanishing, whether violent excision or mere overlooking, was made possible. In other words, I take the absent woman as a problematic to be dissected and better understood. This is different

from other scholarly approaches that are also concerned with disappeared women which either try to fill gaps in the historical record, as with feminist scholarship concerned with restoring women to a history they have been written out of, or to further bury the traces of the woman's body in the formulation of an aesthetic theory (in art history and film theory). Both approaches, paradoxically, produce additional occlusions, which I take up in my own theoretical inquiry.

The first approach is represented by feminist film historians working in a positivist mode to restore or recuperate women deemed missing from film history. This work follows a longstanding and largely correct view that many female figures have been excluded from the historical record. To redress this exclusion, feminist scholars since the 1970s have embarked on empirical research into women's contributions to film history and production. Lucy Fischer's "The Lady Vanishes: Women, Magic and the Movies" (1979) is exemplary in this regard. The essay both interrogates the patriarchal logic by which early trick films involved male magicians performing often gruesome acts on female bodies ("the rhetoric of magic . . . constitutes a complex *drama of male-female relations*"[23]) and revises the history of magic films along feminist lines, reading an envy of female reproductive capabilities into the actions of male magicians and expanding the historical record to include films featuring female magicians.

Such a restorative method is predicated on the assumption that women have been largely absent in film history. Jane Gaines traces this widely held view to 1973, when Claire Johnston asserted: "It is probably true to say that despite the enormous emphasis placed on woman as spectacle in the cinema, woman as woman is largely absent."[24] In Gaines's historiographical analysis, she observes how this principle—the absence of "woman as woman"—has been especially productive for feminist film theorists. For feminist historians, meanwhile, the evidence of the hundreds of women who directed, wrote screenplays, ran studios, edited, acted, and otherwise participated at all levels of the film industry in its early decades came to refute this supposedly fundamental absence.

Although the putative absence of women from film history has been contested for decades by a steady supply of counterevidence, the assertion of their neglected or forgotten presence in various aspects of filmmaking remains a central issue in feminist scholarship. My concern is that this presence is representational in its basis—the same logic of diversity and inclusion we find in the topic of casting and the question of "whose stories" get to be told. In the *Feminist Media Histories* genealogy mentioned earlier, Maggie Hennefeld warns of the "hazards of historical amnesia,"[25] while in the inaugural issue of the same journal, Shelley Stamp cautions against casting women "as interest-

ing marginalia in someone else's story."[26] Hennefeld calls for feminist histories that offer "new information [with] conceptual invention." Her proposal is recuperative in intent, and it also flirts with a positivist method in its affirmation of feminist research that "[inserts] these lost or sidetracked histories into the center of cultural discourse and social debate."[27]

One example of the "conceptual invention" Hennefeld advocates is Karen Redrobe's *Vanishing Women: Magic, Film, and Feminism* (2003). (I examine Redrobe's argument in more depth in chapter 2). The book tracks its titular motif across a wide range of late nineteenth- and twentieth-century visual culture objects, all of which could be considered proto- or para-cinematic, to express how anxieties about gender, sexuality, and "excess" bodies were bound up with fears around film's reproductive capacities.[28] As a study that locates instances of resistance and critique within an oppressive apparatus otherwise oriented toward the death and disappearance of women, its aim of restoring female presence to the historical record is not far from Fischer's much earlier essay, even if its methods are more nuanced and deeply researched. Redrobe's vanishing/presence relation is still tied to representation, because she is examining *spectacular* feats of vanishing, out in the open, as in a magic trick. I am interested, however, in the absconding of bodies that takes place as it were offstage, in the spaces of film material production. The vanishing of the China Girl into its industrial functionality is not advertised on any marquee.

In each of my case studies, the presence of a woman might seem incidental, negligible, or marginal: the split-second appearance of China Girl leader, the early cinema association of women's bodies with editorial manipulation, and the fables that haunt the dusty corners of the film archive. In fact, the woman might not be registered at all, much less her vanishing. This is largely because the objects of my analysis are found below representation, in technical procedures that would seem to simultaneously rely on and also disavow the materialization of the woman's body. Gender—and this is the burden of my argument—is not incidental but critical to these sites of production.

If feminist critics have tended to approach the disappearing woman's body in a positivist sense, in terms of an absence or presence in film history, an important group of aesthetic theorists situate the disappearing woman's body at the center of art and film production. To be more precise, their theories of art and film production are complicit in that disappearance. The critics in this vein take up the mythological figure of Medusa in art history, a figure that many have used to account for the powers and dangers of the aesthetic. Hal Foster, W. J. T. Mitchell, and especially Siegfried Kracauer emphasize Medusa's severed and weaponized head—what becomes the *gorgoneion*—to provide accounts of the dangers and potentially transformative powers of

art.[29] None mention her discarded body. With this important omission, they miss the violence in the removal of her body and, because of this, perpetuate their own form of exclusion. I turn now to these theories in some detail because they seem to me to enact—at a sophisticated conceptual level—the dialectic of the woman's body in image production, figuring it as a necessary material substrate that is ultimately negated. As a counterpoint, I show how its absence, and the further denial of its violent remainder, structure their claims.

The myth of Medusa involves two instances of image-making: the sculptures that Medusa's gaze makes out of mortal men by turning them into stone, and, after Perseus arrives, his proto-cinematographic "framing" of Medusa's reflected image in his shield. For this reason, Medusa has been frequently made into a figure for the artistic image as such. Specifically, it is the gorgoneion, the head transformed into the image of Medusa's face with its petrifying glance, that has been a common motif in the visual arts and literature since antiquity (fig. 2). It would therefore be inaccurate to describe this face as only female, or as having a recognizable gender at all. This is no ordinary face, but one that expresses a range of contradictory characteristics: both male and female, young and old, beautiful and ugly, human and monster. As Jean-Pierre Vernant notes, "all the categories in this face overlap in confusion and interfere with one another . . . [this] calls into question the rigorous distinctions among gods, men, and beasts, as well as those between different cosmic elements and levels."[30] The gorgoneion is a figure of "extreme alterity," the sign and symbol of all possible otherness.[31]

Medusa thus becomes the occasion for a theory of the unassimilable in art. For Foster this means the Lacanian real in sculpture; for Mitchell, the ever-withdrawing object of ekphrasis; and for Kracauer, the traumatic horrors of history as confronted in film. As with the myth, her body exits their accounts as soon as her head is lopped off. The female body provides a structure to organize the work of unassimilable otherness, relocated from the limp, headless woman— arguably *more* real, withdrawn, and traumatic—onto the now-independent image function of the gorgoneion. In these interpretations of the Medusa myth, the missing body (*qua* unassimilable), rather than the ubiquitous gorgoneion, serves as the basis for theoretical accounts of the origins of art. Gender is thereby tethered to the materiality at the origins of the image, as the aporia of that origin.

The severed figure of Medusa in these aesthetic theories is organized along the same conceptual axis I describe for the film image generally. In the aesthetic outcome of the myth, the head of a living woman becomes the gorgoneion: a sheer image whose gender has been sublimated out of view. Her body,

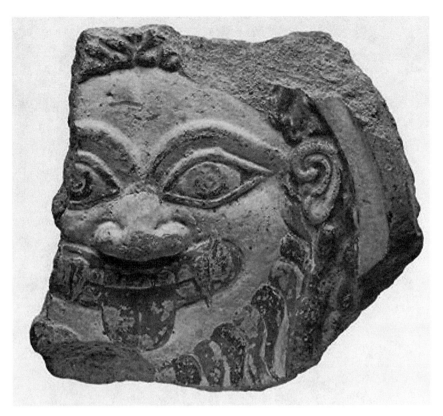

Figure 2. Terracotta antefix with the head of Medusa, sixth century BC. Courtesy of The Metropolitan Museum of Art, New York, Fletcher Fund, 1927.

meanwhile, comprises the material remains that are cropped out, but nevertheless form the basis for these theoretical structures. The Medusan art theories demonstrate an underlying anxiety of women, couched in a conception of the material-image relationship. In each, Medusa becomes an invented rationale for a representational logic where femininity is a required condition for the aesthetic as such. As mythology become ideology, it is precisely this underlying anxiety concerning the material status of "woman" that animates these aesthetic theories. By foregrounding her genderless head, they are able to distance themselves from the violence visited upon Medusa's body. Further, in order to maintain this generative power, the woman is reimagined as a gorgon, a monstrous figure who can then be killed, who *must* be killed, so that the gorgoneion can assume its status as pure image, an object untethered to the woman's body.

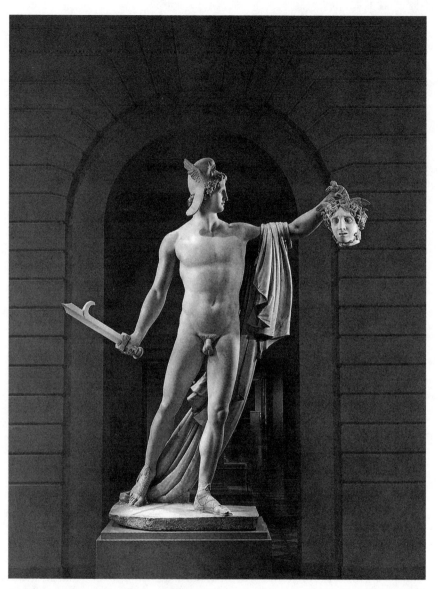

Figure 3. Antonio Canova, *Perseus with the Head of Medusa* (1804–1806). Courtesy of The Metropolitan Museum of Art, New York, Fletcher Fund, 1927.

For Foster, the vanquishing of Medusa is nothing less than the foundation of art. He calls the scene of Perseus's encounter with the gorgon the "ur-painting, an originary model of art," taking Antonio Canova's rendering in *Perseus with the Head of Medusa* (1804–1806) as his primary example (fig. 3).[32] In Canova's sculpture, the hero stands contrapposto, his left hand holding aloft Medusa's head, to see it directly for the first time. Her body is nowhere to be seen. His shoulders are relaxed, though in his right hand the sword is still slightly raised; this combination of tumescence and release suggests an immediately postcoital moment.[33] The deed is done, and Perseus appears to be admiring his conquest. In this scene, repeated countless times in the history of Western art, Foster sees the genesis for the model of all art: Perseus's vanquishing of the gorgon is the triumph of art over feminized nature.[34]

To decapitate Medusa is Perseus's destiny—Adriana Cavarero reminds us that the name Perseus means "he who cuts"[35]—and the scene stages, for Foster, the central conflict within art. He adopts Nietzschean terminology to describe how the Apollonian forces associated with order and rationality, aligned with Perseus, conquer the unruly Dionysian forces of nature, assigned to Medusa: "Perseus-Apollo triumphant" stands over "Medusa-Dionysus subdued."[36] Perseus, in his victory, affirms the capability of art to bring order and purpose to nature. Foster associates Medusa with the threatening force of reality, understood in terms of Lacan's theory of the real. As with the staging of Perseus/Apollo versus Medusa/Dionysus, the symbolic order is opposed to the real, which precedes and exceeds it. Art negates and mediates the real, and so has the effect of taming it.[37] Perseus's mirror screens and screens out— it shows, but also filters—the appearance of Medusa, so that her deadly force is mitigated, if not entirely repressed. The real, meanwhile, invariably threatens. Foster writes: "the uncivilized is not eradicated . . . because the symbolic order also requires the power of the uncivilized, or the power that is projected there."[38] The gorgoneion loses its gender in the process. It comes into being independent of any original female body, simply as a symbolic object of male conquest: a "prized trophy."[39]

Once severed from the body, the Medusan visage becomes a weapon mounted to Athena's shield, and the emblem of the goddess's military might. Medusa is no longer nature, but nature repurposed: as art and ornament, and, closely related to it, as an object invested in creating and maintaining civilizational order.[40] This fulfills what Foster identifies as art's apotropaic mission: to ward off those irrational forces by appropriating them for a different purpose: "this apotropaic transformation of weapon into shield is fundamental to art, perhaps its originary purpose."[41] This is manifest in the gorgoneion, a seemingly genderless object (insofar as gender has been sublimated) that is no

longer suggestive of the body to which it was once attached. In Canova's sculpture and Foster's account, the body has disappeared altogether.

For Foster, the force of the repressed real lingers in the power of the gorgoneion, somehow preserved and harnessed there. There is still more conspicuous evidence of this repression of the bodily remains of Medusa in a completely different sculpture, Benvenuto Cellini's *Perseus with the Head of Medusa* (1545). Here the scene is not as sanitized, and the traces of violence have not been as thoroughly scrubbed away. Though Foster makes passing reference to Cellini's work, he does not comment on its chief difference with Canova's rendering—namely, the use of Medusa's headless body as the sculpture's base (fig. 4). Cellini and Canova offer strikingly divergent depictions of the same scene. While the hero shares the same pose, counterbalanced with the head of Medusa held out by his left hand, sword cocked in the right, the sculptures' differences are significant. In contrast with the clean, neo-classical base of Canova's sculpture, Cellini's mannerist rendering shows the hero standing atop the grotesque remainder of Medusa's body. Curled rivulets of blood stream out from her open neck, matching the ones dripping from her bodiless head. This is a moment of reflexivity: Michael Cole interprets the blood that is so realistically dripping from Medusa's severed neck as a figure for the sculpture's poured bronze.[42] Though her face is expressionless in death, her body is dynamically convulsed in reaction: her torso twisted, her body curled into a tight ring, and on her left hand, the index finger half-extended, as if to identify and incriminate Perseus for his terrible deed. Canova's work, by contrast, keeps Perseus's feet planted on a clean and even floor, and instead of blood pouring from her severed neck, his Medusa shows no neck at all, its chin instead neatly collared by a few coiled snakes. Where in Cellini the head maintains a visceral connection to the body that forms its base, in Canova, the head is already the gorgoneion, the face alone. Foster, we see, has selected as the basis of his aesthetic theory a moment of the myth where the woman's body has been decisively carted offstage. Cellini's sculpture posits a counter-narrative, where the underlying material of art keeps its gender.

The literary practice of ekphrasis, as discussed by Mitchell in his reading of Shelley's poem "On the Medusa of Leonardo Da Vinci in the Florentine Gallery" (1819), would seem to be far removed from the dynamic of gender and materiality in film. Yet ekphrasis offers an instructive counterexample for an artistic medium's distancing and protective functions, which are relevant to the play of repression and sublimation of film vis-à-vis its materiality. Ekphrasis does not replicate the visual in its own terms as does, by comparison, a photograph of a painting. Rather, it sublimates an artistic image into descriptive language, and therefore is a practice of dematerialization. The Medusa

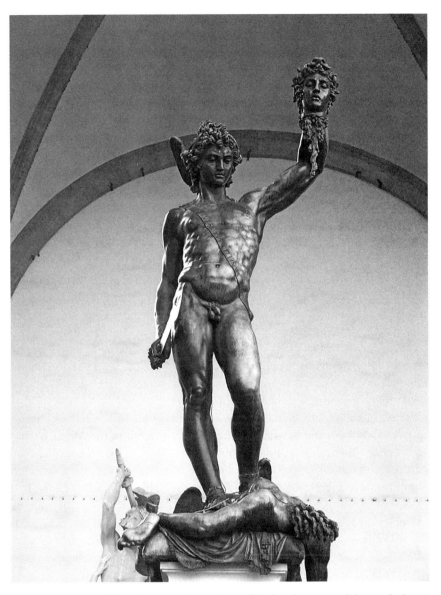

Figure 4. Benvenuto Cellini, *Perseus with the Head of Medusa* (1545–1554). Loggia dei Lanzi, Museo Nazionale Del Bargello. Courtesy of Museo Nazionale Del Bargello.

myth as read by Mitchell animates issues of aesthetic origin, gender, and materiality. Here the threat posed by Medusa remains in anxious proximity to an ineliminable but also unincorporable presence. Not surprisingly, this problematic turns around the nonrepresentation of a woman's body.

The interpretive question posed by Shelley's poem is how *alive* and therefore how dangerous is Medusa's severed head, and how far the image-making of art, whether in painting or poetry, can effect a sufficient barrier against that danger. Ekphrasis *ought* to be safe from the problems of figuration that concern Medusa in visual media, yet Shelley's poem is energized by the doubt that not even literary distance is sufficient. If the general aim of ekphrasis is, as it were, for the image described to come alive, then the case of Medusa gives rise to the opposite impulse: the fear that this may actually happen. Mitchell locates "ekphrastic ambiguity" in the fascination with the woman, which commingle fear of and desire for Medusa. The reader's fear is stoked by the poem's structural ambiguity concerning the status of the visual. Though Shelley's title suggests that it is a description of a specific painting in the Uffizi Gallery (previously attributed to Leonardo Da Vinci, later credited to an anonymous painter of the Flemish school), Mitchell notes that the poem's speaker seems to be standing not before the painting but the gorgon's severed head, in the present tense, unmediated (fig. 5). By the logic of the Medusa myth, then, the speaker has cast aside the protective, intervening frame of the artwork, a repetition of Perseus's shield, exposing himself in imagination directly to the prohibited and petrifying, hence unrepresentable, sight.

The gambit of image-making is the ambiguity of the image both as distancing representation and as what Mitchell sees as explicit in the Medusan subject matter, "the image as a dangerous female other."[43] Like the China Girl, Medusa's "repressed image" tends to become *only* image—the otherness of her femininity is strangely without a gendered body.[44] This is to say that her body—the site of her dangerous femininity, one would think—once again disappears. (At least that other "shattered visage" of Shelley's, Ozymandias, got to keep his "vast [but] trunkless legs"!) Her head, meanwhile, is transformed by Shelley into a mere object: "it." Though Mitchell does not remark on it, Shelley's poem does evoke, if only in misdirection, the body missing from the scene, describing how "from its head as from one body grow, /As [river] grass out of a watery rock, /Hairs which are vipers." In this simile, the head stands in *for* the body, but as with Canova, the sublimation of gender has already begun with the act of decapitation.[45] It is curious, then, that Mitchell regards this painting as a definitive and exemplary "female image" without remarking on the fact that its subject is the *absence of a female body*, or that Shelley himself works to underline the paradox.[46]

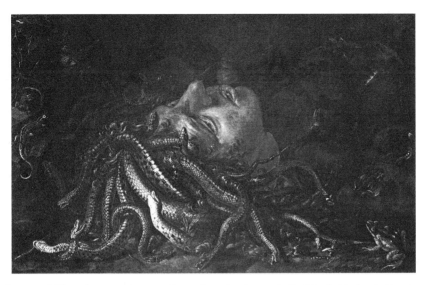

Figure 5. A Flemish painter (previously attributed to Leonardo Da Vinci), *Medusa's Head* (ca. 1600), The Uffizi Gallery.

Like Foster and Mitchell, Kracauer uses the Medusa myth to tell a kind of origin story for the aesthetic as encounter or scene. Kracauer sets himself the problem of film's specificity as a medium in this regard. For him, the mythical scene is analogous to the film-viewing experience: Medusa is the film image, a mediated real presented onscreen, while the film viewer has taken up the role of Perseus:

> The moral of the myth is, of course, that we do not, and cannot, see actual horrors because they paralyze us with blinding fear; and that we shall know what they look like only by watching images of them which reproduce their true appearance. These images have nothing in common with the artist's imaginative rendering of an unseen dread but are in the nature of mirror reflections. Now of all the existing media the cinema alone holds up a mirror to nature. Hence our dependence on it for the reflection of happenings which would petrify us were we to encounter them in real life. The film screen is Athena's polished shield.[47]

Kracauer, like Foster and Mitchell, ignores Medusa's body after it is split from her head, and consequently his theory follows a now-predictable trajectory that divides gender and materiality on one hand and image and immateriality on the other. Yet his interpretation of the myth opens up other, productive

possibilities for conceptualizing the relationship between gender and materiality for film.

Kracauer's film theory is materialist. Because film and photography possess a mimetic relationship with the world they register, they are closer to reality than other forms of art-making, and the images they produce thereby constitute a special category of encounter, tantamount to reality itself.[48] Kracauer bases much of his faith in cinema in its potential for integrating the real—the physical, material world of history—in a way that no other medium can achieve. Kracauer's understanding of materiality is worth following, even if the materiality he sees *in* the image, namely, reality, has less to do with the materiality *of* the image, the filmstrip. The latter is the concern of this book.

Kracauer's emphasis on film materiality offers two new conceptions of Medusa that allow us to place her outside of the narrow characterization provided so far. First, she is a figure that possesses a whole body. Significantly, Kracauer aligns the film viewer with Perseus not as a victor, but as the hero in the moment before battle: "Perhaps Perseus' greatest achievement was not to cut off Medusa's head but to overcome his fears and look at its reflection in the shield."[49] By implication, his use of the mirrored shield protects him from the living, fearsome Medusa as a whole body, which Canova and Shelley have already ushered out of sight. Though Medusa's body is not mentioned in Kracauer's text, we can assume that it is as yet untouched by Perseus's blade. Second, her body is comprised of visceral material. In invoking Georges Franju's slaughterhouse documentary *The Blood of the Beasts* (1949) as an example of "actual horrors" seen in the Medusan reflection, Kracauer presents an industrial repetition of Medusa's decapitation: "puddles of blood spread on the floor while horse and cow are killed methodically; a saw dismembers animal bodies still warm with life; and there is the unfathomable shot of the calves' heads being arranged."[50] To be sure, the slaughtered cows are not gendered, but Kracauer has slyly reintroduced the body—still warm and palpable, and not a metaphysical remainder but an industrial factor—into the Medusa myth.[51]

Kracauer also offers a new purpose for Medusa, which, more than it displays the aesthetic powers inherent in the artwork, provides therapeutic value. In this way, cinema is "redemptive" as the title of his book suggests. He deploys Medusa's image to effectively heal an already traumatized spectator: "The mirror reflections of horror are an end in themselves. As such they beckon the spectator to take them in and thus incorporate into his memory the real face of things too dreadful to be beheld in reality."[52] By relocating the heroic act from Medusa's decapitation to viewing her image in the shield, Kracauer unwittingly restores to Medusa her complete body. Even if he does not describe

Medusa's corporeality in terms of a gendered materiality, his theory offers the possibility of doing so. Strikingly, there is no violence necessary to his account. When he identifies the shield that bears Medusa's image as belonging to Athena, he does not specify whether this is the shield on which the gorgoneion is mounted, or the one the goddess originally gave to Perseus to aid in his quest. This ambiguity is enough to wind back the progression of events in the myth and to end them, as he says, in the "mirror reflections of horror." The body of the woman is left intact, and it is from this place, in the materialities of film, that I begin my investigation into the vanished female body.

Looking Back

In the previous section, I cautioned against feminist approaches that treat gender as something merely to be restored to the scholarly record as well aesthetic theories that address it as something forever retreating into an ontological remove. I maintain that gender is more than a lack or a structuring absence, and that it can be read in and through the processes that undergird the materiality of film. To this end, I offer in each chapter a reading of experimental moving-image works that offer a critical and feminist reflection on film materiality corresponding to the site of production being examined. I move to avant-garde film for two reasons. The first is its unique position in relation to industrial film production, which allows it room for critical analysis. Experimental film is often made using the same industrial facilities and production procedures as mainstream film, and it is distinct from more conventional filmmaking for the way that it often responds directly to the very cultural and technological conditions of its making. For instance, with the 1960s and 1970s structural and materialist investigations of the film apparatus, a significant number of avant-garde filmmakers interrogated the material basis or essence of the medium. These films offer a unique vantage for examining the film artifact in its nonmimetic capacities. As can be seen in the examination of film leader, subtitling errors, camera run-off, and other 35 mm film scraps in *Standard Gauge*, experimental film provides a perspective otherwise unavailable to a model of film analysis based on the interpretation of a film's "textuality" and its representational strategies.

The second reason is a prominent tradition within avant-garde film of using the filmmaker's outsider status to critical advantage. This includes the aesthetic freedom in the heroic strain of Maya Deren or Stan Brakhage; anti-capitalist autonomy in the cooperative model used for distribution organizations such as the Film Makers' Cooperative in New York or artist-run film laboratories such as L'Abominable in France; or pointed political critique in the work of

Yvonne Rainer, Harun Farocki, or Kevin Jerome Everson. This latter strain is of particular interest to *Girl Head*, and it includes a sizeable contingent of feminist filmmakers whose films often paralleled the theoretical work occurring in the academy: Chantal Akerman, Carolee Schneemann, Valie Export, Su Friedrich, Marjorie Keller, Bette Gordon, Barbara Hammer, Laura Mulvey, Abigail Child, Peggy Ahwesh, Beatrice Gibson, Laida Lertxundi, Aura Satz, and many others. Hence, each chapter contains readings of experimental works that construct something of a counter-history by exploring the potential for a reflexive, feminist restructuring of film materiality. These indicate multiple trajectories of critique and possibility in view of film material processes and their entanglements with gender: Barbara Hammer, Michelle Silva, Cécile Fontaine, Sandra Gibson and Luis Recoder, Jamie Allen, and Mark Toscano (see chapter 1), Jennifer Montgomery (chapter 2), and Cheryl Dunye and Radha May (chapter 3).

To offer a preview of this approach, I read Lynn Hershman Leeson's multimedia installation *Room of One's Own* (1990–1993) as an alternative origin story for the art of film. In dialogue with Foster, Mitchell, and Kracauer, Leeson offers a compelling feminist restaging of the Medusa scene, and she brings to the surface what was repressed in their accounts, namely the violence inherent in the viewer's look. In this work, film begins not by the beheading and brandishing of the gorgoneion, but in the fascination and capturing of Perseus's gaze.

The work is set up as a small peephole box that, through a small periscope, reveals a miniature bedroom, like that of a dollhouse (fig. 6). It is a woman's room, as the title's reference to Virginia Woolf indicates, with a four-poster bed, a television, and, in various iterations, a telephone and clothing on the floor. It is also a filmmaker's room, as suggested by the tiny director's chair that is sometimes there.

The scene is Medusan. The viewer is positioned as Perseus, the one privileged with the look, and he (as a stand-in for any viewer) enters the woman's lair apparently undetected, through a viewfinder. He looks into the small, deep space. Directly in front of him, he sees a video projected onto the back wall of the bedroom. Depending on when in the loop he enters, he might hear a voice calling out, "Don't look at me." This recalls the prohibitions against looking at Medusa, and like the many heroes that have come before him, he looks further. He pans from the bed on one side to the television on the other. To his surprise, the viewer finds his own eye peering back at him in the monitor, isolated and enlarged.

A *Room of One's Own* models a strange kind of cinema, one in which the roles of observer and observed have been reversed. Its structure is rooted in

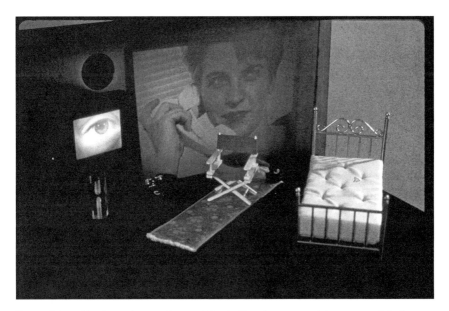

Figure 6. Lynn Hershman Leeson, *Room of One's Own* (1990–1993). Image copyright Lynn Hershman Leeson. Courtesy of the artist and Bridget Donahue, New York City.

cinema: the darkened chamber of the box was designed with Edison's kineto-scope viewer in mind, and, among the videos projected on the back wall, we see a woman pointing a gun at the camera in the manner of the iconic shot from *The Great Train Robbery* (1903).[53] Leeson's device leads the viewer to ex-pect the physical body of the woman who inhabits this tiny room and frus-trates this expectation by replacing it with the live video-feed image of the viewer's own eye in extreme close-up. Instead of Kracauer's vision of a coura-geous Perseus daring to confront the Medusan images onscreen, here the viewer is the one that is hailed, and implicitly viewed, by an unseen woman. She is no longer there to be looked at—insofar as she is invisible—and instead, through her admonition against looking at her, she can presumably see the viewer searching for her. Meanwhile, he is caught in his own gaze, staring at an uncanny, isolated eye that seems to belong to another.

Leeson's miniature cinema inherits many of the conventions of the mythi-cal scene. In endowing *this* Medusa, herself a filmmaker, with the power to look, she dismantles the screen of projection. With this critical insight, Lee-son reconstructs the terms of gender and materiality upon which aesthetic theories about Medusa have relied. The woman's body is still absent, but in this case it has *explicitly* disappeared, since it is not there as the viewer might expect. Unlike the body in Foster, Mitchell, and Kracauer's accounts, this is

an absence that is meant to be noted as something that has purposefully gone missing on its own accord. Furthermore, its replacement by the trapping of the viewer's own gaze places and literally frames looking at the center of the work: no longer is it about what the viewer is privileged to see, as in Bruce Conner's suggestion of a striptease, but the limits of his looking. By catching the viewer's gaze and making it the object of analysis, A Room of One's Own exposes his naked desire to see and effectively control the image. Medusa's body has once again disappeared, because Perseus failed to capture her.

This book problematizes many cinematic gazes, including those of spectators, critics, and filmmakers, in order to better track the motif of the disappearing female body. As A Room of One's Own demonstrates, such gazes are inadequately equipped for seeing where or how the woman vanishes; the tendency is to get trapped in themselves. Girl Head, then, looks askance at sites of material production to search for traces of the disappeared female body, whether materialized as a means of production, or dematerialized as it enters the realm of pure image. All the while, I attend to the historical specificity of these film production practices by noting the inseparable social attitudes that underlie their development, namely the anxieties concerning women's social and sexual status. Each chapter addresses a different site of production:

First, in chapter 1, I show how in the film laboratory, China Girl reference images used in maintaining ideal appearance are literally marginalized on the ends of the filmstrip. Translated into numeric values for color, density, and especially the calibration of skin tones, their bodies are instrumentalized for quality control procedures. These women are rendered as so much industrial material embedded in the photochemistry of film. In order for this to happen, the woman's body is dematerialized and disappears, a process that correlates to the production of the film image. While the laboratory uses of the China Girl are assumed to be rational and objective, I show that they are often more ideological than they are taken to be. The chapter concludes with a survey of experimental films that foreground the China Girl, including those that reproduce the marginalization of the figure and others that, from a feminist perspective, signal the laboratory procedures that determine the terms of the China Girl's liminal appearance.

Next, in chapter 2, I examine how in film editing, the act of excising the woman's body as part of a technical procedure attends a longstanding, alternate history of surreptitious film editing. What I call escamontage, a portmanteau of escamonter (French for concealment or trick) and montage (the practice of constructing meaning through the assembly of discrete film fragments), is a formal practice whereby cuts are made without any apparent break in the framing. In distinction to classical editing style, which maintains a continuity

of action across breaks in framing, escamontage pairs continuity of action with continuity of framing. I trace escamontage, and its accompaniment by a representational practice where the typically female body is the medium on which spectacular effects are performed, in three moments: the first, the development of the practice in Thomas Edison's *The Execution of Mary, Queen of Scots* (1895); the second, its elaboration in classical Hollywood cinema with Alfred Hitchcock's *Rope* (1948), and the third, its enmeshment with digital visual effects in David Fincher's *Gone Girl* (2013). Against a historiographical understanding of invisible editing as a development of classical film style, and the tendency to relegate these barely noticeable cuts to the field of visual effects or to a history of "trick" films, I argue that escamontage constitutes its own lineage of invisible editing. I conclude with a reading of Jennifer Montgomery's *Transitional Objects* (1999), a video that draws on the association of women with cutting by using the image of a woman being violently cut as the basis for a new editing practice.

In chapter 3, I engage with Jacques Derrida's *Archive Fever* (1995), in which the motif of the missing woman appears in the guise of Gradiva, a character from William Jensen's novella (1903) of the same name. At once a ghostly image and a presence evoked by a few, nonbodily, material traces, Gradiva motivates the construction of the archive, and, for Derrida, its eventual destruction. In omitting a key part of Jensen's text, namely the moment when Gradiva's "original," the flesh-and-blood woman Zoë, appears, Derrida consigns the archive to a space of memory and haunting. This same Gradivan logic, where the body of the (living) woman is excluded from her chimerical image, adheres in several films that are pointedly about the film archive. Bill Morrison's *The Film of Her* (1996), about the Library of Congress's Paper Print Collection, reproduces the melancholic terms of Derrida's Gradivan theory. Meanwhile, Cheryl Dunye's *The Watermelon Woman* (1996), about the Hollywood archive of a fictional Black lesbian actor, and Radha May's *When the Towel Drops, Vol. 1, Italy* (2015), about the censorship clippings from postwar Italian cinema, offer feminist critiques of the gendered materiality on which they are predicated.

In each of these sites of production, the disappearing female body makes visible different technical and theoretical aspects. At times this body corresponds to the onscreen representation of a vanishing woman—implicitly in *Mary, Queen of Scots* or explicitly in *Gone Girl*—so that the hiding of the body is associated with a hidden edit (itself largely hidden within the history of film editing). The excised body serves as a figure for materiality in theoretical accounts or in technical ones. It is itself material incorporated into the production of film, a means of production. We might even speak of the woman's body in the age of its technical reproducibility, since it is no longer strictly

mimetic but a complex and disavowed component of production. Among the technical sites I visit in this book, this body is materialized as a reference image not intended for viewing, as what is spirited away in the earliest splices, and as the fragments upon which the film archive is built. It's materialization is not an ontological claim, but a historical one. Hence, it is not the case that the woman's body is essentially or even technically necessary to film production processes—this could well have unfolded differently. But, throughout the record of film as a historical practice, woman-as-material has been closely associated with the film image in both theoretical and technical procedures, in an entanglement that cannot be simply undone.

1
China Girls in the Film Laboratory

> Before my eyes—there, passing in slow procession along the wheeling
> cylinders, I seemed to see, glued to the pallid incipience of the pulp,
> the yet more pallid faces of all the pallid girls I had eyed that heavy
> day. Slowly, mournfully, beseechingly, yet unresistingly, they gleamed
> along, their agony dimly outlined on the imperfect paper, like the
> print of the tormented face on the handkerchief of Saint Veronica.
>
> —HERMAN MELVILLE, "THE TARTARUS OF MAIDS"[1]

The most ubiquitous woman in film has hardly ever been seen. This woman, often conflated with the name for the China Girl reference image, was for the majority of film history used in quality control procedures in film laboratories. However prominent behind the scenes, the China Girl rarely made it to the cinema screen. As John Pytlak, a former Kodak engineer who pioneered the Laboratory Aim Density China Girl image, described, "she has probably been in more movies than any other actress in the world."[2] Yet the China Girl, though crucial to the final look of a film, and common across commercial film production worldwide, remains unknown.

The China Girl appears in every country that has a major film industry, including the United States, France, Germany, Italy, China, Korea, Japan, and India. In Western nations, the China Girl model is almost always female, young, conventionally attractive, and, despite the racial connotations of the name, white. The China Girl can be found on the ends of the film reel, with a few frames cut into either the head or tail leader. On 16 mm or 35 mm film, three to six China Girl frames are typically cut into the countdown leader, normally between the numbers 10 and 3. Its appearance on a release print is an artifact

of developing and printing processes by which it had been used to calibrate exposure, density, and color, particularly ideal values for skin tone, as well as the machines by which these values are set. The China Girl functions primarily in a feedback system, where the image tests for quality control in the making of master and positive elements from edited film negatives, the duplication of positive prints, and the mass production of release prints, among many other uses.

Strictly speaking, the China Girl is a reference image not to be mistaken with the many anonymous women who posed as "China Girls." The singular China Girl is an object, a tool used in film laboratories and an emblem of the production process in which it partakes, while the plural form fits into a history of female labor in the film industry. This distinction is important for the way this figure is understood both historically and conceptually. Pytlak's romanticized remarks above indicate how easily one can slide between these two terms. By posing as China Girls, women are made into *the* China Girl reference image, a transformation from *she* to *it*, and from female body to material for film. This process happens far below a film viewer's awareness. A China Girl would only appear during a screening if a projectionist failed to switch film reels at the correct moment; even then the short duration of its fugitive appearance would be just as easy to miss. Save the projectionist's error, there is, of course, no explicit prohibition against seeing the China Girl, though glimpsing it runs the momentary risk of disrupting a movie's narrative reverie by literally exposing the constitutive seams of a film's construction. The China Girl is generally only known to those that handle and scrutinize film, chiefly laboratory technicians and archivists. The women who posed as China Girls disappear twice over: first as the China Girl image on the film leader that are overlooked by viewers, and second as the anonymous laborers whose behind-the-scenes work, like many others, goes under-recognized by film historians and enthusiasts in favor of the achievements of actors, directors, and other above-the-line talents.

The image has been in use since the early to mid-1920s, and it remained a central part of laboratory culture throughout the twentieth century. Though today the photochemical processing of film has nearly ceased in commercial film production, the China Girl and the quality control methods associated with it continue in limited application, especially in hybrid processes requiring film-to-digital conversions. As this chapter shows, the first decades of its use were crucial in establishing a gendered and vaguely racialized practice that formed the basis for the appearance of all film. The China Girl is more than just a woman's face but an instrumentalized image whose values for tone, density, and color are broken down, isolated, and abstracted to establish the mate-

rial basis for other images. In the China Girl, material is inextricable from image—it is indeed constitutive of it. Specifically, the China Girl delineates the material conditions of laboratory processes, which, however scientific, were for the majority of the twentieth century manually executed and always in need of adjustment.

As a technical image, the China Girl is far from neutral. Despite the rhetoric of objectivity used to describe laboratory processes in trade journals, the image yokes prevailing cultural notions of race, gender, and sexuality to technical function and practice. In a perhaps unconscious way, the China Girl imports a complex matrix of cultural assumptions to the terrain of filmic representation and its material basis. As with any technology, of course, film can never be presumed to be innocent of the cultural conditions in which it was developed and practiced. Technology can only function within a cultural logic. Like the computing technologies that for Tara McPherson invoke "operating systems of a larger order," film is crucial to the way culture understands and organizes its constituents and their images.[3] Though rarely seen by typical film viewers, the China Girl image has been necessary to the ongoing function of the film laboratory. The techniques fundamental to film production conceived of filmic materiality in terms of a woman's body. This is not just an empirical claim—although it would cover all cases of commercially produced film. What interests me is how the woman's body, while not specifically necessary to film production processes, has been incorporated into them by laboratory technicians, and how the China Girl has been *made* crucial to these procedures. Here it is important to draw a distinction between the practical, standardizing function of the China Girl for film and the way these materials have been historically understood as part of a filmic imaginary.

The China Girl is distinct from the referential or representational quality of the types of images that appear onscreen in that it is regarded *only* as a technical tool, used to calibrate *other* images. On a strictly technical level, the reference image need not depict a woman at all. In the China Girl's technical capacity, the body of the model disappears—subordinated, along with other laboratory and postproduction procedures, to a regime that privileges the luminous faces of actors onscreen. It remains behind the scenes, overlooked. Yet, because of its perceived utility, it has survived as an unusually durable figure.[4]

The woman's body is, in effect, a means of production consumed to produce a "correct" appearance for images onscreen. In this sense the China Girl is no different from the standardization tests and procedures one would find in, say, industrial iron smelting. The test image is simply another cost of production, folded into the laboratory's operating budget. We are accustomed to

thinking about images as cultural objects rather than as functional technical components. Photographs of individuals automatically tend to signify particularity, but individuality makes up no part of the use-value of the China Girl, in Marx's sense. Although the China Girl is a film image of a woman's face, it is nonsignifying and kept outside the domain of representation. From the point of view of industry, any signifying feature should be considered a kind of semiotic excess along the lines of the capitalist imagined by Marx with "a foible for using golden spindles instead of steel ones."[5] It is a nonscenic element, consigned to the ends of the filmstrip, different even than the diegetic contiguity suggested by offscreen space. The face of the China Girl is nonmimetic, and for this reason, it cannot appear in the manner of other film images. Instead it is understood as raw material for the production of film, with only a trace left on its unseen margins. Even if the China Girl is profilmic in the sense that it is an arrangement of elements before a camera, it indicates how the film laboratory functions as another kind of "studio" in which an alternative economy of images circulates. The China Girl is a condition of industrial film production, rather than a "film" in its own right.

By this same logic, the bodies of the women who posed as models have remained even further from the picture. As regards the women who posed as China Girls, they have all but vanished, lost to countless hours of uncredited and anonymous labor. While I have been fortunate to track down a small number of former models, as I will discuss later in this chapter, it is difficult to locate China Girl models since their images often migrate from one film to another in the process of reduplication and quality-control testing.[6] The China Girl is a somewhat apocryphal figure. Though many within the more technical sectors of the film industry express familiarity or, as is frequently the case, longtime fascination regarding the China Girl, there is not, to my knowledge, a confirmed written account that describes either the first usage of a China Girl nor the origins of the name.

As the name suggests, the China Girl encodes attitudes about race. China Girls are often attended by orientalist details in dress, hairstyle, and as reported in some cases, a straw "Coolie" hat.[7] In the 1970s, for example, Kodak posed many of its China Girl models in the same mandarin-collared blouse (one of these can be seen in Mark Toscano's *Releasing Human Energies*, discussed later in this chapter). *China* is also suggested in the material of porcelain, as in china or porcelain dolls. The *China* in the term is like the name China itself, a name synonymous with its famed export, porcelain. (The word *China* is the invention of European traders, a phonetic approximation of the Tang Dynasty's center of porcelain production Changnan, or present-day Jingdezhen.) The linking of race, gender, and material is also apparent in the various names given

to the China Girl in countries outside of the United States: in France, it is known as "Lili," "la chinoise," "Kodakette," and "la bridée," with the latter referring to the slanted shape of Asian eyes. In Thailand, "Muay" or "Ar Muay" is used, also referring to the appearance of a Chinese girl. Japanese technicians employ "China Girl" as an English-language phrase, as do laboratory workers in India and Slovenia (where she is also called "kitajka," or Chinese woman). Mexico uses "muñeca" or "mona," both of which refer to dolls, and the similar term "muñeca de porcelana" in Argentina. Laboratories in Austria refer to them as "Conchita," which in Spanish means little shell and is also slang for "little cunt." (Conchita is the name of the main female character in Luis Buñuel's *That Obscure Object of Desire* [1977], and she is played by two different actresses, further underscoring the incidental quality of the woman's actual appearance.) More broadly, this orientalism is suggested in the stereotypical notion of Asian femininity that women be subordinate and submissive, qualities that would be useful for the technological function the image serves.

Asianness as such is subordinated to gender and materiality. In western countries, China Girls are white and pale-skinned. Asian women only appear as China Girls in Asian contexts like the Japanese film industry, and even in those cases the preference for light skin prevails. Some have suggested that Asian women posed as the first China Girls, though in the wealth of China Girl images that crop up in film archives, I have yet to find evidence to back up this claim. Instead, race is reduced to oriental embellishment, eroticism, and exoticism in the China Girl name, appearance, and apocryphal origin. Within the marginal figure of the China Girl there is a further concealment of racialized bodies that do not meaningfully appear at any level. As Karen Redrobe observes about the figure of the vanishing lady in cinema, the emphasis on the spectacle of a disappearing white woman often served to conceal other kinds of missing bodies, namely the racialized subjects of colonial England.[8] With Redrobe, we should remain attentive to the ways the China Girl, although marginal, can screen other figures from view.

The image's history is largely vernacular. The authors of the technical literature preferred descriptions of the sensitometry practices and instruments for which the China Girl was employed over mentions of the image itself. The first reference to a "close-up of a girl" does not occur in the *Journal of the Society of Motion Picture Engineers*, the chief professional journal for the film industry until 1933, though the densitometer, the instrument most closely associated with the China Girl, first appeared in the journal in 1923. "Gray lily card," another synonym, first appears in a 1958 article. "China Girl" and "girl head" (and its variant "head girl") are only used in the journal beginning in the early seventies, though they had long been used in film laboratory vernacular.[9]

It is more common for technical literature and cinematography and labora-
tory manuals to write "test strips," "control strips," "picture tests," "test pieces,"
or "sample printing," though not all of these necessarily indicate a process that
has a face.[10]

A rare acknowledgement of China Girls occurs in a 1967 ad thanking "The
Group" at Kodak (fig. 7). The image features four white women dressed in a
range of attire: wedding gown, black lingerie, slacks and flat-heeled shoes, and
cocktail dress, They are posed in a living room set, with the lighting and mo-
tion picture camera of the backstage area visible. The ad is startlingly aware
of the peripheral place these women typically occupy:

> Before any Hollywood starlet gets her big chance in a new film, these
> girls at Kodak have seen thousands of images of themselves. On the
> same type film! Such is life at Kodak—we do a terrific amount of
> testing before we put our best footage forward. And what better subjects
> for our screen testing than these four lovely girls? . . . Thanks, girls, for
> your splendid efforts in movies that will never put your names up in
> lights. But you knew all along: *your roles were played only in the name
> of progress.*[11]

While technical histories documenting the development of film stocks or
standardization methods for the film industry abound, the China Girl remains
largely absent from film scholarship in a manner not dissimilar from her mar-
ginal place on the filmstrip.[12] As a projectionist at the George Eastman Mu-
seum said to me during one of my visits to the research library, "you're looking
for exactly what we're trained to ignore." The China Girl serves, somewhat em-
blematically, as a mute, subservient, female foil against the male-dominated
accomplishments in photochemistry, engineering, and industrial expansion,
particularly in the first half-century of film's existence. On my reading, this
characterization is not accidental, but was understood as necessary to the
technical operation of the film laboratory. To understand how and why the
China Girl matters requires tracing the history of standardization and quality
control within the film laboratory. I begin this chapter by visiting the histori-
cal and industrial conditions in which this figure first appeared and was de-
veloped, namely, at the major junctures of sound and color and film-to-digital
technologies. In all cases, the China Girl is a mediating figure that smooths
over the technological transition and enables the desired appearance of
images onscreen. I then turn to a number of experimental films that have,
against the industrial norm, figured the China Girl prominently and with it
the possibility of regarding her obscured position differently, even possibly
recuperating it.

Meet
"The Group"
at Kodak

Before any Hollywood starlet gets her big chance in a new film, these girls at Kodak have seen thousands of images of themselves. On the same type film! Such is life at Kodak—we do a terrific amount of testing before we put our best footage forward. And what better subjects for our screen testing than these four lovely girls?

They've been photographed on some pretty far-out films, we'd like you to know. Some never got past the focal plane into the factory. Others looked very promising indeed, and are now pleasing audiences—and professionals like yourself—around the world. But we never would have felt sure about these films if we hadn't put them through long hours of actual shooting situations. Thanks, girls, for your splendid efforts in movies that will never put your names up in lights. But you knew all along:

your roles were played only in the name of progress.

Kodak knows where the cinematographer's needs are. Wherever possible, we put ourselves in your place. And we have a direct line to you through our motion picture engineers in the offices listed below. We think this gives us a sound business relationship: professionals working with professionals.

EASTMAN KODAK COMPANY

ATLANTA: 5315 Peachtree Industrial Blvd., Chamblee, 30005, 404—GL 7-5211; CHICAGO: 1901 West 22nd St., Oak Brook, 60523, 312—654-0200; DALLAS: 6300 Cedar Springs Rd., 75235, 214—FL 1-3221; HOLLYWOOD: 6706 Santa Monica Blvd., 90038, 213—464-6131; NEW YORK: 200 Park Ave., 10017, 212—MU 7-7080; SAN FRANCISCO: 3250 Van Ness Ave., 94119, 415—776-6055

Figure 7. "The Group" advertisement, Kodak, 1967. Courtesy of George Eastman Museum.

Control

Many women, likely thousands, have posed as China Girl models. For much of the twentieth century, individual film laboratories produced their own China Girls, sometimes hiring models especially for that purpose or persuading their female employees to pose. In addition to China Girl, they were given lab-specific nicknames such as Ullie, Marcie, Shirley (more commonly the name for the still photography analogue for the China Girl), and Lily, or more generically they were referred to as "china doll," "girl head," "lady wedge," or "lily card."[13] In larger corporate settings such as the research division of Kodak, though the term China Girl remained a part of the corporate culture, this nickname was replaced by more neutral-sounding terms such as the "LAD target," especially after Pytlak's invention of the LAD system (which I discuss later in this chapter).

Although the China Girl denotes an image that does not appear to move, it is not photographic but cinematic: an image created by shooting a roll of 16 mm or 35 mm film. Indeed, if one is paying close enough attention, it is possible to spot subtle changes in the China Girl's expression, such as a dulled smile or the blinking of her eyes. The nickname of "china doll" is appropriate for the stillness required in posing; as Roland J. ("Rollie") Zavada, a former standards director for imaging technology at Kodak, notes, models were used in many color analysis applications beyond laboratory control. "Our model in the film Testing Division Studio could hold the exact pose so perfectly that we could shift a MP [master positive] take a few frames to print superimposed frames when studying the early problems with ECN [Eastman Color Negative] grain size."[14] In the lab, meanwhile, quality-control technicians expose a roll of film and duplicate it in batches many times over.[15] The images are then stored in a freezer to preserve their chemical composition, with individual frames periodically snipped to be used as test images in the various applications described above. In this way, the image of a given China Girl model could linger in a laboratory for years, even decades.

The China Girl cannot be understood without reference to the conditions of its appearance, namely, as a metric for standardization in the film laboratory. There it is used to calibrate the desired exposure and color balance of film reels, check the functionality of developing and printing machines, determine the evaluation of negative or intermediate film, and test rating of print stocks. For example, in developing film, a technician would run a few frames of China Girl leader with the film, then examine the developed filmstrip against a previous one to check that the film or chemicals are consistent. In this way, the China Girl is nonrepresentational: the female model is never

meant to "appear" or signify in the manner of actors onscreen, or in any way other than visual information. It need not be recognized even as a woman in order to fulfill its key role. Functionally, the China Girl does not have to "be" anything particular, and there are rare cases where the China Girl image is an object, like a puppet or mannequin, or a dog, a child, a man,[16] or a group of people (plate 1). The image matters less than its comparison to other iterations of itself; it is the master against which duplicates of its own image are tested. The China Girl is only meant to be seen as a part of technical analysis, only important in the way it refers to itself.

The majority of research into laboratory procedures, especially in the early decades of the film industry, occurred at Kodak and its research laboratory. The story of the China Girl is inseparable from that of Kodak's own development: both its rise in the teens and 1920s, up through its decline toward the latter part of the twentieth century. Though not officially recorded in any historical account, I maintain that the China Girl image, and the practices associated with it, were first introduced in the early to mid-1920s and became widespread by the early 1930s.[17] During the first decades of cinema, the motion picture industry was rapidly expanding, with every stage of production becoming more standardized. Correspondingly, the motion picture laboratory also grew significantly in both output and research. Since the start of the film industry at the turn of the century, Eastman Kodak, owing to its robust business in still photography, was responsible for supplying the vast majority of raw stocks to film producers, producing both camera negative and motion picture positive film. Through an emphasis on technological innovation and canny business alliances, Eastman Kodak secured its monopoly of film manufacturing and, by extension, the developing and printing of its film stocks.[18] Eastman Kodak further expanded its reach in 1911 when it agreed to sell to independent film producers as well. The company shored up its stake in the burgeoning film industry by attempting to exercise control over processing and developing of its film.

With the move of the "independents," a group of film producers and exhibitors, to the West Coast, Eastman Kodak worked to consolidate its East Coast business. On July 9, 1920, Eastman Kodak announced that it was buying up several large laboratories in the New York metropolitan area, where the bulk of film development in the United States occurred. "The time has now arrived," the statement read, "when, in order to protect its own interest, it is necessary that it should go into the printing and developing of motion-picture films for the trade generally."[19] Unsurprisingly, other film laboratories and their industrial partners, among them the trade organization Associated Film Laboratories, Inc., balked at Eastman Kodak's declaration.[20] Many of those who

reacted most vehemently to Eastman Kodak's news had by then relocated to Los Angeles, in part for better filming conditions and, as independents, the opportunity to escape the reach of the Trust. In 1921, the *Los Angeles Times* reported that 80 percent of shooting occurred in Hollywood, though 90 percent of processing and developing work still occurred in New York at a rate of an estimated fifteen million feet of film processed every week, or what amounted to a twenty million dollar industry annually.[21] The same article waxed optimistic about the construction of the Standard Film Laboratories in Hollywood, which, the author suggested, "adds an important industrial unit to the manufacturing element in Los Angeles, and foreshadows the transfer to this city of the bulk of the developing and printing of films now done in New York."[22] As the locus of film production shifted to Hollywood, major studios correspondingly began building their own laboratories out west. Meanwhile, smaller film laboratories more peripheral to the industry were formed in New York and other cities. DuArt, for example, the country's oldest continuously run lab, was founded in 1922 in New York.[23] Despite the monopolistic practices in other areas of film production, film laboratories maintained a stronger degree of independence, and in 1953, roughly thirty unaffiliated film laboratories joined to form the Association of Cinema Laboratories (ACL) union.[24]

Owing to its shrewd business practices, Eastman Kodak dominated the film industry in the manufacture of raw stock and its processing. While several antitrust suits had been filed against the company, including a 1915 case in the US District Court accusing the company of a monopoly of photographic goods, it nevertheless fended off its competitors with trade alliances such as the Motion Pictures Patents Company (MPPC) and a technologically superior product bolstered by the work of the Kodak Research Laboratories, established in 1912 under the direction of Dr. Charles Edward Kenneth Mees. The Kodak Research Laboratories, headquartered at Kodak Park in Rochester, New York, set many of the industry's technical specifications pertaining to the manufacturing, developing, and printing of film. The Society of Motion Picture Engineers (SMPE), later renamed the Society of Motion Picture and Television Engineers (SMPTE), was founded in 1916 to establish a set of technical standards for the industry. SMPE was closely involved with the work occurring in Rochester. In the first issue of *Transactions of the Society of Motion Picture Engineers*, C. Francis Jenkins declared, "It is our duty . . . as engineers, to wisely direct this standardization, to secure best standards of equipment, quality, performance, nomenclature, and, unconsciously, perhaps, a code of ethics."[25] Jenkins cautioned against allowing the pursuit of commercial gain to influence technological development, but as the early years of the organization

show, the researchers at Eastman Kodak were also the ones who contributed most frequently to SMPE. Those who stood to profit most from industry standardization were also those positioned at the forefront of development and research. As the strength of major film studios grew, Eastman Kodak became all the more intent on controlling its stake in the industry, and the company did so largely by setting the standards for quality control procedures and instruments.

The China Girl, though not yet named or recognized, attended these developments in quality control. John Crabtree, one of Kodak's top researchers in the photographic chemistry department and from 1916 to 1938 the head of the motion picture film developing department, outlined key functional and technical milestones in "The Motion-Picture Laboratory," published in *SMPTE Journal* in 1955.[26] Function and technological innovation, of course, correlate strongly, particularly with regard to economic incentive. Crabtree notes twelve functional milestones significant to the historical development of the film laboratory, including: The establishment of the laboratory as a separate unit ("when the laboratory work was no longer done by the cameraman and his helper") (1900); the production and printing of sound film and the sensitometric functions associated with those changes (1928); color film processing in non-specialized laboratories (1950); and the technological adaptations required for a burgeoning television industry."[27] For each advancement, laboratories devised new methods of developing, processing, and printing that were then widely disseminated through professional organizations such as SMPTE and the ACL. Each required more exacting standards for quality control, and to this end film laboratories used various types of test images, including the China Girl, to measure their results.

The cumulative result of the changing demands of the film industry accounted for more efficient printing and developing processes that could be executed on a mass scale. For example, in the booming first two decades of filmmaking, laboratories made film positives by printing original camera negative on fine-grain stock. These negatives were prone to wearing out, and making duplicate negatives from positives often resulted in a deteriorated image quality. To address this problem, Kodak introduced a 35 mm motion-picture duplicating film in 1928 that could more accurately make multiple prints from the same negative.[28] Another issue was ensuring consistency across multiple reels, which became the norm with the early 1910s advent of the multireel feature. While variations in the appearance of single-reel films were less noticeable, the growing popularity of multireel films meant that laboratories had to invent more sophisticated ways to control density and exposure among different batch-printed reels.[29]

The China Girl is most closely associated with the field of sensitometry, or the reading of tone, density, color, and other related values of the filmstrip. I trace its emergence through parallel histories for which there is ample documentation, including sensitometric research as well as the densitometer and similar instruments. In *Motion Picture Laboratory Practice*, a 1934 Eastman Kodak manual widely considered to be the industry standard, John Crabtree and Glen Matthews assert: "The improvement in processing machines, emulsions, developers, and the like have all played an important part in the improvement of picture quality during the past few years. And yet, when all of these have been taken into account, the fact remains that sensitometric control has been a primary factor in the general improvement of picture quality, since it has revealed certain deficiencies in processing technique, the importance of which has not been thoroughly recognized."[30]

A little over a decade earlier, in 1922, Crabtree had presented to the SMPE a paper entitled "A New Sensitometer for the Determination of Exposure in Positive Printing." In it, he and L. A. Jones suggest the utility of a mechanized system for ensuring consistent exposure. At that time, judgments in printing quality were entirely dependent on the human eye. "Admitting the remarkable ability of the trained timer," they write, "errors in estimating the effective printing density of a negative are to be expected on account of the inherent nature of the human eye."[31] Later conclude: "For these reasons it seems desirable, if possible, to develop a method for the determination of exposure from which the personal equation is entirely eliminated."[32] Mees concurred, and in the discussion that follows the transcript of their communiqué, he throws the full weight of Eastman Kodak's research capabilities behind these research efforts in sensitometry. After observing the significance of sensitometers in creating a standard method of measuring image density and tone, he notes, "We shall be glad in our laboratory to assist the Standards Committee in any work with machines showing what the changes are in those that are made."[33] The following year, in 1923, John Capstaff and N. B. Green announced the successful fabrication of a densitometer (fig. 8), the instrument used to register sensitometric data by measuring the amount of light blocked by the silver grains in a filmstrip.[34]

Though the invention of motion picture densitometers and scene testers occurred in the early 1920s, it was only with the adoption of sensitometry for sound in the latter part of the decade that these instruments became widely used. Because inconsistencies in sound were far easier to perceive than poor image quality, these materials were used to adjust variable density, which occurred in the soundtrack area of a filmstrip. R. H. Bomback cites the

FIG. 5. Exterior View of Densitometer with Operator

158

Figure 8. Densitometer in *Transactions of the Society of Motion Picture Engineers* 7, no. 17 (October 1923).

introduction of sound as pivotal to the adoption of more precise quality control methods:

> Prior to the advent of sound considerable latitude was permissible in the handling of motion picture film, since the judging of the screened image was to some extent a matter of artistic consideration. The introduction, in 1929, of the combined sound and picture theatre release print, however, made it imperative to study the technical aspects of the processes involved, since any marked departure from the recommended practice was at once apparent to the ear and for this, of course, no latitude on artistic grounds could be tolerated.[35]

At Kodak, Crabtree concurs with the necessity of more stringent sensitometric measures after the introduction of sound:

> After sensitometry had proved its worth in the control of variable-density sound tracks, the next step was to apply it to the control processing of picture negatives and prints. . . . Provided with a sensitometer and densitometer and other refined instrumental aids, the laboratory was able to measure not only variations in the activity of the developer and variations in the degree of uniformity of processing resulting from changes in temperature and degree of agitation, but likewise variations in uniformity of the photographic characteristics of the film emulsions. This had the beneficial effect of compelling the film manufacturers to improve the uniformity of their product, the lack of which it was previously possible to blame on the laboratory.[36]

Quality control practices were refined in the laboratory and led to changes in the manufacture of film, namely, what was produced by Eastman Kodak. The relay between film laboratories and industrial research in the 1920s led to a loose but more or less standard adoption of a system of developing, printing, and quality control, including the use of China Girl reference images.

Test Cards

Until the late 1920s, lab technicians and timers generally relied on the human eye to judge the quality of a print. As early as 1913, Colin Bennett asserted that "a single glance" was sufficient in evaluating a strip of film after development.[37] Accordingly, the earliest surviving examples of China Girl test strips I have located depict medium close-up shots of women, without additional references to black and white values (plate 2). These were sometimes photographed during production. (In Le Mépris [1963], Godard pokes fun at this convention by

showing a statue posed in front of clapboard of color swatches [plate 3]). In such instances, the image functions primarily as a visual check to be registered by the eye. Decades later, in *Motion Picture Laboratory Practice*, Crabtree and Matthews admit the shortcomings of relying on the eye alone:

> Until a few years ago nearly all negative film, as well as a great deal of positive, was developed on racks, and the photographic quality of both was controlled by visual judgment. Usually, the supervisor of the laboratory, or those designated by him, examined the developed negative or print. . . . Obviously, the standard of photographic quality in this case depends upon the skill and judgment of those whose duty it is to pass upon the finished product.[38]

The Kodak Research Laboratories, meanwhile, worked to produce a technological means that would complement, though not altogether replace, the reliance on the human eye. Crabtree and Matthews mention the effective use of "sensitometric control strips," affirming that "it is evident that the sensitometric control strips must be processed under the same conditions as the materials being controlled."[39]

The scene tester machines then in use were inadequate. Crabtree and Matthews note: "While it is generally agreed that an intensity-scale instrument represents the *ideal type*, since, in practice, photographic materials are almost always exposed under conditions of variable intensity, no really satisfactory methods of producing intensity scales have yet been found."[40] In other words, photographic materials are always vulnerable to different conditions of lighting and exposure and require additional methods of evaluating quality. The authors concede: "In some laboratories, samples of a test negative or positive, usually a *close-up*, are developed along with the sensitometric impressions. Many laboratory men still feel that they can tell more from the picture than from the sensitometric data. By developing both, a practical test is made."[41]

In these passages, we can observe a tension between the objective precision of the sensitometric machine and the subjective registration of the human eye. Counter to the assumption that the machinic device would be superior to the eye, in practice, it seems, each corrects or at least compensates for the failings of the other. Thus the quality control procedures outlined in *Motion Picture Laboratory Practice* are not absolute measures, but *comparative* ones, instruments that measure the image of a close-up, presumably a human face, against its perception by a human eye. Crabtree and Matthews suggest that the resolution of this conflict between scientific rigor and subjective, even "artistic" impression might occur in the future: "There is at present no means of expressing, in a quantitative manner, the requirements for satisfactory screen

quality. Very probably, the artistic considerations involved largely preclude an-
alytical treatment of the subject. Positive quality cannot be precisely defined,
as it is based essentially on personal judgment as to what constitutes satisfac-
tory screen reproduction."[42]

George T. Keene reinforces Crabtree's and Matthews's conclusion that good
printing results are not the sole province of the densitometer but must also be
adjusted to the satisfaction of the eye. He writes: "A print made in this man-
ner, i.e., with gray cards in all scenes matched, might be called a sensitometri-
cally correct print. It probably will not be the most *pleasing* print, but it should
be close enough to optimum balance to require only minor changes in some
scenes. These final *artistic* corrections would be made by the timer after view-
ing the first gray-card timed print."[43] Sensitometry, in Keene's view, can only
produce correctness up to a certain point. The rest, the pleasing or artistic ad-
justments—in other words, the subjective rendering—are determined by the
eye of the timer himself.

Keene's mention of the term "lily gray card" is shortened in a 1965 article
by Pierre Mertz to the cameraman's "lily."[44] Lily, in both of these senses, would
seem to refer to a common nickname for the China Girl, or as I will soon
discuss, the color suggested by such colloquialisms as "lily-white." Pablo Tab-
ernero's article "Establishing and Maintaining Printer Light Color Balance in
Additive Color Printing by a System of Controlled Chance" (1961), mean-
while, obscures the reference to the human form altogether, naming these test
cards "Test Object." Tabernero is significantly less reliant on the use of Test
Objects than Crabtree and Matthews or Keene; for him, "it is desirable, but
not mandatory, that [the Test Object] contain a short scale of the fundamen-
tal colors R, G, B and Y, M, C. If it contains normal flesh tones, this also will
help."[45] It is not until the challenges of representing flesh tone on television
that the body of the China Girl, at least in abstract form, finally surfaced in
the research and training material employed by film laboratories.

Color

Though various attempts at adding color to film had existed since the begin-
ning of cinema, Technicolor dominated the color market from the late teens
through the early fifties, owing to the vast resources the company poured into
its color processes and the protectiveness with which it guarded its photochem-
ical secrets. Although Technicolor opened up its operations to licensing ser-
vices and equipment to other producers in the 1930s, it maintained a significant
degree of control and secrecy over the cinematography, developing, and print-

ing of its film stocks.[46] Technicolor thus held a virtual monopoly over the color film market during the first half of the twentieth century.

Technicolor did much to shift the work of color film away from projection systems to the laboratory, though this occurred only in facilities controlled by the company. The Technicolor I process, invented in 1917, required a specialized projector that added color to black and white film prints through filters. Technicolor II, from 1922, added color on the film itself in a subtractive process, and could be shown on regular projectors. A third and far more advanced Technicolor stock, which made use of a three-color system, was introduced in 1932. Technicolor opened its own laboratory and photographic unit in Hollywood to exclusively process its own films.[47] It is notable that, at the time of Technicolor II, there is an image of what Ulrich Ruedel describes as "an attractive and exotic young woman" that appears in a technical notebook by a Technicolor researcher. Ruedel suggests that this image may have come from the 1925 feature *His Supreme Moment*, putting the date of the Technicolor woman around the same time as the emergence of the Kodak China Girl.[48]

In 1950, Kodak, which in the meantime had been collaborating with Technicolor on Kalmus Positive, introduced a three-color, single-strip color negative and printing film stock. Previously it had been working on its own color formulas at its research facility and had already achieved success with the second iteration of Kodachrome, developed by Leopold Mannes and Leopold Godowsky and released in 1935 on 16 mm. This Kodachrome was significant because it located the dynamics of color within the chemistry of the film, rather than in the optics of the camera and projection apparatus as previous systems, including those of Technicolor and Kinemacolor, had required. The image of a woman in a headscarf, possibly Mannes's and Godowsky's secretary Shirley, appears in different batch tests for Kodachrome (plate 4).[49] This woman later reappeared as a China Girl for an important early Kodak film stock, Eastman Color Negative Film Type 5251, used from 1962 to 1968.

The development of the Eastman Color negative color stock in 1950 was significant because it meant that any lab, and not just those operated by Technicolor, could now develop and print color film. DuArt built the first printing machine to handle color negative film in the early 1950s, and other labs soon followed suit, just as other film manufacturers released their own chromogenic stocks. With the newly available color stocks, laboratories faced more pressure to maintain consistent control over variations not only in image density, but now color. Initially, individual labs produced their own China Girls. By the 1960s, the film manufacturers had also begun to sell China Girls to accompany each of their film stocks.

Accurate color reproduction was seen as especially crucial in the representation of flesh tones. As former Kodak engineer David Long maintains, it is "well understood in imaging research that the colored element to which human beings are most sensitive is skin tone reproduction" and "the face is the most critically, easily observable reference."[50] Accordingly, articles describing the difficulties of representing flesh tones dominated SMPTE publications during the period. The authors of these articles tended to abstract the body into a range of different skin colors, couching implicit issues of race and racial differentiation within technical jargon and supposedly scientific-objective rhetoric. In response to new technologies such as sound, color film, and, later, television, film laboratory technicians and video camera and monitor calibration specialists had to adjust their methods of quality control. For all the emphasis on densitometry between the 1930s and the 1950s, there are few printed references to the human figure until the challenges posed by television. "Flesh tone" and "skin tone" do not appear in SMPTE publications until 1955 and 1956, respectively, and both occur as particular problems arising from tonal and color variables of broadcast television.[51] In color television, Salvatore J. Bonsignore confirms the primacy of the representation of flesh tones. "Skin tone is regarded as the most important standard in the color picture," he writes. "As long as skin tones appear natural to the public, the color picture will be successful."[52] Color effects in lighting, make-up, and staging were permissible so long as they did not interfere with the perceived natural color of a (white) actor's face.

In 1970, the British film manufacturer BKSTS produced a China Girl reference image, the "BKSTS Reference Leader Picture," to "assist the object and subjective colour balance control of 16mm and 35mm prints in both the film laboratory and the television studio."[53] The company, following the practice of inserting China Girls into the countdown leader of a filmstrip, prescribed that "four frames of the standard negative are inserted into the leader at the colour reference position of each cut negative roll and the whole roll is then graded to look consistent with the leader picture. The leader picture later helps the telecine operator to adjust the colour balance of his machine."[54] Here, in this conversion from film to video, which involves a change in frame rate (from 24 frames per second to 29.97 frames per second) as well as to NTSC color standards, the BKSTS Reference Leader Picture formed the foundation of "a system of control . . . allowing each laboratory to continue with its individual grading technique, the end result being assessed on one common picture."[55] It was used to assist in the film-to-television conversions, or the telecine process, containing both "a GREY SCALE for television waveform use and a CONTROL SQUARE for laboratory densitometer use."[56]

Knight explains the choice of the female figure as the BKSTS reference image (plate 5):

> An aesthetically pleasing picture was required that would provide both objective and subjective information relating to tone response and colour rendering at the laboratory grading phase of producing a print and later in setting-up telecine. The picture therefore contains a face, in close-up, and a selection of neutral grays. . . . A *girl's face was chosen, rather than a man's, for no better reason than it seems traditional to do so.* However, since the BBC Research Department finds that the face of a man makes a more critical test of colour fidelity than that of a girl, future test scenes may be based on men: after all, more men are seen on television than women.[57]

This passage expresses some ambiguity as to the utility of a face, whether that of a man or a woman, for setting the color standard of an entire film or television program.[58] This discrepancy between subjective apprehension and objective calculation pervades the entire history of the China Girl. While the scrutiny of a China Girl by a technician's eye was the chief means of determining image consistency in the early twentieth century, its utility was diminished as technological refinements took over its original functions. Because of these developments, the China Girl's face, by the late 1970s especially, was no longer strictly necessary to the procedures to which it had previously been essential. It became a visual reference, a "gut-check reaction reference," and an unusually durable vestige of traditions past.[59]

The BKSTS article touches on another ambiguity concerning subjective and objective apprehension, which is its presumption that a single, and implicitly white, skin tone could be the check or basis against which all others are measured. The flesh tone issue here speaks to the racial bias in film and television equipment, namely the degree to which white skin is perceived as natural, ideal, and singularly correlative to instruments valued for their precision and accuracy. Knight's rhetoric, because it characterizes the woman's flesh as *material*, thereby obscures the racial implications of the technical procedures that are organized around it.

Hence this racial bias is only implicit. The avoidance of race and of bodies in general is manifest in charts that display "flesh tone" chips or dummy heads fitted with wigs made from human hair. In another BKSTS publication at that time, white skin, or a "light European face," is described as a "surface" analogous to and just as easily measured as the 18 percent gray card used to calibrate light measurements.[60] Writing on the BBC's Test Card 61, E. W. Taylor and S. J. Lent argue that the image of a live female model provided advantages

over these two strategies in "consistency, uniformity, naturalness, and spectral reflection characteristics."[61] They note: "[In the printing of film] the portrayal of a live model enables the subjective flesh tone balance to be readily made. In this respect, care has been taken to ensure that the picture reproduced on the television display appears as natural as possible."[62] The authors seek to reproduce the accuracy of China Girl cards for television, but do so by abstracting the colors of the body in a "suitable choice of printing inks . . . [which have] resulted in spectral reflectance characteristics which are substantially the same as real human skin."[63]

The BKSTS article, along with Taylor and Lent's experiments, indicate that the China Girl was valued for the woman's flesh alone, which they agree provides an index of ideal skin tone.[64] Given the fact that nearly all China Girls in Western countries are racially white, the woman's idealized appearance means an index based on her white skin. The notion of "perfect" or "ideal" skin tone, of course, is conflated with whiteness.[65] The idea that one single skin tone can be representative for all others, whether restricted to the tonal range of white skin or inclusive of nonwhite values, speaks to the degree to which whiteness is perceived as natural, ubiquitous, neutral, and to a great extent, invisible or inconspicuous, like the China Girl model herself.[66] The aim for an ideal is also measured as a norm. In his study of whiteness and photographic media, Richard Dyer observes an inherent "racial character of technologies" that reveals itself in the use of white skin tone as a measure for others.[67] As a racial trait, whiteness may be *ideologically* neutral or invisible, but in color analysis, it nevertheless registers a range of chromatic values.

This "racial character" means that these technologies are designed according to perceived markers of racial differentiation and are not tantamount to racism (e.g., the notion that technologies themselves are or can be racist). Dyer writes: "Stocks, cameras and lighting were developed taking the white face as the touchstone. The resultant apparatus came to be seen as fixed and inevitable, existing independently of the fact that it was humanly constructed. It may be—certainly was—true that photo and film apparatuses have seemed to work better with light-skinned peoples, but that is because they were made that way, not because they could be no other way."[68] Against the presumed neutrality and scientificity of imaging technology—the "natural" character of whiteness as affirmed by Taylor and Lent—racial biases nevertheless have governed the development of film stocks, chemicals, and other machines that produce the very conditions by which representation can occur.[69]

The characteristics of the natural are organized around what Kalpana Seshadri-Crooks calls "a master signifier—Whiteness—that produces a logic of differential relations."[70] Whiteness, in an ideal, singular form, is taken as

natural, and in the film laboratory this is translated into technological and seemingly rational terms. "This inherently asymmetrical and hierarchical opposition," Seshadri-Crooks asserts, "remains unacknowledged due to the effect of difference engendered by this master signifier, which itself remains outside the play of signification even as it enables the system."[71] In visual terms, whiteness institutes a "regime of visibility" that also remains outside of that system, a value that is natural, neutral, and because of these traits, invisible.

White signifies both a color and the absence of color. Dyer affirms this paradoxical invisibility of whiteness: "Whites must be seen to be white, yet whiteness as race resides in invisible properties and whiteness as power is maintained by being unseen."[72] In descriptions like that of the BBC Test Card 61, the white face is assumed to be natural and normal, with the implication that nonwhite faces are deviant. Dyer notes a similar tendency in trade photography publications: "The assumption that the normal face is a white face runs through most published advice given on photo- and cinematography. This is carried above all by illustrations which invariably use a white face, except on those rare occasions when they are discussing the 'problem' of dark-skinned people."[73] These manuals, like those of the motion picture industry, "never refer to the white face as such, for to do so would immediately signal its particularity. It is rather in describing facial and skin qualities that the unpremeditated assumption of a white face is apparent."[74] In the technical rhetoric of trade publications for both still and motion picture photography, white faces are presented as the norm, while nonwhite faces are discussed only as problems, a range of darker tones that fall short of the ideal.

The presumed neutrality of white skin tones, meanwhile, often conflicts with their actual color values, giving rise to problems of technical analysis. When, for example, David L. MacAdam pursued printing tests of "a young lady" in the 1950s, he concluded: "Optimum reproduction of skin color is not 'exact' reproduction . . . 'exact reproduction' is rejected almost unanimously as 'beefy'. On the other hand, when the print of highest acceptance is masked and compared with the original subject, it seems quite pale."[75] Lighting and exposing a film based on a white face often means that the values for everything else—sets, props, costumes, and other actors—are thrown off. A correct exposure for a pale white face, then, might mean that a darker complexion will be underexposed. In films where two actors with starkly different skin tones appear in the same frame together, Hollywood cinematographers have tended to favor exposures that calibrated to the lighter-skinned actor.[76] Describing the later history of Kodak, Long also notes that objective values for color did not always correspond to the *desired* look of, particularly, a face; his work as a color engineer emphasized "*intended* skin tone reproduction [which acknowledged]

a cultural bias to the reality of skin tones." In this way, film had to "intentionally perturb reality."[77] In these examples, the objective neutrality of the white face is not only revealed to be a highly subjective and unreliable visual referent, but it can also undo the work of verisimilitude it is meant to uphold.

The widespread adoption of color in film thus introduced the problem of turning white faces into "colored" ones.[78] The film industry responded with strict guidelines around the uses of color to minimize the risk of "coloring" a white face. Richard Misek notes that SMPTE's *Elements of Color in Professional Motion Pictures*, published in 1957, limited the photography of food and faces to white light, and he surmises that the prohibition against colored lights, permissible in other contexts, arose from a fear of racializing white faces, or obscuring the differences, and the implicit hierarchal structure, between white and nonwhite faces: "Perhaps the true horror in classical Hollywood was in fact not a green face, but a yellow face or a pale brown face, a face whose 'true' whiteness or blackness was obscured by colored light."[79] Lending too much color to a white face with lighting, make-up, or costuming risked racializing it, thus destroying its ideological neutrality and implicit superiority.

Technicolor, which billed itself as "natural color" in an advertisement from the 1940s, was unsurprisingly vocal in its prescriptions for color applications.[80] Natalie Kalmus, then wife of Technicolor's chief color consultant Herbert Kalmus, published guidelines for color usage in her 1935 article "Color Consciousness." In an attempt to codify uses of color according to genre, she suggests that vibrant, gaudy colors be limited to musicals, fantasy sequences, and pageantry while restrained uses of color be applied to naturalistic scenarios that strive for realism. While Technicolor's motives were undoubtedly economic — Misek argues that Technicolor purposefully prescribed color schemes into preexisting codes of narrative Hollywood cinema[81] — Kalmus's directives also encode a racial and ethnic bias. Bright colors, she writes, should be used sparingly, as embellishment or accent and not overwhelm the narrative structure which would otherwise be cast in "neutral" tones: "taking our cue from Nature, we find that colors and neutrals augment each other."[82] As Kalmus urges restraint with regard to bright colors, it becomes apparent that the "color balance" she suggests as belonging to a "natural" order only works if there is a relative scarcity of color to offset and flatter predominantly neutral tones, which is to say, white faces. The racial connotations of the genres Kalmus suggests are clear: spectacle was associated with ethnic displays of dance and music, while the more sober genre of realist drama, which comprise the bulk of cinema, were enacted by white people. Too much color, she concludes, lead to "unnatural and disastrous results."[83]

The female body, and in particular the woman's face, has been taken to be more prone to the effects of color. Just as women often bear the burden of nar-

rative meaning in film, their bodies have also been made to express the many and often contradictory significations of color, including as models for ideal-ized whiteness. As Dyer notes, stars such as Lilian Gish were commonly bathed in radiant white light to appear even whiter than their male counterparts.[84] bell hooks more pointedly observes the racial imperative to make the ideal-ized woman "ultra-white," being "a cinematic practice that sought to main-tain a distance, a separation between that image and the black female Other; it was a way to perpetuate white supremacy."[85] In the classical system, white female stars were given undisputed priority as to the color of make-up, hair, and costume that would best complement her complexion and her figure, and this determined the color scheme for the rest of the mise-en-scène. Neale observes: "From the earliest days of colour photography [women] function both as a source of the spectacle of colour in practice and as a reference point for the use and promotion of colour in theory."[86] Women have also been seen as susceptible to the deleterious effects of intense color and shadow. This oc-curs even in black-and-white films, where color variation registers as different shades of gray. Female stars such as Marlene Dietrich in *Shanghai Express* (Josef von Sternberg, 1931) and Martha Vickers in *The Big Sleep* (Howard Hawks, 1946) represented the luminous white ideal as being corrupted by tonally deeper, ethnicizing influences, the moral darkness of their femmes fatales matched by orientalist mise-en-scènes.

The association of women and color has functioned as a screen for ethni-cized or racialized bodies. This is especially the case in Hollywood's zeal for orientalism. In cases like Doris Day's green, mandarin-style pajamas in *Pillow Talk* (Michael Gordon, 1959) or Kirsten Dunst's red qipao in *Spider-Man* (Sam Raimi, 2002), the corrupting influences of "color" are kept in check, on an ideological level, by barring the faces of ethnic actors. Michael Rogin ob-serves, "Hollywood orientalism could bring once-forbidden pleasures to movie audiences as long as actual Asian Americans were kept out."[87] Again as Kalmus insists, color has its undeniable pleasures, and very often these are as-sociated with displays of ethnicity. Color can be enjoyed so long as it is kept at bay, subservient to the rules of naturalism that positions neutrality qua white-ness as primary.[88] White women in mainstream film have served as acceptable proxies for colorful, ethnic, and often orientalist entertainment.

The term *China* in the name "China Girl" signals an entanglement of race, embellishment, and the model's femininity. The orientalist designation of the China Girl, along with the quality of the feminine and the decorative, form what Rosalind Galt has described as the category of the pretty. In its opposi-tion to masculine, heroic, rational, and Western aesthetics, the pretty has of-ten been denigrated and minimalized. As Galt contends, it can also productively form a politics of the excluded, namely, that of race, gender, and sexuality.[89]

Seen in this manner, the pretty becomes a kind of shadow aesthetic from which to disrupt the homogeneity of dominant forms of representation. In the context of Galt's theorization of the pretty, then, Knight's remark about a man's superior "colour fidelity" might accord with the desire to be rational and objective, rather than any physiological traits or, even more problematically, a set of color values for skin tone. This is indeed a desire and one that indicates the degree to which arbitrary preferences for *certain* skin tones and a *particular* gender are made to conform to supposedly objective and neutral technological procedures.

Throughout the history of film industrial standardization and laboratory procedures, the China Girl has been crucial to establishing and testing the norms for processes fundamental to the production of film, including processing, developing, and printing as each of these have adjusted to moments of technological innovation. Though rarely mentioned in the technical literature, we can see how important the China Girl reference image has been in developing quality control methods. Moreover, the sum of these procedures is to create and maintain ideal appearance for the actors who appear onscreen. With color film especially, the China Girl has been key in determining a white, racial norm.

We have seen how the ideal of whiteness in the appearance of the China Girl prevails even where it concerns the reality of skin tone. For this to happen, the singularity of the China Girl model, which is to say the woman herself, must also dissolve. In order to become a China Girl, a technical tool, she must be transformed into an anonymous object whose race and gender are sublimated into function and whose appearance is translated into quantifiable information. Once again, we see the logic of the film technical site articulated according to the partial concealment of the woman's body. In this case, the body of the China Girl is instrumentalized for the production of the image, the face of the leading lady. Though the China Girl is itself an image of a woman's body, it is not "part of the film." Instead, as a nonrepresentational image, it is a means of a film's technical production. Its only trace is left on the margins of film, a disappearance deemed necessary as the condition by which the *proper* film image can appear.

Obsolescence

In 1976, Kodak engineer John Pytlak introduced the Laboratory Aim Density (LAD) system, which gives a more precise radiometric reading of density based on an 18 percent gray patch that forms part of the China Girl image.[90] By 1982 Kodak was producing its own LADs, with the LAD patch being the

spot of gray read with the densitometer.[91] This became and remains the industry standard. Long describes the LAD as a "universalization" of a tactic already developed at Kodak laboratories, and sold to smaller labs and postproduction facilities to assist them in achieving "the optimum translation of the image from one stage to the next in the production pipeline."[92] From a technical perspective, the LAD patch rendered the China Girl obsolete, to the extent that the image was ever necessary for more than "artistic" reasons. (Already in 1960, the SMPTE laboratory guide *Control Techniques in Film Processing* admitted that "picture tests give very little quantitative information . . . [but] they do offer the advantage of a quick visual check."[93]) Yet even the LAD was accompanied by the image of a woman in close-up.

Digital technologies, meanwhile, have developed their own variations of LAD controls. Like the telecine procedures in film-to-television conversions, which are workflows that involve film at some level, processes requiring digital intermediaries (DIs) to move between analog and digital formats depend on digital LADs, or DLADs. There are also numerous faces used in reference charts for printer settings as well as monitor calibration reference sheets. The model established by the Kodak LAD has waned somewhat, owing to the more diffuse nature of digital imaging manufacturing. Whereas Kodak—along with a handful of major photochemical film producers, including Agfa, BKSTS, and Fuji—more readily set standards for the film and photography industries, there are far more companies involved in digital production.

Despite the increasingly sophisticated technological means, the image of the China Girl persists even when, and especially after the innovation of the LAD patch, it is in many ways unnecessary to the process for which it was originally intended. Many of the technicians I've spoken to both in traditional film and digital facilities have admitted there is no longer any real need for the China Girl: as a white, female face, or any human face at all. As David Corley, a former film laboratory technician and founder of DSC Labs, a company that makes digital test patterns for television broadcast, remarked to me: "Personally, I found [China Girls] totally useless. Because there is an enormous range of skin tones, how do you say one skin tone is right and another is wrong? The only thing a China Girl would be useful for would be a subjective evaluation of the image."[94]

Given the apparent nonfunctionality of the China Girl, the image's enduring presence, in use still today despite the fact that it is no longer required for technical analysis, is telling. Some technicians insist that the China Girl offers a visual check, however subjective, of densitometer readings, and that it provides a recognizable form to confirm sensitometric measurements. As a face, the China Girl suggests something more. Within the laboratory, it

provokes an attachment that approaches a kind of pathos or sentimentality. Pytlak observes, "The original LAD was based only on a gray patch, but many still wanted a 'real' scene to aid in setup and control, so the two ideas were combined."[95] The matter of "tradition" that Knight describes in the BKSTS reference image also speaks to the inertia of a fairly hermetic company culture, one that Long affirms. He speculates that the image of a woman as the China Girl, begun most likely owing to market demands for an attractive young woman ("a wartime pinup kind of thing"), endured largely because there was a more or less conscious desire to "not rock the boat." When his group of researchers hired a China Girl model in the late 1990s, he selected, again, a white woman, reasoning, "that's what they've been, and that's what we're going to do."[96] I contend that these attitudes toward the China Girl are not only a "laddish" fondness for a bygone era, but recognize in a limited sense the debt owed to this figure within the history of laboratory practice. (Beyond the lab and the projection booth, of course, the China Girl is all but entirely unknown, being successfully subordinated to the regime of the face onscreen.) Without admitting fully of the mechanism of the concealment of gender at work in the use of the China Girl, the acknowledgment is turned into wistful sentiment.

Such nostalgia persists as the motion picture industry turns away from film to digital material workflows. As film facilities shrink or shut down, the China Girl has become one of the more poignant symbols of a disappearing industry. Its ephemerality, the anonymity of the women who posed as models, the abstractions and rare mentions of the image in industrial manuals, and the literally marginal position the figure occupies in relation to the history of cinema, may be, somewhat ironically, the trait that best expresses a sense of nostalgia for a rapidly vanishing medium.

The Face of the China Girl

Thus far I have described the China Girl only generally in gendered, racially complex, and fundamentally descriptive terms, treating it only as an object or an image. We should also bear in mind the distinct, if typically anonymous, identities of the many women who posed as China Girl models. The majority of the likely thousands of women in China Girl images are shot in close-up, a framing that, since the 1910s, privileges an individual's psychological expression. Béla Balázs was one of the earliest and most persuasive theorists of the close-up, suggesting that the proximity of the camera to the face revealed "'microphysiognomic' details even of this detail of the body."[97] In addition to minute expressions, the close-up also opened up the possibility of *unconscious*

ones.[98] This unconscious expression is that of "the invisible face behind the visible," a reading *into* the face of the performer that discerns a countenance potentially quite different from what a viewer might immediately perceive.

The China Girl's face, meanwhile, does not admit of psychological access. As Mary Ann Doane contends, "Far from an insistence upon mimesis or verisimilitude, this is a demand for blankness, illegibility, and absence as the support of illusion."[99] The China Girl is positioned differently in relation to the faces onscreen, not as the invisible other buried *behind* the visible image but as something that remains *outside* the field of vision afforded by the screen. In the rare instances in which we see a China Girl image in the theater, it offers another view of cinema. Its visibility is a kind of glitch, a momentary breakdown in the cinema machine: A China Girl only appears when we see *too much* of a film, namely the ends of its reels. This sudden apparition has the effect of bringing to light, to visibility, all the previously unseen processes, both cultural and technical, that attend its images. When we happen to glimpse a China Girl, we are afforded the opportunity to realize that there is a different system of signification at work behind the images we typically see: for every *leading* lady, there is a corresponding *leader* lady laboring behind the scenes.[100]

As the flip side to the image of a Hollywood starlet, the China Girl is the link between the images that appear on the surface of the film and their physical construction. Within the laboratory, furthermore, it sets the conditions *before* and by which filmic representation can appear. At the same time, the China Girl stands apart, or adjacent to, these two representational layers: neither wholly like the faces of actors as Balázs describes nor a mere technical instrument, as the figure is imbued with cultural meanings pertaining to race and gender. Why, then, does the face of a woman remain, when a gray patch could serve all the necessary technical requirements of densitometric measurements? And is the face (and if the goal is skin tone registration, why not a foot or an elbow?) merely a check, or is it something more, as I am suggesting? In order for a film to appear as such, the woman in the China Girl image, which is crucial to the production of film images, must remain a nonrepresentational, nonscenic, and literally marginal figure. Transformed into a technical image, she becomes a mostly vanishing mediator that connects postproduction laboratory procedures to the apparitions onscreen.

In terms of a film's diegesis, the China Girl is only incidental to the movie to which she is attached. Though China Girls are on rare occasions produced for individual films, their production and usage exist independently of the films to which they are spliced. Because of this, a China Girl can accompany any number of films, and in some cases, especially with restored or duplicated films, several different China Girls can accumulate on the same strip of leader,

artifacts from different laboratory processes. Positioned on the film's leader, the China Girl plays no part in its story or setting, save its material conditions that make possible, and to an extent determine, the manner of representational expression. From the perspective of the average viewer, which is to say the one for whom a film projection runs smoothly or the one who watches a restored version that has digitally stitched together its discrete film reels, the China Girl produces a structure from which it is absent. Furthermore, this absence is not an observable gap but an imperceptible nonappearance. Most viewers are typically unaware that the China Girl even exists, much less conditions the manner of filmic representation. This apparent marginality must not be mistaken for the foundational role the China Girl plays in the construction and representation of film images. It is only by looking at the level of laboratory practice that we can perceive the persistent presence and durable iconographic markers of the China Girl. The "marginal" or occluded visibility given to China Girls within laboratory culture as well as film historiography indicate, not least, the repository of attitudes concerning a woman's role in the film industry. Seen this way, the woman who poses as a China Girl is an extreme manifestation of that which suture seeks to exclude, though she is no less critical in determining cinema's system of representation as a gendered construct.[101] If, for Balázs, a close-up reveals an invisible face within that of an actor, the China Girl that appears behind the scenes figures a different kind of invisible face, a chemical apparition that is even more deeply buried.

As with the other disappearing women examined in this book, the China Girl poses a peculiar problem of critical looking: how do we, or how should we, look at this image, or the woman in the image? In what ways have they been overlooked, even when scrutinized closely? Though China Girls are rarely viewed in the theater, they are the most carefully studied image in film laboratories. The way a China Girl is regarded in a laboratory is highly particular: technicians rely on the woman's familiarity, memorizing the ideal amount of detail and contrast in her hair, the color of her eyes and lips, and comparing them against the test China Girls that travel with other images. In the lab, a China Girl presents an image of an ideal appearance which is also entirely ordinary. It is most effective when it disappears as a distinctive image and registers instead as a common, ubiquitous one, noticeable only when something appears out of place.

To a large extent, the figure of the China Girl is a woman, like the female characters of classical Hollywood cinema, that is made meaningful for the way men use and regard her. As many feminist film scholars like Mulvey have observed, female characters "can exist only in relation to castration and cannot transcend it."[102] Women serve to structure the journeys of men, typically as

objects: as rewards, obstacles, or both. Meanwhile, the objecthood of the leader lady fulfills a different function than that of its leading lady counterpart, who serves narrative purposes. As a technical tool, she need not signify anything particular at all, whether a woman or anything else. The China Girl possesses no intrinsic value *as* an image. Its gender is sublimated out, similar to the way the gorgoneion is divested of gender after the head is severed from Medusa's body. The China Girl is then understood as neutral, effectively genderless, and racially unmarked to the technicians who employ it, which is why the language used to describe it makes claims to scientific objectivity.

As we have seen, the China Girl is far from that objective, or culturally neutral, ideal. However incidental its appearance as a woman may have been at the outset, its characteristic guise as an attractive, young, white, and often smiling woman has endured for almost the entirety of photochemical film history. The China Girl's persistence is all the more curious given the fact that the China Girl is still used in photochemical film development, despite the fact that it has, for nearly forty years, been unnecessary for strict technical analysis. What would explain the survival of this object, among so many others that have been rendered useless and obsolete? I would argue that the image's appearance as a woman's *face* matters, and not only in a material sense. Unlike a swatch of colors or a gray dot, this face exceeds its material functionality to become a constant companion, even something like a living presence, for the laboratory worker.[103] As DuArt president Bob Smith, who first began working at the lab in 1955, said to me when I described to him my research: "I love the project, I really do. Normally I do not get emotionally involved in these, but this one is, as soon as I heard [it was about the] China Girl, it was almost like a commandment to me."[104] It is perhaps unsurprising that laboratory workers often have a personal connection with the China Girl. DuArt's model, like those of many laboratories, was for many decades a person closely associated with the company, Lili Young, later the wife of Bob Young, the son of company founder Al Young and brother to its president Irwin Young. (Bob Young also happened to be the person who filmed Lili in her China Girl shoot.) Given the close familial structure of the company, it is not surprising that the employees had an enduring fondness for their China Girl.

From one perspective, the China Girl is an analytic tool equivalent to test patterns, color swatches, and other instruments used in quality control procedures. Its appearance is only incidental to its function, which was rendered minimal by the late 1970s. From another perspective, the China Girl is a suggestive photographic image, and however depersonalized, it still carries a charge of personal significance, even of life. Though laboratory technicians will often cite the former as the rationale for using the China Girl, it is the

latter that accounts for its persistence. Film, too, is often conceived in terms of this contradiction: both a mass-produced object and an image imbued with and organically underpinned by a quality of life. If the China Girl becomes an *emblem* for all of film, as Morgan Fisher suggested in his film *Standard Gauge* (1984), it is because its materiality—as both an instrumentalized "it" and a sensual "she"—expresses the film image's dual nature. By maintaining this division, the figuring of the China Girl as an emblem of film partakes of the same logic in which the concealment of the woman's body, which denies its unity, is necessary to the functioning of the film technical site. In the next section, I examine a number of experimental films that reproduce, critique, and move beyond this image/material divide.

The China Girl in Experimental Film and Video

The predominant ways of looking at the China Girl include, on one hand, intensely scrutinizing particular elements of her face in the manner of a laboratory technician and, on the other hand, catching the offhand glimpse of her in the theater as a film spectator. Experimental film presents a third possibility of looking at the China Girl: the way it, or just as often *she*, has been reclaimed as a subject by certain filmmakers expressly interested in revealing different aspects of the cinematic apparatus.[105] These films address the duality of materiality and image in the China Girl, linking its function within film production practices to its enigmatic appearance as a woman. The degree to which experimental films address the connection between the concealment of the woman's body to the articulation of filmic meaning (including but not limited to the laboratory) varies by maker. Whereas Owen Land, Morgan Fisher, Cécile Fontaine, and Jamie Allen leave the China Girl shrouded in a sense of enigma, Michelle Silva, Barbara Hammer, Sandra Gibson and Luis Recoder, and Mark Toscano restore a fuller if still limited sense of the women who modeled as China Girls. Together, these films walk us back through the hidden and gendered technical conditions undergirding the supposed immediacy of the film image. Hence in these experimental films, the presence and position of the China Girl reminds us of the dual and often mutually occluding aspects of an image with its technical basis.

The China Girl has played a prominent role in a number of structural films, a branch of the avant-garde explicitly concerned with the material properties of film, including light, projection, and the filmstrip itself. As James Benning, who included a China Girl image in *Grand Opera* (1978), a film that surveys his own career as a structural filmmaker, observed, "All films were always structured by a China Girl."[106] Perhaps the best-known example of a China Girl

occurs in *Film in Which There Appear Edge Lettering, Sprocket Holes, Dirt Particles, Etc.* (1965) by Owen Land (formerly George Landow). Here, Land optically printed a strip of China Girl test leader and doubled it horizontally across the frame so that four China Girls, along with the titular edge lettering and sprocket holes, are visible (plate 6). The clip's brevity and its repetition through optical printing produce in the China Girl a convulsive blinking. For P. Adams Sitney, the film is "a found object extended to a simple structure, . . . the essence of minimal cinema,"[107] with the industrial footage Land employed serving as a synecdoche for the entirety of filmmaking as an industrial as well as artistic practice. Correspondingly, the film's title is provocatively generic, describing, in a sense, the conditions for *every* film, or at least every film's leader. The word "appear" in the title suggests a "performance" of incidental material, including the accumulation of scratches and dirt particles as well as the marks of edge numbers and sprocket-hole punches that exist prior to the film's exposure. What's missing from this description, of course, is the lead performer, the China Girl model herself.

Sitney's commentary on the film, as well as that of Land, focuses on the Duchampian readymade quality of the China Girl image that remains on-screen for the duration of the film, and it ignores the specificity of the figure that we see. When asked, Land, too, did not seem to realize that he'd used the China Girl image in a number of films, referring to them decades later as "bimbos."[108] Here, the four multiplied China Girls, though positioned centrally in the frame, still appear in much the same way as they do in regular film-viewing contexts: underacknowledged, if not entirely ignored. The insistence on the found material's generic quality, its industrial use standing in for the rest of cinema, overshadows the images it shows, particularly that of the China Girl.

In Land's film, the China Girl is still obscured by the cinematic processes that in essence upstage it. The model's repetitive blinking in Land's film could be seen as analogous to the blades of the shutter, and in this way she becomes a figure for the apparatus itself. Though the China Girl appears in a manner that seems fully present, the convulsive and quadrupled visibility of her face merely reproduces, from within the domain of structural filmmaking, the industrial structures that kept her from view in the first place. Moreover, the China Girl is constitutive of cinema's system of representation, even if she herself is excluded from it. This is because, in my reading, structural film purports not to "see" gender in precisely the manner Land constructs. As David E. James argues: "Consequently, the film's major tension becomes the competition for our attention between that image and the formal and material effects it carries, between seeing it and seeing through it."[109]

Here we see the China Girl in the place where, in a commercial film, an actress would appear: positioned centrally in the frame. Yet she remains only something to be seen *through*, as James argues, or an object that, in Sitney and Land's commentary, serves as an abstracted marker of the medium's industrial conditions. If, as Doane has argued, female faces have functioned in cinema as the "technological support of the process of imaging," the woman's face is something that signifies only *generally*, as a generic, blank image. For Doane, the China Girl is one of the most revealing examples of this paradoxically obfuscating tendency of the female close-up: "What we witness in the China Doll phenomenon is the hollowed-out form of the star system, its evisceration—the impossible oxymoron of the anonymous star. In these hidden 'screen tests,' the figure of the star is drained of its most essential traits—recognition and recognizability—and the female face becomes sheer surface."[110] Rather than concern himself with the particularities of the woman looped and reprinted within the frame, Land's point may have been to use the China Girl figure to demonstrate the analogous marginality of avant-garde film in relation to Hollywood.

Morgan Fisher's *Standard Gauge* (1984), by contrast, gives specific attention to the China Girl, naming it among a collection of artifacts gathered during Fisher's time working at a stock-footage company and as an editor on various low-budget films in the 1970s (plate 7). In this single-take film, Fisher pulls out scraps of found 35 mm film and describes the ways he came into possession of the material. Fisher's film is structural in the sense that it concerns the material properties and histories of 35 mm and 16 mm film, though it departs from the "purist cinema" (to use James's term) of Land in its explicit engagement with commercial filmmaking. *Standard Gauge* was also made considerably after the structural film heyday of the 1960s and 1970s, lending Fisher's reflections an attendant sense of nostalgia. Fisher positions himself on the margins of Hollywood, revealing the behind-the-scenes workings of archives, editors, and laboratories in Los Angeles.

Throughout the film, Fisher scrolls through different footage illuminated on a light box. All the footage he shows, while motion picture film stock, appears as still frames that are then *moved* by the rewind apparatus Fisher operates. Sometimes his commentary is technical, as when he describes the mechanics of Technicolor's IB dye-transfer process, and other times autobiographical, as when he pulls out clips of scenes from the low-budget feature *Student Nurses* in which he plays a bit part. Often Fisher's explanations are insufficient—he often lingers on images for their enigmatic beauty, describing them as "interesting incidents"—and toward the end of the film, long, silent stretches pass in which Fisher scrolls through and pauses on images without a

word. Despite the somewhat droll, pedantic tone of Fisher's voice and the flat presentation of film artifacts, there is a pervading sense of loss: of an industry that, as he explains, heaped many of these once-useful objects into the trash bin, and of Fisher's own and now distant past, bound up in incidental fragments whose value he alone seems to recognize.

The China Girl stands out among the neglected materials Fisher assembles. It appears toward the latter part of the film, though is semantically prefigured in the first filmstrip he shows, which is of Godard's *La Chinoise* (1967). Fisher pauses to look at several China Girls, musing that it is a "figure who in some quarters is emblematic, almost, of film itself." He suggests, "This figure's sex, her being in the margin of the film, her serving to establish and maintain a standard of correct appearance; these are aspects of a single question that deserves thought." Fisher provides no answer to this question. Nor, for that matter, is it clear what question the China Girl poses; for Fisher, in a sense, the China Girl herself is a question of the more or less mysterious processes that bring film into being. Furthermore, by making the China Girl the emblem of film, Fisher, like Land, yokes these unanswered questions to a medium that in 1984 was already rapidly vanishing. The question the China Girl poses, and the hope of learning anything more about her, seems already too late.[111]

Land's and Fisher's films engage the two modes of viewing typically associated with the China Girl by allowing the audience to study the image in the manner of the technician. In doing so, they also reproduce the obscurity of the figure within, similar to the way that technicians do not see an individual within a China Girl frame but use her face and flesh tones to measure other types of film images. While Fisher acknowledges the labor of the women who posed as China Girl models, and in doing so is considerably more sympathetic to the figure (whom he calls "she"), his account remains occluded by its function as a class of image. Though it may be an emblem for all of film, it is, in the end, anonymous and enigmatic, no different than the assorted bits of leader and filmstrip irregularities that Fisher scrolls through. It does not transcend the material to which the model's image is intrinsically tied, nor does she emerge as anything other than an image.

Land's and Fisher's works create the possibility, or at least raise the question, of an alternative view of the China Girl image. By positioning the China Girl in the center of the frame, they create a space for the apprehension of the woman who posed for the image, distinct from its technical function. Put differently, this potentially separates the view the China Girl provides of the media it structures from the *look* of her as a woman: both in appearance and, possibly, as a woman who herself is capable of looking, and hence is possessed

of her own autonomy. The latter suggests the possibility of a fuller reconstitu-
tion of the woman. While this possibility is only raised but not fulfilled in
Land's and Fisher's films, it is taken up by other artists who have attempted to
reshape and in some cases denature the relation between the China Girl and
its materiality in and across film and digital media.

The films that best convey the paradoxical visuality of the China Girl retain
the image's marginality, blankness, and invisibility, in order to expose the sig-
nifying system it anchors. Michelle Silva's *China Girls* (2006) situates China
Girls in what the filmmaker describes as their "natural habitat of countdowns
and end-tones," sustaining, in part, the viewer's mode of incidental looking
while providing some longer segments of China Girl footage as it was origi-
nally shot.[112] The film presents China Girls "in the wild," as Silva describes,
showing strips of countdown numbers that pass rapidly by with long spaces of
clear, dusty leader separating them. Silva emphasizes the movement of the
China Girl, a reminder of the fact that China Girl models were shot using
motion picture film, not still photography. By running full lengths of leader
containing partial glimpses of China Girl figures, some of whom, like the one
in Land's film, are seen blinking, the film offers something like a "complete"
view of the China Girl, however fragmented and marginal its position. This
sense of the woman "coming to life" through movement, however slight, is
rendered in even longer segments in Timoleon Wilkins's *MM* (1996).

Movement, of course, is central to cinema's structure of moving images,
and in Silva's film it transforms the inert China Girl, the inanimate doll, into
a living, moving, flesh(-colored) and blood woman. The reanimated China
Girl is not given the fixed scrutiny of Land or Fisher's treatments, both of which
reify, in their own ways, the occluding gaze of the laboratory technician. Here
the figure's movement is rendered as something that fleetingly appears and
disappears. Yet even with Silva's rendering of the China Girl as a moving be-
ing, this strategy of making the China Girl visible does not entirely address
the constitutive invisibility that inevitably attends her image.

Barbara Hammer's *Sanctus* (1990) turns the China Girl toward more explic-
itly feminist aims. The film begins and ends with images of a Kodak LAD
girl. This is the only face we see clearly in the film, though others are sug-
gested in the image of fleshy shadows on X-rayed skulls. In between the LAD
shots, the rest of the film consists of optically printed and manipulated foot-
age of X-ray cinematography shot in the 1950s by James Sibley Watson. Watson's
film, as processed by Hammer, depicts the human body decoded by the X-ray
camera and recoded by cultural signifiers, as when a skeletal figure who ap-
plies lipstick can then be read as female. The film is as follows: After a brief

prologue that intercuts images of the China Girl with SMPTE test cards and x-rayed skulls, the film shifts to Watson's footage. Hammer alternately superimposes the footage, repeats and rewinds certain sequences, overlays portions with text, and recasts the images in bright primary colors. Female bodies are signaled by anatomical clues, including breasts on rotating torsos, as well as behavioral ones, as when a figure applies lipstick. The LAD girl resurfaces toward the end, at first just a pair of watchful eyes and then, with the closing sequence, a full face returns, followed by the curling of burning film. She appears precisely *as* surface, as a kind of skin, and one vulnerable to destruction. The framing structure of the LAD girl is analogous to the way China Girls appear on countdown leader, and it is as if Hammer were showing not just the length of her film but the entire filmstrip on which it is printed. At these extended ends, we see also sprocket holes that signal the "foundness" of the footage Hammer reworks.

Both the China Girl and the X-rayed figures suggest an economy of the invisible made visible, of invisible bodies coming into view: The China Girl is usually situated on the unseen margins of a film, while the X-ray images show the body's interior structure on its surface. Through superimposition, the film suggests a more direct correlation between these two figures. We can even imagine that the China Girl's face belongs to the X-rayed figures onscreen, forming different parts of the same repressed body, or what Akira Mizuta Lippit, writing on X-ray photography, calls "a repressed corporeality."[113] On their own, neither X-ray figure nor China Girl form a "whole" woman, but layered on top of each other, skin to skeleton, and tellingly matched at the overlapped place of their eyes, they begin to reconstitute a body in and through the material of film.

The reconstituted corporeality is nevertheless incomplete. At the end of *Sanctus*, the image burns, as if the destructive force of the X-ray were being visualized onto the skin of the film (plate 8). This act of burning forms the central event in *A Sourceful of Secrets*, a projection performance first performed by Sandra Gibson and Luis Recoder in 2002. The pair, then going by the name of the Presstapes, exhibited the piece four times that year: at the PDX film festival in Portland, the Onion City Film Festival in Chicago, the Images Festival in Toronto, and TexasSpace, a student-run series also in Chicago. No documentation exists of these first four performances, save a strip of burned film.

The work as it was performed at Anthology Film Archives in November 2012 consisted of two projectors, one 35 mm and one 16 mm. Over a digital audio score of birdsong and deep rumbling sounds, Gibson and Recoder placed colored gels and water sprayed on the projection-booth glass before the 35 mm projector, while the 16 mm projector was fed strips of China Girl leader. The

artists held the filmstrips there, still, as the China Girl images burned from the heat of the projector lamps. (Ordinarily film does not burn because it passes too quickly through the projector.) These fiery images appeared on-screen, overlaid with the watery abstractions coming from the 35 mm projector. After burning through several China Girls, the artists concluded the performance.

A *Sourceful of Secrets* not only depicts but also enacts the China Girl's material dissolution. While the other films I have discussed have aimed in one way or another to make the China Girl visible, this performance presents us with another kind of view of the China Girl: the image of its destruction. The scorched image, or face, in A *Sourceful of Secrets* reveals an opening, a hole through which the light of the projector shines. This goes beyond *Sanctus*'s metaphoric destruction, wrought by irradiating light, and gestures toward the point at which new images, images not constrained by the cinematic apparatus, might be generated. The footage for A *Sourceful of Secrets* came from Gibson's earlier short, *Scratch Test Number 1* (1994–1995), which no longer exists. Gibson, previously employed as a film inspector at a library in Portland, had clipped and collected China Girls, later optically splicing them into *Scratch Test Number 1*, only to cannibalize the film to make A *Sourceful of Secrets*. From library to film to performance, these few frames had been recycled and *re-sourced*, each iteration destroyed to give way to something new.

Even as they burn in A *Sourceful of Secrets*, the China Girl images suggest a continued path to a place beyond the filmstrip. In her discussions of a politics of the postcolonial other, Trinh T. Minh-ha has argued, "The space of creativity is the space whose occupancy invites other occupancies. . . . Thus, if she [and here Trinh means the other] negates, it is also to refute negation—joyfully."[114] Out of this negation, the ashes of the image, arises a space through which the politics of the visible might be expressed. As seen in the burning of A *Sourceful of Secrets*, the close-up of the China Girl presents a potential explosion of cinema's signifying system, one built on the regulation of filmic materiality and its often fraught visibility.

On a broader level, we might understand the rise of digital technologies, which have largely replaced analog film in contemporary moving-image production, as also emerging from the scene of cinematic destruction. Cécile Fontaine's digital video *China Girl* (2010) uses scanned images of several 35 mm China Girl frames and deforms them through animation, slow motion, and mirroring effects. In this film, the China Girl, the same LAD image used in Hammer's *Sanctus*, is rendered barely recognizable.

The mirroring of the image has the effect of multiplying, layering, and animating the single image. The fragility of the film frame is replaced with digital fluidity and algorithmic multiplicity. The work denatures the material of the China Girl image, specifically its physical basis, by digitally resequencing or reconstituting it. For some, this might register as digital immateriality, though such a view offers too narrow an understanding of what technological materiality can mean or is too constrained by a filmically derived notion of materiality. The term *postcinematic*, in this sense, is especially myopic: it relegates anything that appears after cinema as ghostly. Fontaine's digital China Girl occasions a different view, that digital media are imbued with their own materiality and cultural logic related to but not overly determined by cinema.

One question that arises in the wake of structural film is whether China Girls, whenever they appear in a film, are always "about" film and filmic materiality, or whether they are always emblems for film and film only. The intermedial mix of film and digital images in Fontaine's video, while it clearly suggests the endurance of filmic materiality within a digital context, also offers a way of conceiving the China Girl from the perspective of digital media (plate 9). To the extent that Fontaine's *China Girl* is "about" its medium, it is from the perspective of the technical process it describes: here, telecine recording from film to video produce a digital intermediate. In industrial terms, the intermediate suggests that a film, scanned and manipulated digitally, will eventually be outputted as something else: recorded to film, or, as is becoming increasingly common, outputted as a digital cinema package (DCP) or some other digital file. A digital intermediate (DI) indicates the transformation, or the mutation, of film into something that exists not only in the wake of film, of filmic materiality, but that comprises its own materiality. In other words, Fontaine's video may be less a ghostly afterlife—an After Effect—of film translated into pixels than a new kind of materiality singularly constituted in digital terms.

While the China Girl is rooted in practices associated with film, especially in its linking of femininity and materiality, Fontaine's video demonstrates how the figure might also function emblematically for digital technologies as well. If China Girls, in their celluloid incarnations, told us something about the physical and chemical processes that attend the processing and printing of film images, then the digital China Girl, as a structural unit, offers a way of looking at the history of cinema from the perspective of new media.[115] However new the technical means, the ideological orchestrations of discourse and practice remain consistent with the media that came before. In chapter 2, I examine

the reconfigured postproduction processes involved in the making of digital films and how a concept of materiality adjusts in relation to these technological shifts. What remains consistent, and what digital China Girls demonstrate, is a continued entanglement between gender and material.

This can be seen in Jamie Allen's *Killing Lena* (2007), which makes explicit the ideological terms and consequences of digital encoding (plate 10). The digital video consists of a single image, the Lena (or sometimes "Lenna") that is the digital equivalent of the photographic Shirley and the cinematographic China Girl. In this case, the image was originally taken from a November 1972 *Playboy* cover image of model Lena Söderberg which has been used in digital image processing since 1973; chiefly it is used in compression tests and determining image parameters for formats such as GIF and JPEG.[116] Here Allen, an artist who previously worked as an engineer in image and signal processing at DuPont and IBM, subjects the Lena image to the compression protocols it was instrumental in establishing. By running a script to recursively recapture an image from progressively compressed and degraded JPEG files, the image starts to disintegrate into a uniformly pixelated field. As Lena fades into a field of bright green distortion, Roberta Flack's "The First Time Ever I Saw Your Face" plays, explained in an opening title as the top single in 1972, the same year Lena appeared on the cover of *Playboy*. The mournful song accompanies this gradual vanishing as though it were the music for a memorial montage reel. This is how the film portrays Lena being "killed": it returns to the "first time," the moment the Lena image was chosen for this digital process, her image unblemished. She then slowly degrades, consumed by the process to which she was once essential.

Killing Lena illustrates a key issue that attends the history of the China Girl. Inasmuch as the China Girl can be considered *structural* not just from a film perspective but also a digital one, there remains a problem that plagued structural filmmakers in the 1970s: namely, that these structural elements inevitably also have content. This is to say, the structural project tends to treat the China Girl only as an emblem of film processes not ordinarily considered, or an enigmatically and alluring image, purposefully overlooking the gendered, material body. In this way the woman in the image disappears, not only in film industrial (written off, as previously mentioned, as a semiotic excess) or digital practices, but within the supposedly recuperative domain of experimental media as well. As David James argues, the appearance of the China Girl is not incidental, as when he describes the woman in Land's *Film in Which There Appear . . .* : "The representation of the female model does engage issues of spectatorship that are continuous with the dominant

issues of the film: for instance, her profession is to be looked at, but here she will alternately be overlooked by and look at us."[117]

With the medium of film, the China Girl image highlights the disjunction between the women onscreen, whose images are given to be seen, and the women behind the scenes, like the China Girl model, who are not typically seen at all. She is constitutive of cinema's system of representation, though largely separate from it. In digital media, the figures equivalent to the China Girl are similarly obscured by the processes that depend on their images, chiefly monitor calibration and other forms of image adjustment—in these ways the China Girl is subsumed into software. To the extent that there is no longer a physical artifact to grasp, its materiality is sublimated all the deeper. With digital production and projection, the incidental view of a China Girl during a screening is no longer possible; what then is the materiality of the China Girl image in our contemporary era, or that of its digital descendants? Fontaine's continually morphing image, a familiar face made strange, as well as Allen's programmatically degraded Lena, demonstrate the transmutation not only of the image onscreen but the entire process by which films are made and exhibited in a digital context.

I maintain that these two media share more than they diverge, and this is especially apparent in the endurance of China Girl–like figures across both. As Jussi Parikka observes, perhaps a bit hyperbolically, "modern processes of abstraction and dematerialization can be understood to be having effects as a crisis of the phenomenological, experiencing human body, and also to demand a different vocabulary that would take into account the new forms of materialities of the technical media age."[118] If digital materialities direct us, as Parikka describes elsewhere, to "go under the hood" of digital technologies, the problematic of image and materiality manifest in the China Girl image is a reminder, as it has been in film, to probe the construction of *digital* materiality as being founded on the concealment of the material bodies of women.

If Fontaine's video looks to the future of the China Girl and its uses for digital technologies—and indeed it is the *eyes* of the China Girl that endure even as the rest of her face continues to shift—another recent film returns to the China Girl's past to press more deeply into the questions it left unanswered. One of the most recent films to feature the China Girl returns to celluloid and to the tradition of China Girl uses in experimental film, *Releasing Human Energies* (2012), made by filmmaker and archivist Mark Toscano (plate 11).[119] For a little over five minutes, the woman in the China Girl image sits in real time, visibly uncomfortable and blinking. Her smile occasionally brightens, as she was apparently being directed offscreen to keep smiling. The woman's

discomfort is underscored by the narration of Morgan Fisher, who once again speaks over the image of a China Girl. As the woman fidgets slightly, we hear him read aloud motivational passages from a 1964 manual by Donald Lundberg called *The Management of People in Hotels, Restaurants, and Clubs*, a text that, despite its datedness, remains in print and is listed on many syllabi for hospitality and tourism management courses. Against Fisher's exhortations for effective (and presumably male) managers to "release their human energies," the woman's awkward posture reminds us that this injunction is denied to many whose tedious labor is much less human than it is instrumental.[120]

The stretch of uninterrupted time in Toscano's film provides a clear view of the China Girl model's movement. It is very unlike the brief glimpses and frozen bodies more commonly associated with the China Girl and seen in Silva's *China Girls*. While the footage may be the same, the manner of displaying it is exceedingly rare: the 180 feet of camera original footage Toscano used was almost certainly never shown in its entirety, but, as was typical, clipped a few frames at a time. While on one level the experience of watching the reel is similar to that of a Warhol Screen Test, the knowledge that this found fragment originally came from an industrial source restores a sense of labor and endurance, of life itself, to the woman in the China Girl image. Here she is as she is truly never seen: uncomfortable, awkward, and very much alive. This dispels the reference-effect normally required of the reference image, instead reminding us of the enduring and physical presence of the sitter. This woman is there not merely to look pretty but must suppress her movements, doll-like, and become a picture for our prolonged pleasure. We suddenly *see* her, and moreover see the *process* by which she has been pressed into a reference image. As in Hitchcock's unshot scene for *North by Northwest*, in which a corpse tumbles out of a car that had otherwise been seamlessly assembled, we are provoked into separating the components of industrial production from the seemingly spontaneous eruption of a woman's body—only this time, we glimpse the woman not only as a kind of byproduct, but in her more or less prolonged resistance to becoming-object. I have been arguing that film production requires such a concealment of the China Girl as a woman who is allied with the material apparatus of the film laboratory. With the exceedingly rare view Toscano provides, we see the cost of this occlusion. Note the dissonance between the woman's sense of twitchy struggle—as in my epigraph, an "agony dimly outlined on the imperfect paper"—and Fisher's upbeat corporate banalities. As former China Girl model Lili Young (plate 12) described of her experience of posing: "It was not a very exciting thing to do, you know. Just sit and be very still. Expressionless. . . . They just wanted my flesh tone. . . . It was like being in a long still shot, forever."

2

Gone Girls of Escamontage

That celluloid angel you saw there? They oughta cut her up a little bit—she'd look more interesting.

— CLASH BY NIGHT (1952)

In *Theory of Film*, Siegfried Kracauer describes Thomas Edison's *The Execution of Mary, Queen of Scots* (1895) as a key instance of cinema's tendency to depict horrifying images. As one of the first deaths to be portrayed on film, it is the basis for later "elemental catastrophes, the atrocities of war, acts of violence and terror, sexual debauchery, and death . . . events of this type."[1] Edison's film is a concise depiction of the historical event. Before an audience of guards and noblemen, the Catholic queen is first blindfolded, then kneels before the executioner's block.[2] The blade comes down, her head falls into a basket, and the executioner pulls it out, presenting it to the camera. That is the entire movie. The moment Kracauer isolates, the lifting of the queen's head "so that no spectator can possibly avoid looking at the frightful exhibit," recalls his "Head of Medusa" passage, discussed in my introduction. Like the Medusa encountered onscreen, the beheading in *Mary, Queen of Scots* serves for Kracauer as an emblem of the kinds of fearsome images and experiences that would later become commonplace in cinema.

The film's central action of decapitation is accomplished by the technique of stop-motion substitution, where, in the course of shooting, the camera is temporarily stopped, profilmic elements are rearranged, and recording resumes. This technique is attended by a subsequent splice. In his discussion of Edison's film, Kracauer does not mention the barely noticeable splice that interrupts the falling motion of the executioner's blade. In the space of this cut,

the actor's body is replaced with a dummy whose head is promptly severed. The sum total of the film's suggested violence—Kracauer mentions it in the context of cinema's relation to "overwhelming" phenomena in real life—and its behind-the-scenes manipulations is that the woman's body disappears three times over: first, in the portrayal of a female character by a male actor, Robert Thomae; second, in the substitution of a dummy body; and third, in a splice that conceals the traces of the stop-motion effect, thereby omitting a substantial length of film footage. The splice in *Mary, Queen of Scots* is the earliest known to film historians.

In this rare and early splice, gender, a spectacular visual stunt, and a subtle technique of editing converge. The woman's body is cut both on the level of representation, in the staged scene of violence, and by a formal procedure whereby it has been removed from the frame. The spectacle of decapitation, commonly understood to have been accomplished via stop-motion cinematography, has established *Mary, Queen of Scots* as a progenitor of the field of visual effects. However, because this effect was "cleaned up" by a later splice, I contend that this additional technique marks the film as a foundational moment for a wholly alternative form of editing: what I am calling *escamontage*.

Escamontage denotes a form of editing whose compositional principle is to conceal mise-en-scène elements or postproduction visual effects in order to produce narrative meaning. The term is a portmanteau that combines *escamotage*, French for concealment by trickery (as in magic), and *montage*, the compositional practice of assembling a film through discrete elements.[3] Escamontage is an editing *out* that also hides its own occurrence. On my account, the excision of film elements or techniques is paradigmatically linked with the woman's body. This is not accomplished by cutting *away* to another angle or by a jump cut that skips ahead in time, but by an apparently seamless operation that is present only in the film material—that is, the splice is not meant to be seen in the projected representation, as it is not part of the narrative syntax. Put simply, escamontage composes through concealment. It is strongly related to but distinct from the separate genealogies of visual effects and conventional editing.

Editing, as in continuity editing, generally provides the basis of film narrative, achieved by the joining of separate shots across disjunctions in space and time. Scholars trace the origins of film editing to developments around 1896 to 1897, when Biograph and Edison, as well as exhibitors, could suggest spatial and temporal continuities by sequencing single-shot films together.[4] From this notional starting point, editing then developed the repertoire of techniques—close-ups, inserts, parallel editing, match cuts, and the like—that would find full flower in D. W. Griffith's refinement of continuity editing, Soviet mon-

tage, and the invisible style of classical Hollywood. Continuity editing gener-
ally strives to be "invisible" in the sense that it is designed to cover over the
gaps in space and time that occur with each change in perspective, so that we
know where we are and are not disoriented and pulled out of the action. These
are what Jacques Aumont calls "small visual trauma[s]," and it is the goal of
continuity editing to distract or otherwise engage the viewer's attention so as
to render these cuts as unnoticeable as possible.[5]

Escamontage is different from classical continuity editing in three ways.
First, as the example of *Mary, Queen of Scots* shows, it precedes the earliest
experimentations with continuity style.[6] Though escamontage may seem to
presuppose the tenets of continuity editing, historically this has not been the
case. It predates continuity editing, then later survives alongside and within
it. Second, escamontage composes by hiding select profilmic elements or ar-
eas of the frame. This is unlike the dominant presentational mode of conti-
nuity editing, where meaning is constructed through showing. Escamontage
creates meaning through the act of concealment.

Third, escamontage is a principle by which different takes from the same
camera perspective are joined together by maintaining the integrity or conti-
nuity of the frame, with the result of escamontage being difficult to discern.
Historically escamontage has been achieved through a splice: the physical
joining of two separate pieces of film with glue or cement. This is distinct
from an in-camera edit, in which a camera stops filming mid-magazine and
then resumes after profilmic elements have been rearranged. Often, an in-
camera edit is later augmented by a splice, as was the case for Méliès and
many other trick cinematographers.

Meanwhile, the difference between escamontage and a jump cut, which
also keeps the same perspective, is that the point of the former is to create an
artificial continuity between different takes, to make them seem like one shot—
in other words, precisely to avoid a jarring "jump." Continuity editing also joins
different perspectives, though it requires that the framing always change and
that a new shot be set up. Hence escamontage goes further than continuity
editing as a strategy of "invisible editing." The cuts of continuity editing are
undisguised—in a dialogue sequence of shot and reverse shot, the cuts are not
noticed as intrusions, and they have to be registered, somehow spatially com-
prehended, for the scene to make sense. Such cuts are out in the open, so to
speak. By contrast, escamontage hides its own traces. It aims to conceal, so
that there is nothing apparently hidden.

Visual or special effects have an origin distinct from that of escamontage.
They descend from the early cinema genre of the trick film. In the first decades
of cinema, the techniques of stop-motion cinematography, postproduction

tinting, dissolves, superimpositions, and the like were developed to produce fantastical illusions. By the 1970s, when computers were entering postproduction processes, the category of "special effects" was relegated to on-set practical effects, while "visual effects" came to designate anything that happened in "post," including opticals and titles, the creation of computer-generated elements, color correction, and "compositing," or the integration of multiple discrete elements in a single film frame. I will say more about the expanded arena of digital visual effects later in this chapter.

I distinguish escamontage from visual effects for two reasons. First, because it occurs in *Mary, Queen of Scots*, it predates and is separate from the trick film genre, which, like its magic theater predecessor, is overt in its presentation of a fantastical transformation. Edison's film is meant as a historical reenactment—something "real" and not a fantastical trick defying the laws of nature. Second, visual effects are by definition noncompositional. They exist, and have only ever existed, to serve the meaning established by a film's editing scheme, as when the dress of a "serpentine" dancer was hand-tinted with brilliant colors in the late 1890s or, to use a more recent example, when the actor Chris Evans was "wimpified" as the scrawny Steve Rogers before becoming a buff supersoldier in *Captain America: The First Avenger* (Joe Johnston, 2011).[7] Like the postproduction practice of adding Foley effects to a film's sound mix, these are interventions designed to support and enhance narrative cues, and they are not meant to suggest alternative or deviant meanings. Escamontage, meanwhile, might ostensibly support a film's dominant meaning, but it can also subtly undermine or critique it, as I will show with Hitchcock's *Rope* (1948).

At the time of this writing, we have arrived at a "postcinematic" moment in which the material operation of escamontage has become indistinguishable from the methods of visual effects, which is to say that both are accomplished through subtle digital intervention. Historically, the technical operation of escamontage has varied according to the material at hand. With nitrate and acetate film, escamontage was enacted by a splice that joined together separate shots. This has changed with digital postproduction tools and methods which no longer require "cuts" in the conventional sense. Such transformations in the techniques of escamontage are part of a broader story about the merging of editing and visual effects in contemporary film production. For most of the twentieth century, editing and effects were separate domains, where the former designated the basis of film narrative, and the latter descended from the trick cinematography of early cinema. With the expansion of digital postproduction, these procedures have dramatically transformed and, in the process, increasingly overlapped. Still, even if it is no longer unique in its technical

arrangement, escamontage's *function* to compose through concealment remains unchanged, as I will show with David Fincher's *Gone Girl* (2014).

Escamontage troubles a separation between editing and visual effects that has been foundational to film history. This can be seen with the example of *Mary, Queen of Scots*. The splice is distinct from the stop-motion substitution, which occurs entirely during the course of cinematography. Significantly, the cut occurs *after* the film has been shot. It is a procedure that effectively "cleans up" the traces of the prior effect, somewhat like Norman Bates rushing in with a mop. In this way, although escamontage frequently *attends* a trick, which is often the spectacular violence against or vanishing of a woman's body, it is not coextensive with it. Notwithstanding its pre- and non-trick context, the splice in this film has generally been consigned to the history of visual effects, rather than that of editing. For Tom Gunning, the distinction between stop-motion splices in early cinema and later continuity editing is axiomatic: if a cut is a "trick," then it cannot also be an instance of "editing." Gunning contrasts the function of the splice in trick films—especially as pioneered by George Méliès—which is "maintaining the apparent continuity of [a] single viewpoint," with montage, whose purpose is "dramatic articulation of a story through varied shots."[8] Films centered around tricks incline, rather, toward the "cinema of attractions," Tom Gunning and André Gaudreault's characterization of early cinematic spectacle.[9] Because the cut in *Mary, Queen of Scots* affirms the single viewpoint and mode of display found in the cinema of attractions, it points away, for Gunning, from the classical continuity system.[10] Gunning takes such instances of stop motion plus splice as evidence of a technically sophisticated understanding of continuity, but he refrains from calling this editing. Instead, these "splices of substitution" uphold the "regime of the single uninterrupted shot, independent and unsubordinated to the demands of montage."[11] The paradoxical outcome of this axiom is that some of the earliest splices in cinema become sequestered from editing proper.[12] A "trick" cannot be "editing," just as the uninterrupted shot is opposed to montage. To the question—Should we consider Méliès the "father of montage"?— Gunning answers a firm no.

There are two reasons we might still want to consider the cut in *Mary, Queen of Scots* to be "editing," though to be sure not the continuity editing Gunning has in mind. First, *Mary, Queen of Scots* is not exactly a trick film. Certainly it is not like Méliès's films which employ cinematic techniques to conjure magical illusion.[13] In Méliès, a woman who disappears after a stop-motion interruption do so *within* the represented scene. Cinema is the enchantment that effects the impossible. But as a historical reenactment, *Mary, Queen of Scots* proposes itself as a sort of realism, even with the kind of authenticity we

later see in the reenacted *tableaux* whose sources are cited on title cards in *Birth of a Nation* (1915), as with the scene of Lee's surrender to Grant at Appomattox Courthouse. The woman vanishes in this instance, too: with the substitutions first of the male actor followed by the dummy, and most importantly in the footage that is spliced out. But she does not disappear on the screen, where the "character" of Mary is present at all times. She is excised in the *material* process of the stop motion and splice, not in the representation. The second reason to consider the cut as editing is because the artificial prolongation of the shot *can be* a form of editing, when used to construct a bogus long take. It probably does not occur to us to treat the very short *Mary, Queen of Scots* as a long take, but the stitching together of shots as if they belonged to one unbroken shot is not limited to early or "trick" cinema. To the contrary, as I will show in the case of *Rope*, in digitally constructed films this process of escamontage not only counts as editing but flamboyant and virtuosic instance of auteurist editing.

Escamontage presents an opportunity to reconceptualize the history of film editing. It redraws the line separating visual effects and editing, not only in the contemporary realm of digital filmmaking where its goal of seamless erasure would seem to be completely realized but also reaching backward into the history of analog film production. The history of escamontage shows how the distinction between "shot" and "montage," to use Gunning's terms, far from being watertight, has always been porous, as is more clearly the case in digital postproduction. Furthermore, as a practice designed to conceal, escamontage undermines a notion and practice of film editing predicated on the explicit presentation of profilmic elements, not to mention a larger filmmaking project of revelation, illumination, and discovery.[14] Escamontage as editing offers a vision of film that hides as much as it reveals and whose apparent smoothness conceals many "hidden intervals."[15] In short, it asks us to consider cinema as a system of exclusion, of hidings and things that are hidden. We might then ask: what bodies lie behind its trapdoors?

This chapter sketches a history of escamontage and the bodies it conceals. I examine three historical moments in its development, first in the kinetoscope era, second in classical Hollywood, and third in contemporary digital cinema. In its early expression in *Mary, Queen of Scots*, the spectacular image of a woman's body being severed is attended by an all-but-imperceptible splice. Next, in the classical period of Hollywood cinema, escamontage appears in the inverted logic of continuity editing in Alfred Hitchcock's *Rope*. In comparison to the "invisible style" of classical continuity editing, escamontage, as seen in the film's ostentatious "hidden" cuts, strains to produce an illusion of literal continuity (a single shot) rather than the narrative and spectatorial cohesion that provides the rationale for classical continuity. Escamontage

fetishizes continuity insofar as the property of continuity is overtly presented, while the process of cutting and the excised footage are not visible or discernible. D. A. Miller's analysis of this film brings out the difference between the two styles of editing, as well as the substitutions, elisions, and concealments produced by each. Finally, I consider the legacy of escamontage in digital cinema, reading David Fincher's *Gone Girl* as a contemporary example where the vanishing woman's body is both thematized and integrated as a part of the production process. Digital workflow further collapses the distinctions between editing and effects, so that the materiality of the film cut is now transformed into digital processes. The shift from film to digital media allows escamontage to realize its fantasy of a cut without a seam.

Cuts into or disappearances of women's bodies frequently attend moments of escamontage, as though the representation of women onscreen were a sort of compensation for the way that, behind the scenes, women's bodies were treated as a raw material to be used and eventually discarded on the cutting room floor. At the level of the filmstrip, the woman's body is materialized as so much excess film to be neatly trimmed out, in the service of a continuous image. This is apparent in the excised footage in *Mary, Queen of Scots*, as well as the horror, thriller, and crime genres of popular cinema, where violence against women is frequently central to a film's aesthetic and narrative organization. In cult genres such as grindhouse, slasher, and exploitation films, this violence is sometimes displaced onto racialized bodies. Within feminist film, we find many works that offer critical reflection on these same cutting practices. This chapter therefore concludes by looking at the murder-by-editing in Hitchcock's famously misogynistic *Psycho* (1960), pitted against an instance of a feminist counter-editing in Jennifer Montgomery's video *Transitional Objects* (1999).

Tricks of Continuity

Execution. Representing the Beheading of Mary, Queen of Scots—A Realistic Reproduction of an Historic Scene, also known as *The Execution of Mary, Queen of Scots*, or more simply *Execution*, was shot by William Heise and Alfred Clark outside the Black Maria studio at the Edison Laboratory in West Orange, New Jersey, on August 28, 1895 (fig. 9).

Director Alfred Clark described the stop-motion technique used in the making of *Mary, Queen of Scots* without mentioning the splice that was later added: "My first attempt was *The Execution of Mary, Queen of Scots*, and in this, when the Queen had placed her head upon the block, the photographic camera was stopped, a dummy figure was put in its place, and after the camera started again the dummy head was chopped off. (Conceivably this was the

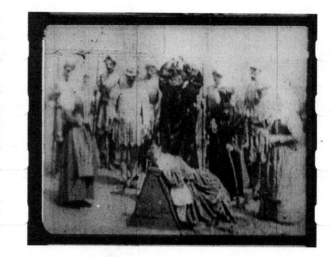

Figure 9. *The Execution of Mary, Queen of Scots* (Thomas Edison, 1897). Courtesy of Library of Congress, Motion Picture, Broadcasting, and Recorded Sound Division.

first professional use of stop motion.)"[16] I have noted already that it is the first splice we know about. *Joan of Arc*, shot later that same day, also makes use of stop-motion substitution with a dummy body when the saint is burned at the stake. Like *Mary, Queen of Scots*, it also has evidence of a splice used to cover over this technique.[17]

Although I have discussed *Mary, Queen of Scots* as a historical reenactment, comparing it to the dubiously authenticated tableaux in *Birth of a Nation*, its "history" is no more accurate than the notorious falsehoods in the latter film. Gone are the layers of clothing Mary Stuart stripped before she knelt at the chopping block, the wig that fell off her head, or the several messy attempts it took for the executioner to accomplish his task. The guards in the film, furthermore, are dressed in the uniforms of the Vatican's Swiss Guards, at best a weak approximation of sixteenth-century English military wear.[18] Yet the problems of historical accuracy would have mattered little to an audience more interested in sensational entertainments.[19] In *Mary, Queen of Scots*, the film's chief subject, more than the historical event of 1587, is the violent act; its being "based on a true story" is—not for the last time—a pretext for prurience.

The gruesome subject of *Mary, Queen of Scots* was in keeping with kinetoscope fare, which tended toward spectacular and lurid subjects. These often trafficked in depictions of violence, erotic thrills, or both.[20] This salacious material was facilitated by the semi-private nature of peep-hole viewing which allowed viewers to enjoy illicit entertainments within a socially respectable space.[21] With a kinetoscope, a device constructed for a single viewer, a visitor

could ogle a belly dancer or watch an otherwise illegal cockfight without attracting attention. In the earliest kinetoscope parlors dating from 1893, several "nickel-in-the-slot" or "peep-hole" machines would be arranged in a row, each equipped to play a single film. For the price of a nickel, an attendant would switch on the kinetoscope loop, a light would flicker inside, and the length of a reel would complete one revolution through the box's rollers, typically lasting ten seconds.

Splices were highly uncommon during the kinetoscope era, which lasted until the introduction of projection-based systems in late 1896. Even into the early projection period around 1900, films tended to be composed of a single, uninterrupted shot, with no splices of any kind. Hence, the splices in *Mary, Queen of Scots* and *Joan of Arc* are exceedingly unusual for the period. Because splices were rarely employed, and also because those few that existed often accompanied the more widely understood stop-motion technique, these splices would have been especially difficult to perceive. Even if a viewer were aware that some kind of cinematic manipulation had occurred to produce the illusion of a woman's beheading, the prevailing unfamiliarity with the technique of splicing meant that the *site* of illusion would have been more or less unintelligible.

The intelligibility of *Mary, Queen of Scots* to a viewer in 1895 would have been impeded by several factors. First, unlike the majority of kinetoscope films, which were either fifty or forty feet long, *Mary, Queen of Scots* is only twenty-eight feet.[22] Ray Phillips surmises that the abbreviated length would have had consequences when placed in peep-hole viewers, which were built for standard reel lengths. The kinetoscope was designed to cycle through one rotation of a forty-two-foot loop, beginning and ending at the same fixed place. This means that the shortened display of *Mary, Queen of Scots* would always have begun and ended at different points in the action, repeating some segment of footage each time the machine was activated. There is no surviving information to account for the discrepancy in the length of *Mary, Queen of Scots*, though we can presume that the missing fourteen feet of film was removed through the splice. The length of the missing footage, which at 16 frames per foot, amounted to 224 missing frames (or just under five seconds when run at 46 frames per second), suggests that the stop-motion technique was not as simple as turning the camera off, rearranging the actors and props, then turning it back on. It indicates, rather, a considerable amount of footage was run off and cut out in the process.

The second issue of intelligibility is that the film's especially wide framing makes it difficult to discern the central figure. This may have been why a man could have been cast in the role of Mary. Robert Thomae's body was mostly

covered in elaborate costuming and his position in profile meant that his face was mostly obscured, so much so that his replacement by a dummy would have passed unnoticed by most viewers. While these aspects of the film might have been the result of production limitations and conventions of the time, they contradict the norms of Marion imagery that, from the time of her death and through the late nineteenth century, privileged the image of her face, whether to emphasize her pathos or to suggest that she might deliver a decree on the divine right of sovereigns.[23] Even within Edison's own catalogue, a significantly romanticized 1913 version of the story entitled *Mary Stuart* featured everything up to but excluding the moment of her death.[24] In 1895, by contrast, she is *only* a body, and moments away from losing her head.

Why has the pioneering of the stop-motion technique been emphasized in the historical record at the expense of attention to these earlier splices, as occurs in Alfred Clark's own account? Stop-motion substitution has a much more prominent and even somewhat mythical role in historical accounts of early cinema, while the accompanying role of splicing has been overlooked. *Mary, Queen of Scots* has tended to be placed within a lineage of trick cinematography and spectacular effects, even if its subject is historical rather than overtly magical.

One reason for the prominence of stop motion is the legacy of the trick or magic film that popularized it. For film historians, this early genre has served as an emblem for the technical wizardry possible in cinema.[25] Stop motion is largely bound up with the early cinema genre of the trick film, itself an extension of magic theater. Trick films have been associated with magical transformations—the sudden appearance or disappearance of people or objects, ghostly apparitions, abrupt changes in scale, multiplication of figures, and the like. Stop motion was one of many techniques used by cinemagicians, along with dissolves, multiple exposures, compositing, and reverse motion, though it was often the basis for enacting these other effects. As Frederick Talbot notes in 1912, they were the most common of tricks to be employed.[26] It is not surprising, then, that Méliès took credit for inventing the stop-motion substitution technique foundational to his practice. In "Cinematographic Views" (1907) he declared, "it was I myself who successively discovered all the so-called 'mysterious' processes of the cinematograph."[27] According to him, he discovered stop-motion photography when his camera jammed while shooting outside the Place de l'Opéra in Paris. Later, when reviewing his footage, he noticed several elements had changed in an instant: a horse trolley became a hearse, and men became women. Méliès's account involves no small amount of misdirection; like Alfred Clark, he makes no mention of the splices that were used to tidy the traces of this effect in every instance in which it occurred.

Though it remains the dominant narrative about the trick film, even to this day, Méliès's story is probably only fanciful.[28] He and his contemporaries likely knew of the technique used in *Mary, Queen of Scots* and studied it closely.[29] Writing seven years before Méliès's "Cinematographic Views," for example, Victor W. Cook is already well familiar with trick cinematography. Without attributing the technique to anyone in particular, he notes: "The method is ingenious and yet simple enough. Suppose you want to make a man vanish, at the right moment you stop the handle of the camera, wait till the man has walked off, and then go on. When the pictures are thrown on the screen at the rate of sixteen a second, with no stoppage, the effect is as if the man simply ceased to exist. . . . This simple process is the key to all sorts of fantastic jugglings."[30]

Most early film manuals refer to this type of effect without so much as hinting at a postproduction splice. L. Gardette's "Some Tricks of the Moving Picture Maker" (1909) describes various uses of the "stop motion," David Sherrill Hulfish's *Cyclopedia of Motion-Picture Work* (1911) contains a section on the "stop picture," and Bernard E. Jones's *How to Make and Operate Motion Pictures* (1916) mentions "'Stop Camera' Tricks" among a variety of other effects.[31] In *Handbook for Motion Picture and Stereopticon Operators* (1908), which references *Mary, Queen of Scots* as a key example of "trick pictures," C. Francis Jenkins treats the effect as an instance of pure in-camera stop motion:

> The execution of Mary, Queen of Scots, was made in this way:
> Property soldiers were grouped back of the headsman's block; the
> executioner stood by leaning on his broad-axe; the Queen was lead in,
> with hands tied behind her back; she kneels and lays her head on the
> block. At this point, the camera is stopped and a dummy takes the
> Queen's place at the block; the camera is started again and down comes
> the axe and the dummy head rolls off into the sawdust. In the repro-
> duction this substitution is not easily detected.[32]

Colin Bennett, writing in 1911, is one of the few to acknowledge the addition of a splice.[33] Describing Méliès's apocryphal discovery, he observes that the effect of a substitution occurred not because of a faulty camera but owing to a worn-out print that was later repaired with a splice: "The positive film had got worn and had broken at the point where the incident should have culminated, the result being that a foot or more of it had been cut away by a none too careful film mender."[34] The resulting "sudden disappearance of [a] traveler" was not intended as a trick, but was nonetheless "destined to be the starting point of many another deliberately produced effect of the same kind."[35] The use of the splice was thus carried over to trick effects. This is to say, the

technique was first encountered in postproduction and only later applied to the shooting of a film: "[The trick effect] is adjusted finally by careful cutting and rejoining of the negative film prior to printing from it, omitting in the process whatever pictures may be superfluous or prejudicial to the general apparent continuity of action depicted."[36] Far from being a simple accident, the stop-motion technique, requiring great precision but effected by the rudimentary mechanism of ceasing to crank the camera, is aided by the splice, which renders the traces of the effect all but invisible.

The prominence of Méliès—of magic and trick films—in accounts of the invention of stop motion directs critical attention away from the technical innovation of the splice and its probable origin in the nonmagical Edison films. The distinction I am drawing between the genealogy of trick films (where stop motion is emphasized, as preliminary to visual effects) and escamontage (where the splice is emphasized, as a form of editing) also carries over into the issues of feminism and materiality. From the start, the female body was the one most frequently subjected to the transformations of stop-motion cinematography. Karen Redrobe offers a thorough analysis of the pervasive trope of female disappearance in her 2003 book *Vanishing Women: Magic, Film, and Feminism.* Citing Georges Méliès's popular film *L'Escamotage d'une dame chez Robert-Houdin* (1896) as her primary example, she places the woman's body within the trick film lineage. Here the disappearance of a woman is accomplished through the rhymed acts of magical display and the stop-motion technique in a dazzling feat of cinematographic sleight-of-hand. The trick itself is directly descended from the enormously successful stage act *The Vanishing Lady Trick* from 1886, a moment in which, as Redrobe asserts, "vanishing firmly establishes itself as female."[37] The female body at the center of these magic practices was consistently dematerialized, and its material instability had the effect of affirming fears over its underlying unruliness. Redrobe notes: "Magic repeatedly presents the manipulation of fantasy or imaginal bodies *as if it were* the manipulation of real bodies."[38] Seen from this perspective, *L'Escamotage d'une dame* is a reassertion of the male magician's power over women.[39]

A distinction should be made between this kind of magic *in* movies and what is properly "movie magic," where the event onscreen need not itself be magical or impossible. Méliès puts magicians and fantastic features onscreen, while Edison's innovation of escamontage arises to replicate a real, if unpleasant, occurrence. In the introduction, I noted that the spectacularly staged disappearance of women in narrative representation, as discussed by Redrobe, is different from the concealment of the woman's body in the material construction of the film. A lady who vanishes in a Méliès film, or even in a Hitchcock film, is the center of much dramatic interest for the scene or story. Whereas

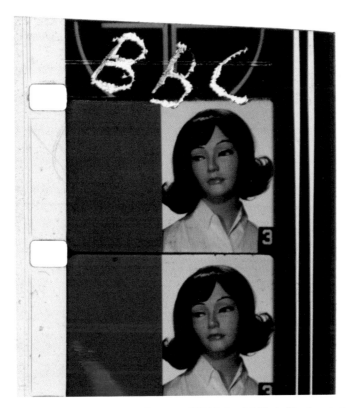

Plate 1. BBC reference image. Courtesy of Ulrich Ruedel, Haghefilm Foundation, 2013.

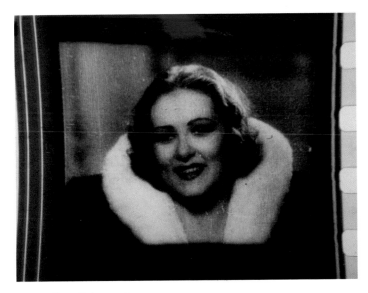

Plate 2. China Girl, ca. early 1930s.

Plate 3. Film still from *Le Mépris* (Jean-Luc Godard, 1963).

Plate 4. Kodachrome test strips with handwriting by Leopold Godowsky and Leopold Mannes, ca. early 1930s.

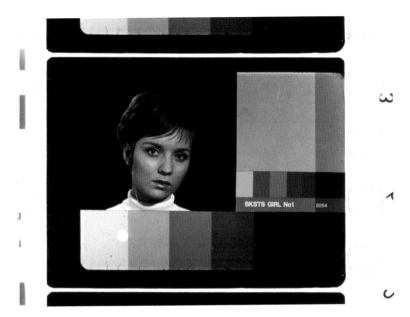

Plate 5. BKSTS Reference Leader Picture, ca. 1970.

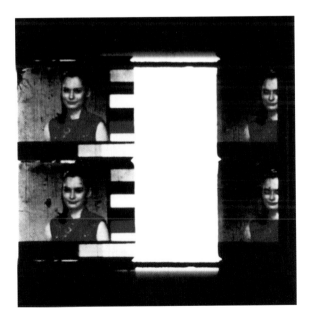

Plate 6. Film still from *Film in Which There Appear Edge
Lettering, Sprocket Holes, Dirt Particles, Etc.* (Owen Land,
1965). Frame enlargement by Georg Wasner, courtesy of the
Austrian Film Museum, Vienna.

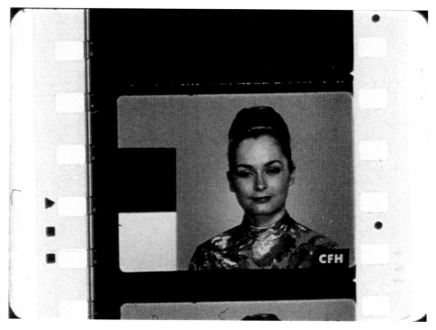

Plate 7. Film still from *Standard Gauge* (Morgan Fisher, 1984). Courtesy of Morgan Fisher.

Plate 8. Film still from *Sanctus* (Barbara Hammer, 1990). Courtesy of the Barbara Hammer Estate and Electronic Arts Intermix, New York.

Plate 9. Film still from *China Girl* (Cécile Fontaine, 2010). All rights reserved by the artist. Courtesy of Light Cone.

Plate 10. Film still from *Killing Lena* (Jamie Allen, 2007). Courtesy of Jamie Allen.

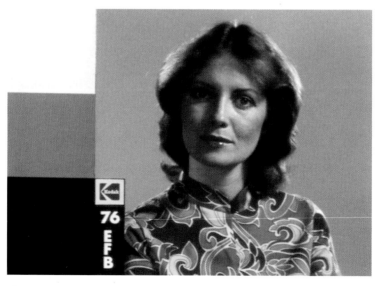

Plate 11. Film still from *Releasing Human Energies* (Mark Toscano, 2012). Courtesy of Mark Toscano.

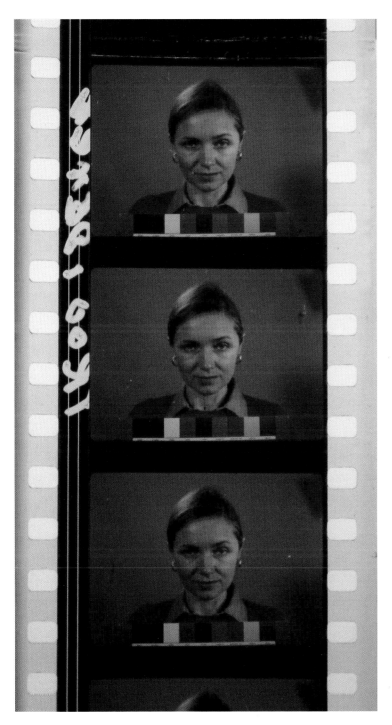

Plate 12. China Girl (Lili Young), DuArt (ca. 1960s). Courtesy of Lili Young.

Plate 13. China Girl. Courtesy of Aurélien Haliene and Chicago Film Society.

the sublimation of the China Girl into nonmimetic laboratory processes is a feature of production that never rises to the level of narrative. Another difference is that in trick films, the woman's body is made to disappear—that is the great interest. Hence, *escamotage*. We are familiar with this disappearance already from the topic of Medusa's disappearing body in art and film theory, discussed earlier. What sets apart the *escamontage* lineage, paradigmatically in the Edison execution films, is that while the represented body of "Mary" or "Joan" remains onscreen to be hacked at or burned alive, the disappearing woman is to be registered instead at the material level, in a length of footage that is excised and craftily sutured.

In *Mary, Queen of Scots*, the visual stunt overshadows the cut of escamontage that follows it. With André Gaudreault, I recognize here "a type of editing which is all too often occulted by the privileged status that film historians regularly grant to the later form of narrative editing."[40] Escamontage is not a mere adjunct to a spectacular effect, but a crucial device by which filmmakers, early on, could subtly divert a viewer's attention. The following sections examine the function of escamontage as a custodial procedure that accomplishes subtle ideological work, sometimes eclipsed by a spectacular effect though just as often hidden in plain sight.

Unravelling *Rope*

In continuity editing, we tend not to notice the breaks between shots because our attention follows matched actions—a gesture, a camera movement—that move seemingly unimpeded across these gaps. Escamontage, too, is predicated on the maintenance of continuity, though what appears continuous in this case is a nonmoving element: the frame itself. During the classical era, escamontage shows up mostly as editorial "cheats," where cuts are hidden to suggest the continuation of a preceding shot—a sham lengthening of the take, where two shots are taken as one. For instance, in the first shot of Anthony Asquith and Leslie Howard's *Pygmalion* (1938), during a pan across Covent Garden, a cut occurs on a wide column and picks up on the other side as if a single shot. In the last shot of *The Earrings of Madame de . . .* (Max Ophüls, 1953), a surreptitious cut renders seamless a pan across an empty church—a Frankenstein's creature made up of two different sets. As with *Mary, Queen of Scots* and the stop-motion effects of early trick films, escamontage was also used to mask what would now be called visual effects. For instance, during a shooting contest in *Red River* (Howard Hawks, 1948), a series of subtle cuts are used to suggest that a tin can is being suspended in the air by alternating gunfire. The screwball comedy *Rhubarb* (Arthur Lubin, 1951) depicts a dog chasing a cat across a

baseball diamond in quickly succeeding shots, and the "blank" grass background provides the appearance of continuity. In *Assault on Precinct 13* (John Carpenter, 1976), the windows of a police station are shot out, again in seeming quick and uninterrupted succession. In these cases, the frame remains unchanged, and the cuts are only noticeable in exceedingly minor differences in lighting (*Rhubarb*), dust blooms (*Red River*), and the movement of falling glass (*Assault on Precinct 13*).

Hitchcock's *Rope* departs from these other instances by making escamontage its central and most discussed feature. In this sense, *Rope* can be thought of as "laying bare the device" of escamontage in a Russian formalist way. My interest in *Rope* is to show how escamontage, where the stoppage of filming is covered over with a splice, is itself a form of editing, not just a "cheat" or "trick." *Rope* is instructive in this regard because it is arguably the pinnacle of an auteurist fetishization of the long take. I mentioned earlier that *Mary, Queen of Scots* is such another artificially constructed "long take," at just a few seconds. The uses of escamontage in the construction of artificial long takes can be seen in the cases of *Children of Men* (Alfonso Cuarón, 2006), where the visual effects team digitally stitched together a nine-minute tracking shot out of six separate shots, and the combination of time-lapses and dark spaces, similar to *Rope*, in *Birdman* (Alejandro González Iñárritu, 2014).[41] These digital uses follow the logic of earlier analog ones, where a cut occurs by ending one shot on a uniform surface and beginning the next from the same or a similar place. This is somewhat different from the "digital events" D. N. Rodowick identifies in *Russian Ark* (Alexander Sokurov, 2002) and which I discuss later in this chapter. The peak of excess in this technique, signaling its degradation from auteurist virtuosity, is probably the hyperbolic array of foreground elements used to conceal cuts during the extended fight sequences of *Kingsman: The Secret Service* (Matthew Vaughn, 2014).

Rope is a suspense thriller about two young men, Brandon Shaw (John Dall) and Phillip Morgan (Farley Granger), who murder a classmate, stuff his body into a chest, then lay out a dinner party banquet on top of it in an attempt to get away with the "perfect crime." The plot is not the film's main interest, or what makes it, in Hitchcock's recollection, his "most exciting picture." Famously, *Rope* has the appearance of being a single long take unfolding in real time. Hitchcock himself described the film as "a picture in which the camera never stops."[42] A closer look reveals that the film is in fact composed of about ten shots cleverly joined together. In his landmark essay "Anal Rope," D. A. Miller takes up Hitchcock's complex game of perceptible and imperceptible cuts. Among these, Miller identifies two editing schemes: the first, which occurs five times, is the celebrated device of the "hidden" cut, which produces

the illusion of a long, uninterrupted take—what I have been calling escamontage.[43] Each occurs in the same manner: the camera passes in front of a dark area of the frame whereupon a cut is covertly made, and the next shot begins from a similarly obscure space. As with the splice in *Mary, Queen of Scots*, the cut maintains the coherence of the frame and produces the effect of a long take, being of course artificially constructed. The second editing scheme is the "unhidden" (but still "invisible") cut of the classical style, namely the reverse angle. There are also five of these interspersed among the hidden cuts.

Of course, the "hidden" cuts are not very well hidden at all, as they are the film's gimmick and selling-point. As the screenwriter Arthur Laurents complained, "You see, really, what he's trying to hide."[44] This has the paradoxical effect of further concealing the "unhidden" cuts, since these are just garden variety examples of continuity editing overshadowed by the "hidden" cuts that maintain the apparent long take. Miller's analysis allows us to see how these two "invisible" editing schemes play off each other, and what different ideological work they accomplish. He connects the dual editing schemes to the film's tension between an overt heterosexuality and a repressed homosexuality. While the "unhidden" cuts are typically made at moments Miller flags as heterosexual, nearly always cutting away to a woman, the "hidden" ones are almost all made with the camera panning to a man's backside. The "unhidden" cuts therefore serve a technical purpose, allowing for precision in reel changes,[45] while serving as a semiotic contrast. They moreover preserve a semantic *fixity*, since these reverse angles of the classical style organize the film's overt heterosexual logic. Against this fixity, the escamontage enacts a queer play of meanings. In *Rope*, escamontage lurks amid continuity editing and works by way of connotative suggestion. The "hidden" cuts express both fear of and desire for the man's anus. It is the place where the camera seems magnetically drawn, but also where it dares not to look too closely, stealthily cutting away before it sees too much. Only an especially perceptive viewer, watching "too closely" like Miller, could observe this fascination and repudiation of the film's desire.[46]

Rope's multifaceted editing scheme can be seen as an extension of the splice technique used in *Mary, Queen of Scots*, not least because it shares the motif of the concealed body. In both films the editing is designed to assure the "neatness" of a represented execution and is concealed by a piece of symbolic misdirection. With Edison's kinetoscope reel, the body disappears and is replaced by a dummy, all of which is accomplished within the split-second interval of a splice. In *Rope*, the murderers insist on hiding their victim's body in plain sight, an act that is paralleled in cinematic terms by the seemingly transparent long take—itself periodically "buried" in someone's backside. As

ever, the body, immediately hurried out of view, is the guarantor of the image's continuity.

There is an important difference between *Rope* and the earlier film, which is that the body hidden from view is that of a male character, David Kentley (Dick Hogan). David, we learn through other characters' descriptions, is a "good American," "bright," "popular," wealthy, and dependable. He is engaged to Janet Walker (Joan Chandler), who previously dated Brandon. David, in other words, is far from a female or even feminized character. Yet Brandon provides a provocative link between David and Janet when Rupert Cadell (James Stewart), their former teacher, questions the unusual use of the chest as a banquet table. Speaking to David, he observes, archly: "Trust you to find a new use for a chest. One was always turning up in the bedtime stories he told at prep school. 'The Mistletoe Bough': that was your favorite tale, wasn't it? . . . It was about a lovely, young girl—" At this point Rupert is interrupted by Mr. Kentley (Cedric Hardwicke), David's father, who eagerly jumps in: "She was a bride-to-be and on her wedding day, she playfully hid herself in a chest. Unfortunately, it had a spring lock. Fifty years later, they found her skeleton."

David may not seem especially feminine, but he is *feminized* in the sense that he is stuffed into a chest and ostensibly overlooked just like the bride in the story of "The Mistletoe Bough." He joins a long history of disappeared bodies, from the vanished women of early trick films to the car assembly scene Hitchcock would later describe for *North by Northwest*, as discussed in the introduction. I contend that, in film, these feats of vanishing hold a place for women's bodies, even if the one to be locked in a chest or covered by a veil is male. As Brandon complains, David is someone that "merely occupies space," and Hitchcock would seem to concur, rushing him out of the picture just two minutes into the film. Janet, the main female character in the film, is also someone who merely occupies space. She is incidental to the narrative, neither playing accessory to nor figuring out the murder, though she gets close. More significantly, she is not addressed by the escamontage that tells the story of the film's repressed *male* homosexual desire. On a technical level, Janet does not motivate any of the film's hidden cuts, nor does she appear in any framing alone. She is fussy, self-involved, and superfluous. As the film's logic suggests, she would do well to make like the bride of "The Mistletoe Bough" and disappear into a box. The image of women, or rather the *position* and *placement* of women's bodies onscreen, becomes a trapdoor through which they exit the frame, like a strip of discarded film.[47] This is how male bodies— whether David's, Robert Thomae's playing Mary Stuart, or the morcellated men identified in trick films—can just as easily occupy the place of women, being thereby structurally feminized.[48]

The escamontage in *Rope* is notably gendered in another beyond what the queer and feminizing readings just laid out. In a more recent essay, Miller returns to *Rope* to uncover and scrutinize misplaced elements in the mise-en-scène.[49] A candle is crooked one moment and then, after the camera sweeps away, is righted when it returns to view; couch cushions, flowers, napkins, and desserts appear in various states of disarray. In a strict sense, this kind of mistake would be considered a continuity error, though here the inconsistency occurs not between takes that are later spliced together, but within the same take, a result of mise-en-scène elements that are moved out of frame while the camera is still rolling. These tiny mistakes fall "presumably 'below' the threshold of . . . recognized style."[50] Miller relates these departures from Hitchcock's stylistic perfection to the film's theme of the mistake that gives away a perfect (auteurist) crime. The "mistakes" guarantee, on a barely perceptible level, that a master's handiwork can be appreciated.[51]

Miller raises, then abruptly shuts down, the possibility that these rearrangements might be the work of a "phantom maid," whose "surreptitious housekeeping can hardly be likened to the usual cleanup work of a 'script girl.'"[52] Tania Modleski, a prominent Hitchcock critic, takes the suggestion of an understyle in a feminist direction: "I like to imagine that the continuity girl cleaning up the messes made by men—messes that continue to proliferate throughout *Rope*—performed a role in deaestheticizing the film and thus contributed to its understyle."[53] Modleski's Hitchcock is no mastermind cleverly dropping hints of his genius in subtle continuity errors, but a man whose reputation for flawless execution, like that of so many men, relies on the tireless labor of uncredited women. It seems there is no end to the ways that women can disappear in Hitchcock!

I like the vision Modleski presents, not least for its paranoia, which is at least as plausible as Miller's. *Rope*, a film with no women of consequence, and a more or less perceptible homosexual subtext, is finally unraveled by a vengeful and meticulous script girl. Such fancies aside, *Rope* did involve an unprecedentedly complex shoot, its crew filming a set in which every item had to be continually moved.[54] This made the work especially difficult for the script supervisor, or "script girl," the uncredited Charlsie Bryant—not to mention the character of Mrs. Wilson (Edith Evanson), the housekeeper whose fastidious dinner party place settings are upset by Brandon and Phillip's abrupt relocation to the living room chest. As Melanie Williams provocatively suggests, successful work of this type is measured by the degree to which it disappears.[55] Miller relocates this undervalued, gendered work back to the auteur himself, in a sense. If *Rope* can at some level be considered a work of cinematic sleight of-hand, Modleski's proposition restores to women a role in orchestrating

the trick—at a material, sub-narrative level—even if they are barely in the picture to begin with.

Invisible Editing

The character of Amy Dunne (Rosamund Pike) in David Fincher's *Gone Girl* would seem to be the female equivalent of the male masterminds of *Rope*. In this suspense thriller, she frames her unsuspecting husband, Nick (Ben Affleck), for her would-be murder. Amy not only presents Nick as a murderer but stages his attempt to cover over the act: mopping up the blood, righting fallen picture frames, and disposing of the body. As she writes in her diary, speaking in voiceover: "You need to bleed. You need to clean." With her body missing, both the detectives and Nick pursue her traces. Amy has left behind parallel trails of clues, one for the detectives, who slowly arrive at the conclusion that Nick killed his wife, and one for Nick, who will helplessly realize his wife set him up for the fall.

On one hand, the character of Amy is likened to director David Fincher himself. Both are meticulous and controlling invisible directors, and both apparently delight in toying, cat-like, with their quarry rather than merely entrapping them. Yet Amy differs from Fincher's male masterminds like John Doe of *Seven* (1995), Conrad Van Orton of *The Game* (1997), and the cryptic serial killer in *Zodiac* (2007), all of whom pull off highly elaborate schemes without incident. Unlike them, Amy goes "off script" and, as a result, she makes costly blunders. Deciding not to kill herself, an act which would provide the corpse needed to complete Nick's frame-up, she instead becomes "Nancy," a salty New Orleans woman on the run from an abusive husband.[56] She takes up residence at a rundown inn, gorges on junk food, befriends her ne'er-do-well neighbors, and, needlessly, joins in a game of mini-golf which results in the reveal of her bulging money belt. Naturally, her neighbors steal it, and Amy is left desperate, penniless, and forced to beg her obsessive ex-boyfriend Desi (Neil Patrick Harris) for help. Though these mistakes do not derail her final triumph—she is still able to ensnare her unsuspecting husband—they compromise the audience's sense of Amy's competence. Fincher's all-male postproduction team, meanwhile, makes no such mistakes seamless behind-the-scenes editing, and it effectively beats Amy at her own game. However invisible Amy's scheme might appear to Nick, her gaffes are on full display. The logic here is gendered: while Amy can falter, it is difficult to imagine, say, Kevin Spacey's meticulous serial killer character having a similar, blooper-filled interlude in *Seven*. Fincher's own missteps, such as they might exist, are undetectable. What separates Amy from Fincher, then, is a

gendered difference in relative invisibility: the male director shapes the scene without any visible trace of intervention, while the female director makes sloppy errors that later need to be corrected.

An example of Fincher's exacting control occurs in the pair of bookended shots that begin and end the film (figs. 10a and 10b). These are the same length and contain only subtle differences in lighting, costuming, and facial expression. In both we see Amy from Nick's perspective, her head resting on his chest, his hand gently stroking her hair, as if petting a cat. She suddenly looks up toward the camera, an open, quizzical expression in her eyes. In the beginning of the film, Nick speaks in voiceover: "When I think of my wife, I always think of her head. I picture cracking her lovely skull, unspooling her brains, trying to get answers." At this moment, before anything has happened in the film, the intimation of violence against a woman is unsettling. By the end of the film everything has changed: Nick is the victim, not the culprit, and Amy is the one who has committed murder. Yet from the outside, nothing has *apparently* changed, as this nearly identical shot suggests. He is no match for her, and, as he admits in his final voiceover, he still does not know what she is thinking. Fincher, meanwhile, is the one who sees everything and who lines up these two shots precisely like the picture frames at the crime scene that, as Detective Boney remarks, "looked wrong." When Boney examines the scene, she finds these photographs neatly positioned on the fireplace mantle (fig. 11). Nothing appears out of place—if anything, everything is perfectly *in* place—and the seasoned detective understands that this is a scene of misdirection and part of the cover-up. Boney stomps her foot to show how easily the frames topple over and how they should have fallen if there had been a scuffle between Nick and Amy. More importantly, she demonstrates how deceptive their mundane tidiness actually is.

Crucially, *Gone Girl*'s game of misdirection is recapitulated on the level of its technical composition. Though Fincher is not especially known for lavish digital visual effects, he may be the filmmaker who has most exploited the possibilities of digital filmmaking, where the ability to manipulate the film or digital image at a level far below a viewer's attention has, in recent decades, vastly grown. This is due to the expansion of digital visual effects into all areas of a film's construction. Where, prior to the integration of computing and filmmaking, visual effects designated optical effects, titles, and other secondary, postproduction processes, they now are conceived as a core part of a film's preproduction and principal photography stages, or what Ignatiy Vishnevetsky calls "workflow."[57] Without any apparent disruption in viewer expectations— contemporary digital films appear mostly unchanged in terms of their genres, their narrative organization, or the typical length of a feature film—the workflow film is less *shot* or recorded in the traditional cinematographic model than

Figure 10a. Film still from *Gone Girl* (opening) (David Fincher, 2013).

Figure 10b. Film still from Gone Girl (closing) (David Fincher, 2013).

it is digitally *constructed* or animated, often frame-by-frame and even pixel-by-pixel. With workflow, editing is placed on a continuum with effects, where a shot is composed not only in relation to other shots, as in the construction of eyeline matches, adherence to the 180-degree rule, and shot sequencing in the traditional domain of editing but, in a return to the *Mary, Queen of Scots* paradigm, within the boundaries of its own frame.

This modern-day escamontage is especially apparent in Fincher's films. Already, the majority of digital visual effects generally pass below the threshold of audience detection, including subtle adjustments in color correction and lighting, the "cleaning" of dust and scratches accrued in either the shooting or printing of film stock, the removal of guy-wires or other production equipment, digital set extensions, matte painting, and a variety of "beauty" effects equivalent to airbrushing or Photoshopped touch-ups in print photography. Fincher takes these modifications to the more granular level of what his edi-

Figure 11. Film still from *Gone Girl* (David Fincher, 2014). Detective Boney: "This area? Looked wrong. From the second we saw it. The whole thing looked staged."

tor Kirk Baxter calls "invisible editing."[58] The postproduction workflow of *Gone Girl* especially demonstrates Fincher's interest in the transformation of editing procedures by integrating them with visual effects.

While *Gone Girl* adopts a familiar narrative structure and editing style consistent with the rules of classical continuity editing, below its smooth digital surface there is, similar to *Rope*, a far more complex orchestration of editorial manipulation. Paradoxically, the subtlety of technique is what Fincher aims to flaunt. It is unlike the flamboyance of, say, Alfonso Cuarón's *Gravity* (2013), where camera-like events such as lens flares, shaky camera movement, and whip-pans were added to provide a sense of verisimilitude. (As described by producer David Heyman, "There are 'mistakes' as it were, but—no mistakes. It's all created."[59]) Over 80 percent of *Gone Girl* contained visual effects, ranging from CG gummy bears to frame stabilizations that corrected uneven camera movements. The film's most elaborate technical feats are also its most invisible. For example, at various moments, the editors reframed shots because Fincher's cinematographer Jeff Cronenweth had used the new RED Dragon digital camera to "overscan" the frame, capturing more data (6K) than would actually be used (4K). The technique of reframing effectively gave Fincher the ability to introduce new framings and even camera movements. Baxter described this as "[taking] out the human aspect of camera moves," resulting in the cold and flawless steadiness that characterize many of Fincher's films.[60] This "digital reanimation of the camerawork" has been a core compositional principle for Fincher since 2010 (with *The Social Network*), and overscanning provides the extra digital footage to accomplish this technique.[61]

The other major technique concerns the elaboration of split-screen performance scenes. Previously, the use of different actors' performances within the

same scene would require ample cutting. In a two-shot of the classical style, for instance, the camera toggles between different shots of the actors, cutting between them to indicate their interaction. Fincher's development of what has become colloquially known as the "Fincher effect" involves this same basic set-up, but it achieves multiple performances without any apparent cutting. To accomplish this, Fincher's camera team sets up a fixed camera position that later allows the editors to use one actor's performance from one take, then seamlessly cut in the other's performance from another. Baxter describes this as "rip[ping] apart inside the frame," all while maintaining the fiction of an uninterrupted shot.[62] The Fincher effect, along with other discrete interventions such as trimming out time within a scene or speeding up a particular action, works without having to use a classical "cutaway" shot to conceal these inconsistencies. His split-screen technique amounts to the basic function of editing—choosing and aligning takes—but they are achieved without cutting in the traditional sense, as the linking of discrete shots.

Gone Girl was the first Hollywood film to be edited with Adobe Premiere Pro and the postproduction team worked closely with the software company to develop tools to emphasize flexibility and manipulability of data. The development of the now commonplace offline editing program is inseparable from the parameters of that particular film. Assistant editor Tyler Nelson describes the development process as a tightly integrated partnership: "We dabbled with ideas and used it in our traditional feature film pipeline to really test its limits and work with it as much as possible to find where the holes were, and then discuss those with the Adobe engineers. That way, they could improve it and almost customize it for our needs."[63]

Above all, the Gone Girl postproduction team steered the development of Adobe Premiere Pro toward integrated editing and effects. As Jeff Brue, the film's postproduction engineer, says, "The entire idea behind this production workflow was to bring the effects closer to editorial."[64] What, previously, had only been an idea—the fantasy of a cut without a seam, first imagined by Clark in Mary, Queen of Scots—has now been realized by the decomposition of the image into discrete and manipulatable information. Gone Girl shows that editing, as escamontage, need not be made up of cuts in the traditional sense, but that it can accommodate an array of "digital events" that conceal the evidence of any kind of postproduction intervention.[65]

The postproduction on Gone Girl demonstrates how malleable the operations of editing and effects have become, and how, as a result, previously straightforward terms such as frame, shot, cut, and edit now seem inadequate, while newer terms such as workflow and compositing demand fuller theoretical elaboration. To pick up a question posed earlier in this chapter: if we take

escamontage as a form of editing, what does that mean for the history and the-
ory of editing more broadly? Alexander Sukarov's *Russian Ark* (2002) presents
an extreme test case for the applicability of a standard vocabulary for the digi-
tally constructed long take. Both Rodowick and Aumont take up this film in
which its entire ninety-nine-minute running time occurs in a single shot. Nei-
ther critic accepts the widely promoted idea that the film comprises a single
shot, though for different reasons.[66] The concept they are looking for, I be-
lieve, is best captured by escamontage, which is limited neither to its material
origins in film nor to its advanced realization in digital technologies. Instead,
as I have been arguing about Fincher's process, it persists in both. It has often
been mistaken as mere visual effect, and while it has certainly moved closer
to the realm of postproduction effects, Rodowick's description of *Russian Ark*
as a "montage work" suggests that it plays a significant compositional practice
within a broadened history of editing.

Escamontage has been used to conceal, and while in digital media this
is closely aligned to and functionally indistinguishable from effects, it is not
identical to it. As a compositional practice, it upends fundamental assump-
tions about editing: first, that it is associated only with the overt presentation
of profilmic elements. I have challenged this by looking at the woman's body
removed in *Mary, Queen of Scots*, the sub-narrative–gendered tidying follow-
ing from *Rope*'s editing scheme, and the surreptitious digital interventions in
Gone Girl. The next assumption is that editing is composed of cuts that link
together discrete segments of film footage at the frame line. But escamon-
tage, in its contemporary iteration, does not require cuts in the traditional
sense, because it can accomplish its work at the surgical level of the pixel.

Fincher's techniques of escamontage are all but impossible to detect through
a straightforward viewing of the film. The labor of his postproduction team in
achieving these "invisible edits" is suggested only through displacement onto
Fincher's surrogate Amy, who carefully plots her scheme. Yet Fincher exempts
himself from Amy's embarrassing missteps—she not only plans, but also im-
provises and falters before she eventually succeeds. While this would seem to
add dimension to Amy's character, the film stops short of entering her subjec-
tivity. Why, for example, does Amy become "Nancy"? Why does she undergo
the elaborate transformation to become a bloated, battered, and generally de-
based character? More importantly, who is this disguise for? Since Nick, Amy's
principle audience, never learns about her trashy detour, it would seem that
"Nancy" is merely there to offset Fincher's flawless execution from Amy's im-
perfect one. Just as Amy is bitter about having to perform "for" other charac-
ters, whether in her storybook avatar Amazing Amy or the "Cool Girl" type
she performs to please Nick, Fincher also constructs her as his foil. As a result,

Amy is less a character whose motivations and actions are coherently aligned than a smattering of impressions, or, more appropriately, images. It is not surprising that the film is most concerned with her shape-shifting body, from Amy's lithe frame to the lumpier contours of "Nancy." Lev Kuleshov once observed: "By montage alone we were able to depict the girl, just as in nature, but in actuality she did not exist, because we shot the lips of one woman, the legs of another, the back of a third, and the eyes of a fourth. We spliced the pieces together in a predetermined relationship and created a totally new person."[67] With *Gone Girl*, Fincher created a new person, a woman made of disparate parts that only appear to fit together. Amy is opaque, though not because she is especially mysterious; for Fincher, she is only unknowable because he does not bother to know her.[68] This now familiar treatment of a woman is a sure sign of escamontage, which persists wherever there is anything to hide. In cinema, this is potentially everywhere.

Cutting Women

The association of women and cuts is reflected cinematically in genre films and negatively in the concerns of feminist filmmakers.[69] The "cutting" of women recurs in a material form in the gendered logic of editing, as I have been claiming with respect to escamontage. The association of editing and violence toward women is made most famously by the shower scene in Hitchcock's *Psycho*, the formal and literal segmentation of women in *Rear Window*, and it is menacingly suggested by projectionist Earl Pfeiffer from *Clash by Night*.[70] This motif extends also to the beginnings of avant-garde film, when in Luis Buñuel and Salvador Dalí's *Un Chien Andalou* (1929), the notorious slicing of Simone Mareuil's eye inaugurates an altered and deranged manner of seeing.

Feminist artists and filmmakers, meanwhile, present a range of other female cuts, including the sacrificial offering of the woman's body in Yoko Ono's performance *Cut Piece* (1964–1966 and 2003), documented by Albert and Robert Maysles in 1966; the gleeful snipping of sausage, pickles, paper rolls, and the bodies of the two female protagonists in Vera Chytilová's *Daisies* (1966); and the scalpel-carved scene on Catherine Opie's back in her 1993 photograph "Self-Portrait/Cutting." In this section I address the conjunction of women, cuts, and the practice of editing in *Psycho* and Jennifer Montgomery's *Transitional Objects*, which express, respectively, a spectacular sleight-of-hand and the painful refashioning of editing as a feminist technique.

The shower scene in *Psycho* is well-known for its startling and sudden eruption of violence, when Marion Crane (Janet Leigh) is attacked and repeatedly

stabbed in her bathroom at the Bates Motel. The camera is seemingly everywhere—inside the shower, outside it, looking straight on Marion, angled up at the showerhead—and the edits are increasingly brief, so that the scene appears less like a coherent moment than a series of traumatic, still-frame flash-backs.[71] In extreme close-ups of a hand wielding a chef's knife or Marion covering her face with her raised arms, the images appear terrifyingly abstract, and, aided by a score of screeching violins, they become nearly intolerable. Famously, there is only one shot in which the woman is stabbed—Hitchcock avoided overt depiction in order to evade censorship by the Production Code— though the combined effect of the music, cinematography, and above all a frenzied montage (quite unlike the rest of the film) overwhelmingly suggest it.[72] In his notes on the scene, Hitchcock wrote: "The slashing. An impression of a knife slashing, as if tearing at the very screen, ripping the film."[73] The edit-ing is *so* visible so as to distract from the action it is meant to convey. In short, the editing substitutes for the depiction of violence. With this we find an echo of *Mary, Queen of Scots*: the cutting of a woman onscreen that coincides with an act of editorial cutting.[74]

I am interested in another "ripping" in *Psycho*'s bathroom. The scene in question does not begin with Marion stepping into the shower but the far less titillating image of her writing at a desk. She is calculating how much of the stolen money she needs to repay, soon after deciding to return it. She tears up the paper, enters the bathroom, and flushes the pieces down the toilet. Though its connection is not immediately apparent, I read this gesture in line with the on- and offscreen cuts that follow: first, because it dramatizes an act of con-cealment, Marion's attempt to tear and hide the record of her bookkeeping anticipating the stabs hidden by the editing; and second, with the view of the toilet, as a reminder of the woman's body—whereas the murder sequence shows as little of Leigh's body as possible. Among its other notable features, *Psycho* was the first film to depict a toilet, and here the sight of a woman flushing one suggests excrement, which is to say, her body as flesh, as material.[75] Like the paper bits that swirl downward in the toilet bowl, the viscera of Marion's body will soon spiral down the bathtub drain. (This is an association that would be made explicit in the allusions to *Psycho* in Francis Ford Coppola's *The Con-versation* [1972]. The sound technician Harry Caul (Gene Hackman), search-ing for a corpse in a hotel room that appears immaculate—even the shower drain is clear—opens the toilet bowl, from out of which pours a backed-up flood of blood and toilet paper.) The spiral motion of the water still running after Marion's murder, accompanied by a slight zoom, is matched in the camera's 90-degree rotation and zoom-out as it fixes on her dead and open eye, linking theme back to cinematographic and editorial technique. Moreover, the paper

scraps, initially connected to Marion's crime, are later linked to her disappeared body. Her sister finds one remaining piece and is from there able to place Marion at the motel. Like the single splice in *Mary, Queen of Scots*, this one trace, a not-quite-vanishing mediator, points to a body that has been absented both narratively and editorially.

Jennifer Montgomery's *Transitional Objects* reconfigures the conjunction of the woman's body, the cuts it suffers, and film editing to propose a new method of moving-image construction. The work assembles an array of heterogeneous elements while also dramatizing their assembly: footage from the last stand of *Django* (Sergio Corbucci, 1966), where, with crushed hands, Django painfully angles a revolver in the crook of a graveyard cross; a menagerie of severed and restitched stuffed animals; and shots from a video being edited on a laptop. Most pointedly, the video is framed by shots of Montgomery's bare feet as she struggles to tape-splice two strips of 16 mm film. (Later this spliced film would form part of Montgomery's film *Troika* [1998]). *Transitional Objects* is centrally concerned with the ambiguous meaning of a splice, which can both separate and join together. The process is painful and difficult, as Montgomery's toes, nicked by the blade of the splicer, make viscerally apparent. Here, the woman's body is figured as especially vulnerable but also mutable.

The video is loosely organized in four sections, each initiated by a particular sound or voice. The first opens with the sound of howling wind, taken from *Django*. This is combined with an image of clear 16 mm leader positioned horizontally, with both strips of sprocket holes visible, and the surface marked by intermittent red blotches, likely the blood from the wounds on her feet. Next we see a video close-up of Montgomery's feet attempting to splice together film (fig. 12), the audio track now featuring, in addition to the howling wind, the sound of grunting and short, labored breathing. A man (Kit Montgomery, Jennifer Montgomery's father) begins to speak in voiceover, reading aloud Winnicott's definition of the transitional object from "Transitional Objects and Transitional Phenomena." Survival, according to this voiceover, is a process that requires the transformative force of destruction. As he speaks, the image is replaced by footage of Django setting up his gun.

The next several sections introduce new voices and scenes. The second begins with a wide view of Montgomery sitting in the middle of a pile of stuffed animals. The camera switches to a close-up, in which she uses a razor blade to carefully slice off their limbs and heads. On the soundtrack a three-year-old girl (Madeleine Hérisson-Leplae) speaks, apparently watching the footage, commenting on and occasionally querying Montgomery about her actions.

Figure 12. Film still from *Transitional Objects* (Jennifer Montgomery, 1999)

The third section, which is led by the voice of a woman (Marie Mellott) reading from Winnicott's "The Use of an Object and Relating Through Identification," switches to an image of an infant pressing the keys of a laptop and clumsily trying to fit a VHS tape into its side. The fourth and final section returns to the wind from *Django* and the male voice quoting Winnicott, pairing these sounds with the image of a computer screen displaying Avid video-editing software. Within the Avid windows we see footage of a baby suckling a breast, diagrams taken from Winnicott's essays, and the scene of Montgomery splicing film with her feet. With great effort she completes a splice, smooths it over with tape, and removes the filmstrip from the table. The video then leaves the computer monitor and cuts to Django meeting his enemy with rounds from his cross-mounted revolver. With image and sound now remarried, the video concludes with the *Django* end credit sequence overlaid with Montgomery's titles.

The multiple acts of cutting in *Transitional Objects*, including the severed and restitched stuffed animals, the shots of the Avid windows, and the frame scene of Montgomery's feet, all partake of the contranymic meaning of the cut. The splice constructs through destruction, conjoining different filmstrips to construct a new whole out of multiple fragments. In its dramatization of a scene of a woman editing, it places Montgomery in a tradition of female editors or "cutters" who, in Hollywood, dominated the profession until the early 1940s.[76] (Indeed, the term *editor* was invented because Irving Thalberg at MGM wanted to elevate the work of Griffith's mainstay cutter Margaret Booth.)[77] Within the domain of experimental film, Montgomery joins Elizaveta Svilova, whose editing is on dazzling display in Dziga Vertov's *The Man with a Movie Camera* (1929), as well as Danièle Huillet, whose exacting adjustments at a Moviola editing table in Pedro Costa's *Where Does Your Hidden Smile Lie?* (2001) are recognizable in the meticulous essay films she made with Jean-Marie Straub. Female editors have even appeared in contemporary

Hollywood films, most notably with the character of Shoshanna Dreyfus, a Jewish cinema owner in Quentin Tarantino's *Inglorious Basterds* (2009), who, in a counterfactual Occupation, cuts in footage of herself announcing her plan, soon enacted, to incinerate a theater packed with Nazis with a burning heap of nitrate film.

Yet Montgomery's clumsy foot-editing—surely an uncommon expression of "digital" filmmaking—falls short of the perceived nimbleness of female cutters in Hollywood, much less the professional precision attributed to Svilova and Huillet, or the vengeful historical fantasy of Shoshanna/Tarantino. Instead, Montgomery dwells on the difficulty of the task, and in doing so, *Transitional Objects* emphasizes the visceral nature of the cut, a physicality that is typically overlooked in most editing procedures, especially with the advent of clean, digital, offline editing systems such as Avid. By using her unskilled feet at work, coupled with the sound of Django's labored breathing, Montgomery reimagines editing as something painful and arduous. The wounded female body becomes the basis for a new practice of image making. The blend of digital and analog modes of editing indicates that this is not an account of teleological progression from film to video but rather a reconception of feminist film editing. What is transitioned out of and left behind, in the Winnicottian sense, is the type of seamless and pristine editing that characterizes most filmmaking. Rather than concealing the space of the cut, Montgomery pries it open, risking its dangers, and in the process produces new and heterodox bodies.

For the child watching and commenting on footage of Montgomery slicing and stitching the pile of stuffed animals, the recombined creatures provoke disgust and fascination (fig. 13). Through her eyes, the process of remembering is a positivist practice, a means of recognizing commonality across division, of recognition itself: "It's a little bit of cat, and a little bit lion, a little bit . . . what else? That's all. Hey! A little bit of person! Yeah, because look, we have the same skin." *Transitional Objects* contemplates various images of skins,

Figure 13. Film still from *Transitional Objects* (Jennifer Montgomery, 1999).

all of them vulnerable: the close-up and highly pixelated image of a child suckling a breast, the severed and stitched stuffed animal pelts (which Lauren Berlant observed as depicting trauma in its physical senses, both the trauma of the initial cut and the secondary form of the suture),[78] and Montgomery's own belabored attempt to splice film with her feet. "Why don't you do it with your hands?" the child asks in voiceover. "Then you won't cut yourself." Montgomery doesn't offer an answer, but the close-up display of her reddened toes suggests the value of using one's body, especially at its most feeble and vulnerable, to feel through the process of creation and to risk the dangers it entails.

In Montgomery's video, the woman's body is still subjected to the cut. Yet her overt and physical reckoning with the cut lands far from the pristine smoothness of Fincher, the editorial virtuosity of Hitchcock, and the spectacular tricks of Edison and Méliès. From the earliest splices, where escamontage covers the violent vanishing of the woman's body, film has retained an important link between women cut up (in representation) and cut out (in formal procedure). This can be seen in the thematic illustrations and the technical constructions of *Mary, Queen of Scots, Rope,* and *Gone Girl. Transitional Objects* more pointedly makes explicit what is, in these other instances, still relatively hidden. In so doing, Montgomery effectively argues that editing in *all* its guises is a cutting-out, to which women's bodies, both within and outside the space of representation, are especially vulnerable.

3

Gradivan Footsteps in the Film Archive

It was the roughly sculpted face of a woman whose calm smile startled them. . . . They spent an hour by the statue. They admired it silently and said nothing till the next day. Had they ever seen such a smile? Never! And if they did? They'd follow it.

—*JULES AND JIM* (1962)

Bill Morrison's *The Film of Her* (1996) tells the unlikely story of the survival of the Paper Print Collection at the Library of Congress, a vault of some six thousand films from between 1894 and 1912, copied onto paper. Based on interviews with Howard L. Walls, a copyright clerk employed in the 1940s, and his successor, Kemp Niver, the film fictionalizes Wall's motivations in searching through and in the process rescuing 2.5 million feet of film that had been scheduled for incineration. In a reenacted voiceover by Morrison, Walls describes how he came across the collection in 1942, when he had gone in search of an image of a woman he remembered seeing in his childhood at his grandfather's cinema. In *The Film of Her*, the film archive begins not with the founding of the collection in 1894 but with Walls's rediscovery and subsequent rescue of this earliest period of film history. "Every first you could think of was in that vault," he marvels. "The whole beginning of cinema." Its vast treasures, though, are nothing compared to "her," the woman for whom the copyright clerk desperately searches.

I have been tracking various ways in which film material production has been organized according to a gendered logic. Editing practices and laboratory procedures produce the immaterial, cinematic image of a woman by suppressing her material form, her body. As I will show in this chapter, this logic

also organizes the theoretical underpinnings of the film archive. Within this space, we see the archivist searching for a ghostly woman. As we saw elsewhere, in the archive the body of the woman has vanished, though there remain surrogate traces in marble, plaster, paper, ash, and, especially, celluloid. These material fragments, coupled with the chimerical image of "her," form the basis of the archive, an uninhabitable house of memory.

Jacques Derrida calls this woman Gradiva. She figures prominently in *Archive Fever: A Freudian Impression* (1996). Despite the book's influential place in contemporary archive studies and the extensive commentary it has received, its reliance on a model of the lost feminine has been overlooked.[1] I trace Derrida's Gradivan model back to Freud's *Delusions and Dreams* (1906), itself a reading of Wilhelm Jensen's novella *Gradiva: A Pompeiian Fancy* (1903), in which a young man is obsessed with a woman he sees in an ancient marble relief, and later as an apparition in his dreams and waking life.[2] Via his reading of Freud, I examine how Derrida's theory of the archive leans on the figure of Gradiva in its characterization of materiality. As with Jensen's story, Gradiva's traces—as a marble relief and as footsteps in the ashes—haunt Derrida's notion of the archive. But she is always already absconded, a ghostly figure that never coincides with the "real" woman in the story, Zoë Bertgang. For Derrida, the quest for the figural Gradiva drives both the construction and the destruction of the archive. While the material of the archive is a collection of these Gradivan traces, it (and Derrida) cannot admit of the female *body* which drops out of the telling.

Derrida's account is more ideological than it would seem. While he makes a footnoted reference to what he calls the "patriarchive," citing Sonia Combe's acknowledgment of a prevailing masculine orientation of the archive, his articulation of a Gradivan logic notably excludes the body of the woman.[3] His "hauntology," not typically understood in terms of gender, is shown to rely on it, not via the ghostly Gradiva who organizes the logic of the archive, but rather the flesh-and-blood woman Zoë who is all too quickly sublimated into the marble relief representing Gradiva.

Concerning the film archive, the stakes of Derrida's Gradivan logic are heightened owing to an already uneasy relation between real bodies and those that appear onscreen. As discussed in the previous chapter, the desire to "fix bodily presence on the screen" in cinema is what obsesses Walls in *The Film of Her*, and it accords also with Derrida's characterization of Gradiva.[4] Later in this chapter I demonstrate how a Gradivan pursuit persists in three films that address film archives and archival practice: *The Film of Her*, Cheryl Dunye's *The Watermelon Woman* (1996), and *When the Towel Drops, Vol. 1, Italy* (2015) by the artist collective Radha May. All three express how the material traces

suggestive of Gradiva inaugurate the representation of an enigmatic and un-
reachable woman. While *The Film of Her* is loyal to the Gradiva paradigm,
The Watermelon Woman and *When the Towel Drops* critique this logic by ex-
pressly raising the issue of the excluded woman's body. In *The Watermelon
Woman*, Dunye sends her protagonist Cheryl (played by Dunye) on a Gradi-
van search for a lost early twentieth-century Black actress, known at first as
"The Watermelon Woman" and later identified as Fae Richards, a figure lo-
cated at the complicated intersection of lesbian and Black cinematic history.
On one hand, this search for traces of a lost woman is presented as an ideal—
wouldn't it be powerful to recover such a figure? On the other hand, Dunye
sets up Cheryl for a kind of ontological failure, since the discovery of the cor-
responding flesh-and-blood woman is foreclosed from the start. Fae Richards,
however attested by "documentation" unearthed in Cheryl's quest, is an in-
vention of Dunye's film. In a sense, Dunye traps her protagonist within the
auto-inscription of an archival logic based on a constitutively absent woman.
When the Towel Drops, a collection of censored film negative from Italy's post-
war period, also does not produce a Zoë, but unlike *The Watermelon Woman*,
it does not aim to do so. Instead, it focuses on the film archive itself, revealing
the work of ideology in the archive by emphasizing the censored fragments'
materiality over the images they contain. In the prioritization of materiality
over image, my analysis of *When the Towel Drops* accords with a number of
works previously discussed in this book: Lynn Hershman Leeson's staging of
a Medusan trap for the gaze of the spectator (introduction), the woman's body
materialized for film in the China Girl reference image (chapter 1), and Jen-
nifer Montgomery's wounded feet in the construction of a film (chapter 2).
Each is a reversal of the typical manner in which images are presented and
consumed without any significant consideration of their materiality, and each,
in turn, reveals the ideological workings of a given film cultural practice.

 This chapter takes up the film archive in largely theoretical terms, with its
main emphasis on Derrida's account and the interpretations of real and fic-
tional film archives in the three films I analyze. This is neither itself archival
work nor an exhaustive survey of depictions of archives in film. These theo-
retical and filmic scenes reveal what isn't always apparent in overtly technical
and rational practices, namely the motivations of erotic desire. Alice Yaeger
Kaplan describes an "archival passion" that infuses the archival quest with the
quality of "an epic, but . . . also a dime novel, an adolescent adventure story."[5]
Such "extreme emotion," however, must be concealed, for "to reveal those
emotions would not only gum up the narrative, it would threaten its credibil-
ity."[6] I maintain that the desire and search for Gradivan figures in the film ar-
chive, along with their corresponding exclusion of female bodies, are most

readily apparent when the archive is nostalgically remembered (*The Film of Her*), mobilized to produce new archives of the previously excluded (*The Watermelon Woman*), and unpacked to lay bare its ideological assumptions (*When the Towel Drops*). The consistency of the Gradivan logic in these films suggests that the quest for Gradiva functions as an origin story for the archive. Here again, these are subtended by a gendered logic of materiality that is only latent in Derrida's account.

My investigation into the uses of Gradiva for Derrida, as articulated in works pertaining to the film archive, should be distinguished from recent scholarship in the areas of feminist, queer, critical race, postcolonial, and human rights approaches to the archive. These tend to demonstrate, and rightfully reprimand, the functioning of the archive as a locus of patrimonial, legal, and colonial power, where minoritarian experiences are lost to archival gaps, inconsistencies, and absences.[7] There has also been a significant body of literature in queer archive studies, including work by Ann Cvetkovich, Jack Halberstam, and Alana Kumbier, who both critique traditional archives and conceptualize new ones that encompass queer life, including its most ephemeral and affective traces.[8]

Whereas these studies generally take the archive itself to be their object of analysis or site of intervention, I am less concerned with what archives *are* than how they have been conceived, especially given the influence of *Archive Fever*. Despite the intense scrutiny of archives, archive theory has been far less reflexive about itself. For example, I am wary of a tendency to position the traditional archive on the side of history—and with it, a sense of melancholy, ruin, and entombment—while the so-called radical archive, in correcting the problems of the former, is envisioned as recuperative, revivifying, or even utopian. I reject the simplistic claim that visibility is the antidote to invisibility, as if merely revealing what has been hidden would be a just or satisfying reversal. And while I support efforts to construct alternative archives that are more inclusive in the diversity of experiences represented and broader in their scope (as is the implication of *The Watermelon Woman*), my view is decidedly retrospective: I aim to better understand how film archives have sustained, and been sustained by, a gendered logic of materiality.

Tracing Gradiva

To understand how Gradiva functions for and in *Archive Fever* requires tracing her steps back to Freud's study of Jensen's *Gradiva* and to the story itself.[9] When he first encountered Jensen's text, Freud had recently completed *The Interpretation of Dreams* (1900), and, finding *Gradiva* to be full of "familiar

faces" despite its being a work of fiction, he began to expand on the major ideas first presented in that earlier text.[10] Chiefly Freud examines the workings of repression: how repressed erotic desires manifest as delusion, and how such a neurosis might be cured with the analyst entering into the delusion to retrieve the patient. Freud's reading of *Gradiva* bequeaths to Derrida the terms of his own theorization-deconstruction of the archive. Derrida extends Freud's reading of repression in *Delusions and Dreams*, along with *Moses and Monotheism*, to his understanding of the structure of the archive. For Derrida, "repression is an archivization."[11] Just as the unconscious produces a structure according to the workings of repression—where certain thoughts are permissible to consciousness, while others are censored, manifest only elliptically as slips of the tongue, neuroses, dreams, and delusions—the archive is also organized according to the unconscious. This means that the archive produces "traces," "supplements," or various "exteriorizations," all of which map onto Freudian concepts. Moreover the work of repression is preservative; repression itself is an archive, a mutilated text whose revisions and gaps can be retrospectively restored. Reading Freud, Derrida observes how repression in *Moses and Monotheism* becomes a means of passing something down (for Freud the murder of Moses), and how one might then read the archive differently, in view of this repression, interpreting the signs of its traces or "impressions" as what has been preserved by the unconscious.

Before discussing Derrida's uses of the figure of Gradiva and Freud's analysis of Jensen's text, it is worth describing the plot of the story in some detail: Norbert Hanold, a young archaeologist, is taken with an ancient marble relief of a walking woman he sees in a museum in the Vatican. He names this figure "Gradiva," which means "the girl splendid in walking," and when he returns to his northern German city, he purchases a plaster cast of the relief and hangs it in his study.[12] Soon after he begins to dream about Gradiva: that she once existed as a real person, and that she lived in Pompeii, a victim of the eruption of Mount Vesuvius in AD 79. Hanold is unable to articulate precisely what compels him so strongly about this figure, and under the vague guise of professional interest (an occupation that already anticipates a quest for Gradiva's traces), he finds himself drawn to Rome, then Naples, then finally Pompeii. "Without himself knowing the motive in his heart . . . [he came] to Pompeii to see if he could here find trace of her—and that in a literal sense—for, with her unusual gait, she must have left behind in the ashes a foot-print different from all the others."[13] There, in the midday heat, he encounters a young woman who bears the same graceful gait as Gradiva, and he believes her to be a ghost. For the next several days, she returns to the same spot among the ruins, at the same time; they converse. Eventually the woman reveals that she is

in fact a childhood playmate of Hanold's: Zoë Bertgang, whose memory he had repressed. Hanold's circuitous path, studded with cryptic Gradivan traces—a marble relief, an antique metal clasp said to have belonged to a woman in Pompeii, a dream of a woman covered in ashes—eventually leads to Zoë, who at the end of the story accepts Hanold's marriage proposal.

Freud saw in Hanold's delusion and its later cure an ideal model for understanding the work of psychoanalysis. He notes a "similarity between Gradiva's procedure and the analytic method of psychotherapy."[14] Specifically, the novella provided Freud a way of understanding the mechanisms of repression that keep Hanold from consciously remembering his childhood playmate, the dreams that lead him to Pompeii, and the "transference love" that allows him to pass from his delusions of Gradiva to the flesh-and-blood Zoë.[15] (Freud's interest in Gradiva as a therapeutic model is moreover indicated by the plaster cast of the relief he acquired after reading Jensen's story, and which he hung in his office, on the wall adjacent his chaise longue, so that all of his patients would be able to gaze upon it[16] [fig. 14]). Accordingly, *Delusions and Dreams* is structured like a dream interpretation in one of Freud's case studies. Freud presents the fictional Hanold as a patient suffering from the delusion that a marble relief of a woman, a fragment of an otherwise lost original, has come to life. Rather than dismissing Hanold as a fetishist, Freud probes the source of Hanold's delusion, which he finds in the far more common mechanism of repression. This requires careful analysis of Hanold's dreams. As Freud succinctly remarks, "dreams and delusions arise from the same source—from what is repressed."[17]

Freud's dream analysis reveals that Hanold's delusions of Gradiva *"rediviva,"* or the woman come back to life, were founded in childhood, a remnant of his desire for Zoë.[18] Freud observes, for example, that Hanold's characterization of Gradiva as being Greek comes from Zoë's given name (meaning "life"), while her surname Bertgang signifies one "who steps along brilliantly," hence a translation of "Gradiva."[19] What Hanold had repressed was this desire, a "feeling which ought not to occur . . . [o]n account of a resistance to eroticism that was present in him." Hence, for Hanold, "these memories could only become operative as unconscious ones."[20] They were driven underground, so to speak, manifesting only in fragments within dreams, and only occasionally erupting into consciousness, as with Hanold's obsession over the Gradiva relief, or his recognition of her gait.

Throughout *Delusions and Dreams*, Freud is fascinated by the phantasmatic figure of Gradiva rather than the "real" woman Zoë, often collapsing the latter into the former.[21] In a certain sense, this is also the delusion afflicting Hanold. For both Hanold and Freud, Gradiva remains the figure of a lost, even

Figure 14. Freud's study in Vienna, with plaster cast of Gradiva above the foot of the couch, 1908. Courtesy of Freud Museum, London.

impossible, woman: "She accepted the role of the ghost awakened to life for a brief hour, a role for which, as she perceived, his delusion had cast her, and, by accepting the flowers of the dead which he had brought without conscious purpose, and by expressing a regret that he had not given her roses, she gently hinted in ambiguous words at the possibility of his taking up a new position."[22]

Gradiva the statue is Hanold's ideal, while the analyst-Gradiva is Freud's. She occupies the "ideal position" to both administer and be the cure owing to her ability to enter into Hanold's delusions in order to draw him out and, above all, for the way she becomes for the patient the object around which the mechanism of repression is organized.[23] Hence the conceit of Freud's reading is the analogy between Hanold's recognition of the real, beloved woman behind the delusion, and the psychoanalytic cure. To be sure, the former halts enough in Jensen's story and shudders with uncanny coincidences. For Hanold, it is "most strange" that "Bertgang" and "Gradiva" share the same ambulatory meaning, and at the novella's conclusion he implores Zoë "with a peculiar tone" to walk ahead of him so he can again admire her unusual step. In complying, she becomes "Gradiva *rediviva* Zoë Bertgang."[24]

This lingering quality of the ghostly Gradiva is also present in Freud, and we might even say he takes it up as his own mode of approach. In the final section of *Delusions and Dreams*, Freud's own lingering in delusion is symp-

tomatically expressed in his insistence on calling the physician-analyst figure "Gradiva" instead of "Zoë." This slip runs against the entire tendency of his argument, which stresses the translation out of Gradiva into "Bertgang" as parallel to the analytic cure.[25] Freud himself consistently fails to make this translation—remaining as it were within the dream-mist of misrecognition. His characterization of Gradiva as a "ghost awakened to life for a brief hour" recalls Orpheus's attempt to retrieve Eurydice from Hades. Indeed, the Gradiva story can be understood as a variant on this Greek myth. In Freud's reading of Jensen's story, the roles are reversed—here Eurydice, in the guise of Gradiva, is the one to lead Orpheus back to the living—though the outcome is similar. Gradiva, because Freud will not allow her to appear as Zoë, remains a shade, just as, with Orpheus's desperate look back, Eurydice is cast back into the underworld.

Regarding the distinction between Gradiva and Zoë, Joan Copjec takes Freud to task for an error his later theory would repair, namely referring sexual difference "to a real whose existence is prior and elsewhere—to an anatomical woman."[26] Specifically, Copjec insists *contra* Freud that in Hanold's dream "Zoë has no reality . . . until the fantasy of Gradiva constructs her."[27] For her, "the love of Hanold for Zoë" can be read against Freud "as a transference effect, a deception and not a restoration of the real."[28] As we have seen, however, Freud does *not* collapse Gradiva into Zoë as a simple restoration of "pregiven content."[29] He does not finally produce the "real" woman, but preserves the "Gradiva" appellation long after the story's recognition scene. The correction that Copjec wields against Freud is therefore already a tension in his analysis—namely, that for Hanold, Zoë exists prior to and conditions his obsession with Gradiva, while for *Freud himself,* Zoë is partially absorbed into his fantasy of the ideal analyst. But Zoë is both someone who possesses her own reality—and by extension a material body—and who is also constructed out of the chimerical image of Gradiva. In terms of Derrida's theory of the archive, it is essential to apply Copjec's insight that the endeavor to restore the content of a prior, nonconstructed presence is, within the field of knowledge, always already a game of hide-and-seek with a lost woman.

Gradiva is key to Derrida's conceptualization of the archive. Yet while Derrida's work on archive theory has been widely influential, the centrality of Gradiva, which is to say *Archive Fever*'s dependence on an obscure German romance, has gone unacknowledged by most commentators. In *Archive Fever,* Gradiva—not the novella, but the elusive woman within it—unites the analogous structure between the archive and repression and also leads the way to the archive's annihilation. *Archive Fever*'s postscript begins with Derrida's

admission that, "]or more than twenty years, each time I've returned to Na-
ples, I've thought of her."[30] For him, Gradiva is a figure of the archive, but a
troubled one. Though she is the element that repression preserves, she also
introduces, on Derrida's reading, a destructive force that threatens to obliter-
ate the archive entirely. She exemplifies the *mal d'archive* from which Hanold
suffers; Gradiva is the sickness itself. Against the preservative function of re-
pression that constructs an archive in Freud, Derrida also sees in Gradiva the
force of annihilation.

Here a refrain emerges. Once again, the absence of a woman is shown to
be constructive for a cultural practice. In the archive, this woman is epitomized
by Gradiva, a figure that links ghostly image with nonbodily material traces.
Both of these aspects of Gradiva, however, miss the woman's body, which is
manifest in Zoë. The absence of Zoë maintains the presence, albeit unstable,
of the spectral Gradiva. This is in turn productive for both Freud and Der-
rida: Freud is able to imagine the perfect analyst, while Derrida works through
his own deconstruction of the archive. Hence, within Derrida's theory, the ar-
chive is founded on a gendered logic that requires an always partial and there-
fore partially missing female figure to rationalize its existence. On one hand,
Gradiva animates both Freud and Derrida's accounts; on the other, the "real"
woman Zoë poses a difficulty neither can reconcile, much less admit. While
Freud circumvents her by envisioning the dismantling of delusion (what Der-
rida would read as an archive of repression) through the idealized therapeutic
cure, Derrida completely avoids Hanold's recognition of Zoë.

For Derrida, the archive preserves as it conceals. Gradiva allows him to iden-
tify an additional force at work: the death drive that threatens to destroy the
archive entirely. He describes it first as a desire *for* the archive. "It is to have a
compulsive, repetitive, and nostalgic desire for the archive, an irrepressible de-
sire to return to the origin, a homesickness."[31]

This is the archival desire, turned to illness, manifest in Hanold's obsessive
desire to find Gradiva. On Derrida's reading, Freud too suffered from archive
fever, which Derrida (inadvertently echoing Kracauer) attributes to a general-
ized condition in response to the "great holocaustic tragedies of our modern
history and historiography."[32] In such examples, archive fever is a desire for the
archive that threatens to annihilate it. It destroys the preservative work of re-
pression, which keeps such a desire at bay.

Why does Derrida ignore the second half of Jensen's story, when Gradiva-
Zoë reveals herself to be Zoë Bertgang? Why, in the moment Zoë emerges as
"real," does he turn away? In the sole mention he makes of Zoë, she is only
"phantasm or a specter"; she is a ghostly figure that haunts *Freud*. As for his
own reading of Jensen, Derrida seems caught in an earlier moment in the no-

vella, when Hanold both seeks and dreads physical confirmation of Gradiva: "The corporeal existence of the hand would thrill him with horror, and its lack of substance would cause him deep pain."[33] The Hanold Derrida focuses on is forever dreaming of Gradiva coming to life, yearning for a ghostly presence built on material, although displaced, traces of her body. In maintaining this image of Gradiva, Derrida is able to conjure the destructive force of archive fever. He describes it as a desire for the moment of impression, which is to say, the pre-Pompeiian moment when Gradiva was *last* a body of flesh and blood, before she turned to ash, and was later remade in marble and plaster.[34] As a house of memory, Derrida's conception of the archive cannot allow for living beings, though archaeologists and analysts—dreamers all—are always seeking them. Hanold's (re)union with Zoë cannot be gratified, as life (*zōē*) is ultimately incompatible with Derrida's notion of the archive. Instead, it must eternally burn with the ghost of Gradiva. This is the unacknowledged logic of gender that underlies Derrida's theory: not the chimerical image, but a "real" woman whose exclusion from the archive maintains its structuring hauntology.

How does Gradiva become the figure of archive fever? Derrida drives to the place where the archival construction turns on itself in an act of auto-destruction; where, in other words, archive fever burns. His other examples are the murder of Moses both censored and preserved in the biblical text of Exodus, and the logic of circumcision, a means of storing and transmitting Jewish knowledge.[35] According to the operation of deconstruction, Derrida sees a contradiction that runs through Freud's work, and he expresses this most pointedly in Gradiva's imagined footstep.[36] This "place of origin," where the impression is still connected to the imprint, is where her foot touches the ash-covered ground.[37] In other words, it is the index of the woman's body, though this is a body that, in Hanold's first dream of Gradiva, is already being turned into a statue. Here the desire for the woman that underlies archive fever is most palpable, fixed to the moment where her body disappears, transformed twice over, first in sculptural facsimile, then to ghostly image.

Archaeologists (and here Derrida characterizes Freud as an archaeologist trying to outdo Hanold) often "dream" of such a place: "this irreplaceable place, the very ash, where the singular imprint, like a signature, barely distinguishes itself from the impression."[38] On Derrida's reading, neither Hanold nor Freud are ultimately interested in the displaced traces of Gradiva, her marble relief or otherwise, but rather the phantasmatic idea (or we could say image) of the woman, brought back to life (*rediviva*) as a "mid-day ghost."[39] As a result, they feverishly seek this particular impression, "when the step is still one with the subjectile."[40] This is anarchivic because it collapses what comes

after the impression, which is memory and the archive. The exteriority cru-
cial to the existence of the archive, the unconscious, collapses because there
is no longer a distinction to be made between impression and imprint.

Derrida parses materiality in terms of the archive's structure of spectral ap-
parition founded on physical traces. Even more than Freud, he maintains the
spectral ambiguity of the Gradiva who appears to Hanold. She is a woman who
can only be dreamt. Materiality passes into the metaphysical, which for Der-
rida is the realm of the spectral, and hence in the archive things are "neither
present nor absent 'in the flesh.'"[41] The ghostly Gradiva carries with her a se-
cret, which Derrida calls "the very ash of the archive."[42] Ash is not only the
beginning of the archive, created by Gradiva's Pompeiian tread, but it also
marks the destruction of the archive, where its secrets are burned in order to
be kept secret.[43] Ash is not merely a material substance, but the destroyed rem-
nant of another; at the end of the book, there is not even ash to recall the de-
structive force of archive fever. We are left "without a name, without the least
symptom, and without even an ash."[44]

With these readings of Freud and Derrida, I observe a similarity with my
interpretations of Hal Foster, W. J. T. Mitchell, and Siegfried Kracauer, whose
theories of art and film, as I argue in the introduction, project as an origin of
art a productive otherness localized in an image that is always cut off, some-
times literally, from a gendered body. Each of their accounts depends on the
concealment of the woman's body in order to privilege the conquest and ap-
propriation of the dematerialized (because partial, displaced, or otherwise
abstracted) image. By maintaining the identity of Gradiva—not Zoë—as the
perfect analyst, Freud does not allow the flesh-and-blood woman to fully enter
his account. Derrida, meanwhile, uses materiality—the "literal traces"—to
explicate the deconstructive causality of archive fever.[45] This is consistent
with his broader tendency to dissolve materiality into a play of textual and
signifying traces. Yet Derrida's account is especially difficult to square with
the events of the novella. With the revelation of Zoë's identity, Gradiva's con-
clusion forestalls deconstruction. This archive doesn't burn, because there are
no secrets to destroy. The crucial one, the truth of Hanold's delusion, is re-
vealed with the arrival of Zoë. Instead of ashes, he is joined with life.

Neither Freud nor Derrida can escape the constitutive pathos in their ac-
counts, both of which are anchored in fantasies of Gradiva. While Freud sum-
mons a fantastical analyst-Gradiva to make sense of and to finally cut a path
through the dreamer's unconscious, Derrida admits of only the ghostly Grad-
iva. By rejecting the body of the woman as figured by Zoë, he consigns the
archaeologist ever deeper into the archive until his passion consumes it en-
tirely. Though Derrida does not acknowledge the gendering of materiality in his

own account, he nevertheless reinforces a gendered understanding of the archive as one fueled by desire for a lost feminine and built on repression. By keeping the woman's body, which is Zoë herself, from appearing, the woman remains concealed despite the archive's emphasis on her (displaced) material remains. As I discuss in the following section, this same procedure can be found in *The Film of Her*, which stages the play of these forces in the film archive. I conclude with readings of two feminist projects, *The Watermelon Woman* and *When the Towel Drops*, which critically expose this gendered dynamic to envision, at least provisionally, a different model of archival practice.

Women in the Film Archive

The film archive would seem especially vulnerable—literally—to the destructive forces described in Derrida's archive fever. Fire has long been a danger, as nitrate holdings, which are highly flammable, have always been a challenge to manage and store. Even without incidents of spectacular destruction, the materials of the film archive are prone to disappearance and decay. Nitrate is highly combustible and also chemically unstable, and if not stored properly it is prone to rapid decomposition. Given that most films were made on nitrate stock until the 1940s, the threat of a vanished history of film was a serious one.[46] In 1951, the International Federation of Film Archives (FIAF) advocated for the transfer of nitrate films to the newly available acetate-based safety stock. In another historical reversal, safety motion picture film later came into its own crisis with the 1980s discovery of "vinegar syndrome" that accelerated the decomposition of acetate. Once again, this resulted in newly urgent efforts to rescue the history of motion pictures, this time with polyester stocks developed in the late 1990s and, more recently, digital video formats.[47]

Compared with other types of material holdings such as books, manuscripts, and art objects, film is exceptionally fragile. Its storage requires a tightly controlled environment to regulate temperature and humidity, and even under optimal conditions (freezing and dry), a film will still undergo deterioration. Many films enter archives already afflicted with discoloration, distortion, and delamination, and the archivist can at best slow down the rate of decay.[48] Films in the archive tend to be viewed from the perspective of their vulnerability and need for rescue against the onslaught of time and neglect. Such an attitude is embedded in the mission of film archives generally. The rhetoric of a soon-to-be lost history of film has subtended film archives since their founding during a moment of crisis in the 1930s, when many people took the introduction of sound as a sign of the imminent extinction of extant silent films. Thomas Elsaesser observes, "the film archive was itself born of contradictory

impulses," on one hand the acknowledgment of irrecoverable loss, and on the other the recognition of existing materials in need of saving.[49] Hence, archives— such as the Svenska Filmsamfundet (the first film archive, founded in 1933 in Stockholm), the Reichsfilmarchiv (Berlin, 1934), the Museum of Modern Art (New York, 1935), the National Film Library (London, 1935), the Cinémathèque Française (Paris, 1936), FIAF (New York, 1938), and similar organizations— have been organized around the assumption that the materials of film history are vanishing rapidly, and that what remains must be assiduously collected and preserved.[50] Their view is that their intervention is "too late," as so much of film history has already been lost. It is estimated, for example, that 50 percent of films prior to 1951 have been lost or destroyed, and up to 80 percent of films made during the silent era (1894–1930) are gone.[51] Even the celebrated Paper Print Collection featured in *The Film of Her* is, at most, a record of loss, hav- ing entered the Library of Congress as poor facsimiles of nitrate originals. Given such absences, no complete picture of film history can be hoped for. Neither is there a perfectly stable preservation medium to turn to, nor even an archive that does not encounter challenges with its own survival and sup- port. Instead every archive is an ongoing reckoning with the past that is al- ways already slipping away.

The pervading awareness of what has been lost can also be productive. In Derrida's theory, the loss of Gradiva is what constructs the archive, and in a similar vein Paolo Cherchi Usai has asserted that the gaps in the film archive are what produce the medium's history. Because the sum total of films made is too vast for any individual to comprehend, the narrowing of available films, through physical decay and historical contingency, is what allows a picture of film history to emerge. "The destruction of moving images [is what] makes film history possible."[52] Usai extends this constitutive loss to the medium's on- tology: film's essence, he argues, is "by nature auto-destructive . . . [c]hemi- cally unstable, mechanically damaged by each run through a projector, film dies while living."[53] This material destiny of film, in addition to intrinsic ag- ing and decay, is to have this process accelerated with each act of its viewing. To look is to destroy. This is an unexpected reversal of the Medusa myth, where here it is Perseus whose gaze gradually kills the gorgon.

The conceptualization of the archive advanced by Derrida can be exam- ined against the use of the film archive in a number of experimental films. As we have seen, experimental film occupies a privileged position vis-à-vis film materiality in other sites of film cultural practice. Among these, the film ar- chive is especially prominent as both a source of raw material for compilation or found footage work and as an institutional site of investigation, particularly where it concerns the audiovisual organization of history. Because avant-garde

works are already attentive to the historical film record as such, namely as a material, ideological, and constructed object, their approach to the archive is likewise informed by this material and historiographical criticality. Rather than taking for granted that the archive is a repository of historical knowledge, their works begin from the understanding that the history produced by the film archive, much like films themselves, is *constructed* via dialogism, combination and juxtaposition (as with montage), and material remains that do or do not survive.[54] Experimental films frequently produce their own, alternative archives, including those of a parallel or subterranean history (such as Esfir Shub's *The Fall of the Romanov Dynasty* [1927], Eyal Sivan's *The Specialist* [1999], and Phil Solomon's *American Falls* [2010]); imaginative insertions into gap-riddled records (Rea Tajiri's *History and Memory: For Akiko and Takashige* [1991] and Rithy Panh's *The Missing Picture* [2014]); pointed critiques of official discourse (Craig Baldwin's *Tribulation 99: Alien Anomalies Under America* [1992]); lyrical, psychosexual reveries (Bruce Conner's *Take the 5:10 to Dreamland* [1976] and Lewis Klahr's *The Pharoah's Belt* [1993]); exuberant, even utopian visions (Hollis Frampton's *Gloria!* [1979] and Jodie Mack's *Dusty Stacks of Mom: The Poster Project* [2012]); and, most pertinent to this book, alternative accounts for the origins of film (Bruce Conner's *A Movie* [1958], Morrison's *The Film of Her* and *Decasia* [2002], and Gustav Deutch's *Film ist. a Girl & a Gun* [2009]).[55] Made in response to dominant historical narratives, whether official, publicly sanctioned accounts or commercially widespread ones disseminated through Hollywood films, these alternative archives are explicitly marginal, sometimes personal, and frequently "minor" in Tom Gunning's Deleuze and Guattari–inflected sense of the word.[56] Hence experimental film's stake in the film archive is not merely an extension of its modernist auto-investigation, but a crucial site where its own position on the edges of mainstream culture and politics becomes a privileged vantage for critical reflection and revisionist speculation. In the film archives of experimental film, history is directly contested and created. As we saw with Derrida, the logic of the archive's organization can be understood in terms of a ghostly Gradiva and a vanished Zoë, and this structure is affirmed in three films to which I now turn: *The Film of Her, The Watermelon Woman,* and *When the Towel Drops.* Each produces an image of the film archive that recapitulates the material stakes of the Gradiva/Zoë divide: a woman whose chimerical image and displaced, nonbodily material remains motivate the construction (and rescue, in the case of *The Film of Her*) of the archive and a physical presence that must be suppressed in order to do so. While *The Film of Her* illustrates the heightened stakes of materiality for the *film* archive especially, *The Watermelon Woman* and *When the Towel Drops* offer critical reflection on the ideological limitations of the

Gradivan model, including the queer of color figures missing in the archive (*The Watermelon Woman*) and the fetishizing structure of censorship (*When the Towel Drops*).

In *The Film of Her*, film history is produced and rescued by virtue of the copyright clerk's Gradivan quest. This accords with Usai's assertion of film's inevitable destruction both as ontological fact and film historical necessity. If, as Usai writes, "the ultimate goal of film history is an account of its own disappearance or its transformation into another entity," Walls (and Morrison) also recognize that our history of early film, as contained within the Paper Print Collection, was constituted out of destruction.[57] Though Walls managed to save the collection from its planned incineration, the original 35 mm films were already gone, copied over to paper. The historical irony of the collection, Niver later observed, was that these earliest films fared better than the transitional period films made after 1912. When in 1912 the Library of Congress began accepting film prints for copyright, it also deemed nitrate too dangerous to keep, so for many decades it took only synopses and related materials for films. Those original film materials have by and large been lost or destroyed.[58] Following Usai's claim, the unlikely survival of the Paper Print Collection, and the demise of the period that followed, shows the extent to which film history is constructed out of the contingency of its always eroding materials.

The film follows Walls's search for "her," a woman he glimpsed in a stag film as a boy, which leads him deep within the Library of Congress. There he comes across the Paper Print Collection, and his rediscovery of the vault comes none too soon. As he tells it, the collection was slated for destruction the very next day. The head librarian recognizes the value of the collection and commends Walls's work, promoting him from lowly copyright clerk to "curator," and putting him in charge of preservation. Walls continues looking for "her" within the collection, and he finally finds her in a stag film, a young nude woman smiling at the camera.[59] Many years later, Walls is laid off, no longer important or even remembered by the time an Academy Award is given to Niver for his preservation work on the collection. Walls, now an old man, reflects on his accomplishments, chief of which was not his crucial intervention into the Paper Print Collection—but his recovery of "her": "She'd still be stored on some shelf somewhere, waiting to be called up. To be born again."

Walls's voiceover recollection, as well as that of another, third person narrator, plays over clips from the Paper Print Collection. The footage is both evocative of and directly related to Walls's story, as when the second narrator's musing that the paper facsimiles "are all fossils of an extinct species" is paired with the

climactic, tragic collapse of Topsy in Thomas Edison's *Electrocuting an Elephant* (1903). With the image of "her," repeated several times and in slowed motion, we see as Walls sees, fixing his gaze upon the object of his quest.

The search for "her" is inextricable in this cinematic recollection from the archive in which she resides. Morrison notes that in interviews, Walls was vague in providing reasons for why he went looking for the collection, so he invented Walls's motive.[60] The material—its threatened destruction into ashes and its preservation by love—is as if brought into being by the search for a constitutively absent woman. What is interesting from our perspective is the degree to which the institution of the archive counts as finding "her." The fetishized "missing" material—the Paper Print Collection—is equated with "her," the image of an anonymous woman presumably to be found among the paper rolls. In this way, Walls is like Hanold, seeking a chimerical woman whose traces are displaced onto other media. Where for Hanold it is the marble relief of Gradiva modeled "from life," and for Derrida it is the imprint of her footstep, for Walls it is the paper roll that serves as index of the vanished woman's presence.[61] As with Gradiva, "she" is simultaneously in the archive and presented as the motivation for it; for Walls, and by extension everyone else, the collection would not exist without "her."

When Walls finds "her," his joy is tinged with melancholy. The narrator observes: "She is frozen in time. He wants only to restore her to the present time. . . . She is every bit as lovely as he had remembered." Here, at last, is "Gradiva *rediviva*," a strip of footage that promises a restoration of the past. As with the apparition of Gradiva in modern day Pompeii, Walls wishes to fix this woman in the present, to allow her to be "born" through the retrieval, duplication, and projection of her image. But this is all she can be: an image. As Walls rephotographs the image according to his desire to see her, he is rehearsing the work of all film archivists to recopy the film image onto different media. Beginning with the earliest collection of film, a transfer onto paper, and now with digital copies, Walls becomes just another step in an unending process to replace the image with facsimile versions.

I emphasize the material of paper because it presents a limit to the fantasies of projection that can inhere in the film archive. In his incisive critique of what he calls "gendered matter" in *The Film of Her* (fig. 15), Paul Flaig also follows the Gradivan trail to Walls's conquest of "her," but, because the status of the image is for him indeterminate, he consequently falls into a familiar Gradivan trap, namely the promise of utopian recovery: the "oceanic feeling of rediscovery."[62] When Walls finally finds "her," presumably within the Paper Print Collection, Flaig asserts that "this image has no consistency, being

Figure 15. Film still from *The Film of Her* (Bill Morrison, 1996).

equal parts dream, paper print, celluloid copy, and mortal body."[63] Perhaps for the delirious copy clerk this is true, but as material, the filmstrip's existence is straightforwardly presented. It is first found as a presumably paper artifact (even if the young Walls originally saw her on a movie screen, and Morrison sourced the footage from a stag film), is later rephotographed on celluloid, and finally rests on a shelf "restoring . . . waiting to be called up, to be born again." As Walls encounters "her," she is *only* paper, and not yet celluloid copy. This distinction is important because the latter is the basis of psychoanalytic projection, a process that Flaig identifies as "proto-cinematic."[64] The archive's mode of looking, however, is precisely not projective. The image is an inert object, not luminous or fleeting, but held in place so that it can be scrutinized under a loupe. The fantasy of "patriarchal projection," in which these terms become coextensive, and "utopia . . . is figured as female body, insulated from time's ruin or masculine holding," is mere fantasy, because Flaig's emphasis on this psychoanalytic concept misses the crucial materiality of the Paper Print Collection as artifacts that literally cannot be projected.[65] Through projection, the woman in the film would be able to escape what would seem to be an in-evitable material destiny, where "all tension between past and present, origin and copy dissolves, so that the stag film actress is forever 'restoring' and 'wait-

ing,' never decaying, never dying."[66] But transferred to flat, opaque paper, *this* image, the image of "her," can only decay and die.

This is why, however gratifying, the reanimated image can never measure up to Walls's boyhood memory of seeing "her" for the first time. (Even in that first instance, she was never quite there; we would do well to remember Chris Marker's description of how, during a screening, roughly half of the time is spent in the dark on account of the shutter.[67]) She is the impossible ideal for Walls, ideal because she is impossible. To suggest that she is a mediatized Galatea, the film cuts several times to Georges Méliès's trick film *Le Portrait spirite* (1903), in which the image of a woman on a large paper roll is transformed into a fully embodied one that can take the magician's hand and walk off stage. But the process of making "her" move again is not tantamount to bestowing life, and it is at best only an illusion.[68] As much as Walls might wish it, there is no "real" woman to emerge from the strip of film. On this crucial point, Morrison's compilation strategy departs from its mostly illustrative function in the rest of the film. Here it signifies on two levels: While the Méliès images are responding to Walls's telling of his experience, they show us what Walls desires but can never have. The paper roll echoes the 35 mm film on which "she" is found, but Méliès's film produces quite a different result than the one Walls may have been hoping for. The magic trick succeeds in conjuring a "Zoë," a flesh-and-blood woman, whereas the archive can only ever transpose a series of frozen "Gradivas." In this, Morrison displays a melancholic self-awareness that Walls's quest can never be completed, because there never was nor could there ever be a Zoë.

The Watermelon Woman would seem to turn the Gradivan logic of the film archive on its head in two ways: First, instead of the white, heterosexual desiring subject, it is centered on Cheryl (played by Dunye), a Black lesbian researcher-filmmaker. Second, it invents its own Gradiva figure in the made-up "historical" character of the eponymous Watermelon Woman, Fae Richards (also called Faith Richardson). Fae is played by Lisa Marie Bronson, and all films and photographs of her were staged by Dunye and artist Zoe Leonard, though the film does not disclose this artifice until a final title before the end credits: "Sometimes you have to create your own history. The Watermelon Woman is fiction. Cheryl Dunye, 1996."

The film, part indie comedy, part (fake) documentary, depicts Cheryl's search for Fae, a Black lesbian actress who played "mammy" roles in Hollywood films from the 1920s to 1940s. Cheryl is an aspiring filmmaker who wants to make films about Black women because, as she tells the camera, "our stories have never been told." She works as a video store clerk, and there she comes

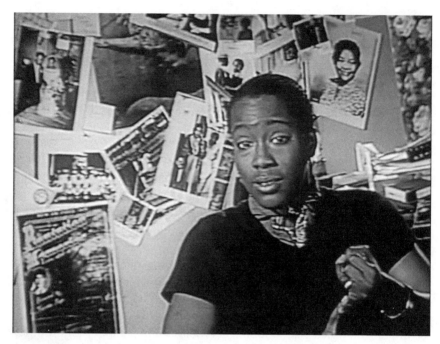

Figure 16. Film still from *The Watermelon Woman* (Cheryl Dunye, 1996). Copyright Dancing Girl Productions, 1996/13th Gen, 2016.

across a woman simply credited as "The Watermelon Woman" in *Plantation Memories*, a race film from the 1930s. This begins her twinned quests of making a film and uncovering all she can about the Watermelon Woman. She conducts her research at a library, a grassroots lesbian archive, and in interviews with a film collector, a professor, Fae's white lover's sister, and finally Fae's last partner June Walker (the latter in a series of correspondences). While Cheryl assembles fragments of Fae's life on and offscreen, her personal life unravels, and she alienates both her closest friend Tamara and her white girlfriend Diana. The film concludes with Cheryl sitting alone, presenting the fruits of her labors: a brief documentary about the Watermelon Woman (fig. 16).

The scholarly literature on *The Watermelon Woman* has generally emphasized the way the film functions as critique, specifically a queer of color critique (to borrow Roderick A. Ferguson's term) that exposes the ideological gaps in the official record.[69] Though Fae never existed, she very well could have—such a figure would have likely fallen through the archival cracks, just so. In an interview, Dunye noted that, while she found archives pertaining to Black women in film, on one hand, and collections on histories of Black lesbians, on the other, she could not find any material where the two areas overlapped.[70]

Scholars have frequently taken the position that the film renders visible what has been excluded.[71] Because both terms—Black and lesbian—have been deemed of marginal significance to film history, they have not been given serious archival attention. Seen as an important corrective, *The Watermelon Woman* has been celebrated in queer archive studies for expressing the imaginative possibilities of alternative or counter-archives.[72]

The film's critique of archives from the perspective of a Black lesbian filmmaker would seem to have as its target the normative, nonqueered model of the sort that Derrida is theorizing (even though the film does not directly address *Archive Fever*). Its critical gesture, however, is blunted by the film's abiding adherence to the Gradivan model. In order to significantly depart from Derrida's framing of the archive as the inscription of the ever-elusive nonpresence of Gradiva, Cheryl, the feminist researcher from "outside" the space of cultural self-inscription, would have to find Zoë, the actual woman, at the end of her quest. But in Dunye's film, Fae remains the elusive Gradiva, a chimerical vision in and of the archive. Dunye's interest is revealed at the end to have been Gradivan all along, in the following sense: Because Fae never existed, there was no possibility of a Zoë popping up in the research. The point of Fae was just to be a *beyond*, an inaccessible horizon, of whom one can only locate or fabricate impressions, traces, recollections. In other words, Fae is set up from the outset precisely to be a Gradiva, rather than a recoverable flesh-and-blood woman. The requisite conjuring up of a loss, on one hand, and a projective community, with its interpellations and exhortations to remember rightly, on the other hand, follow from the archive fever set up around this memorious Gradiva figure.

The outcome is that Cheryl locates herself both inside the archiving project and outside of it. Inside, because she produces a "Fae," an impression recalled from the past, who very closely resembles Cheryl: Black, lesbian, from Philadelphia, and above all interested in film.[73] Instead of Zoë, Cheryl finds only an illusion: *herself* imagined as Fae *rediviva*, staring into the flat mirror of Narcissus. But Cheryl remains also on the outside of the archive project, because by the end of the film she has distanced herself from everyone around her. In the various accounts of Fae's life, there are three sides—lesbian, Black, filmic—which compete to arrange her story in a neater way than the "real" Fae's life will allow.[74] Cheryl ends by apparently disappointing everyone. In this sense, because the factitious reality of Fae is not positioned as being able to "cure" Cheryl's obsession, Dunye stands outside of her character's Gradivan quest, revealed as Cheryl's search for herself.

This ambivalent rhetorical positioning of the director's desire vis-à-vis the character/narrator renders *Watermelon Woman* more psychologically complex

than it has been taken to be. Cheryl, the character, seems oblivious to her de-
sire to use a certain version of Fae in order to ennoble herself as a filmmaker.
Dunye, meanwhile, stages an internal conflict by pitting the made-up charac-
ter of Fae-for-Cheryl (attested in her documentary plenitude) against the evoca-
tion of irrecoverable and contentious aspects of Fae. By not participating in
Cheryl's self-actualization as a Black lesbian filmmaker, this unrecovered Fae
complicates the ready political work scholars have attributed to the film—
namely, by showing how "making visible" previously invisible historical sub-
jects, as Cheryl understands her own project, still can occlude or limit those
that it seeks to reveal.

The prevailing Gradivan logic of the archive—evident in Derrida, reproduced
in *The Film of Her,* and critiqued through its exhaustion in *The Watermelon
Woman*—anchors the film archive in a phantasmatic image of a woman who
is associated with displaced and fragmented material traces. These remains
are always imagined as being in a state of decay, whether a remnant of a mar-
ble relief, a reel of decomposing celluloid, paper rolls, a stack of photographs,
or the haunting motif of ash, all of which are regarded as especially fragile
and in need of rescue by the archivist. What the archivist does not recognize
is the way the body of the woman—the living Zoë—is excluded, and the ex-
tent to which this exclusion is itself constitutive of and incites archival pas-
sion. In Derrida's theory, the archive only exists to hold and preserve Gradiva's
precious traces. This means its rationale would be destroyed were Zoë, the
living presence and origin of the archive, allowed within its walls.
 This schema—the fetishization of the ghostly Gradiva and the subsequent
denial of the flesh-and-blood Zoë—is the subject of Radha May's multimedia
project *When the Towel Drops,* which examines women, film, and state cen-
sorship by using materials taken from film censorship archives.[75] Its first and
so far only completed iteration, *When the Towel Drops, Vol. 1, Italy,* takes as its
case study the national censorship archive of Italy, which is housed at the
Cineteca of Bologna and the Cineteca Nazionale in Rome. Within the Ital-
ian volume, *When the Towel Drops* comprises a 35 mm film installation exhib-
ited at the Granoff Center for the Creative Arts at Brown University (2015); a
digital, single channel version as "What Can Be Seen" shown at the Spring/
Break Art Show in New York (2018); a zine that includes translated and ex-
cerpted censorship documents; "Labor of Love," a "WikiStorm performance"
in Brooklyn (2015)[76]; and a screening and performance where censorship
documents are read aloud by female audience members over animated GIF
versions of the censored film clips (this has occurred twice, the first in 2016 at
Fabrica Del Vapore, Milan, and the second in 2017 at UnionDocs in Brook-

lyn, New York). Each iteration either makes use of the censored clips from the roughly 60 films scanned from the Bologna archive (as in the case of the compilation used in the screenings and performances), selections from the official censorship records (WikiStorm), or both. I focus my analysis on the Italian volume's first and so far most elaborate iteration, the installation exhibited at the Granoff Center. There, Radha May strung together the censored film clips into a single 35 mm reel and used the gallery space to critique and alter their institutional mode of display and encounter. By changing the structure of the film's viewing environment and the circulation of its movement, the artists exposed the structure of desire operative in the Gradivan quest. *When the Towel Drops* showed not only these fetishized images, but the manner in which they are seen, which is to say, as *only* image or trace, to the exclusion of the woman's body.

Most of the footage held in the Italian censorship archive depicts women figured as objects of heterosexual male sexual desire. Though this is not exclusively the case—other parts of the collection contain footage deemed blasphemous, overly violent, or otherwise objectionable to the country's dominant Catholic sensibilities—the majority of images contain women, including instances where female desire, self-awareness, and pleasure are expressed. *When the Towel Drops* depicts, among other scenarios: an opening shot of two nurses attending an apparently difficult birth, seen from below; men photographing nude or semi-nude women; two women caressing each other; women stripping in front of wide-eyed men; an array of women performing primitive or exotic dances; men chasing and undressing women; breast-baring and fondling; women thrown onto their backs in beds, leaves, dirt, or hay; sex, mostly in the missionary position, and on two occasions among lesbians; and finally, a stunning, nearly thirty-second shot of a masturbating woman, its low angle camera matching that of the first shot (fig. 17). These images, marked as "offensive to decency and morality," were deemed unfit and therefore unallowable for public consumption.[77]

While the holdings of the Italian archive date back to 1913 (official film censorship in Italy began in 1907) and extend to the present day, *When the Towel Drops* focuses on the immediate postwar years up to the cultural tumult of the late 1960s, a time during which the onscreen image of women dramatically changed due to the shift from Catholic conservatism to countercultural rebellion. During these decades, the Movie Reviewing Commission (Commissione per la Revisione Cinematografica), under the authority of the Ministry of Tourism and Entertainment, examined and selectively censored every film made or released in Italy.[78] For foreign imports such as Jean-Luc Godard's *Breathless* (1960), this meant that the Italian release version would differ from

Figure 17. Film still (from *Inga*, directed by Joseph W. Sarno, 1968) from Radha May, *When the Towel Drops, Vol. 1, Italy* (2012). Detail of the 35 mm film installation. Granoff Center for the Creative Arts, Brown University, Providence, Rhode Island, 2015. Courtesy of the artists.

those shown elsewhere, whether through excised scenes or, aided by the practice of dubbing all foreign films in Italy, altered dialogue.[79] Italian films, meanwhile, were censored by the Moving Reviewing Commission, with stretches of negative, sometimes whole scenes, removed before the films were exported. This means that there are segments of films made in Italy during this period, including towering works of art cinema like Michelangelo Antonioni's *La Notte* (1961) and Pier Paolo Pasolini's *Accattone* (1961), that have never been screened

Figure 18. Installation view of Radha May, *When the Towel Drops, Vol. 1, Italy* (2015). Granoff Center for the Creative Arts, Brown University, Providence, Rhode Island. Courtesy of the artists.

publicly. Put simply, the films that have achieved worldwide fame are not exactly the ones that were originally made.

The Italian censorship holdings were moved to Bologna in the mid-1990s. These materials, including 6,000 full-length films (with 1,300 Italian productions), 2,100 clippings of censored footage, and accompanying dossiers pertaining to visas required for domestic exhibition, had previously been held at the Ministry offices. Owing to issues of space (not unlike the Paper Print Collection at the Library of Congress), the Ministry elected to transfer the massive collection to the Bologna and Rome archives. These facilities took considerable steps to organize the collection, including digitizing the paper records and some of the film clips for the online database www.cinecensura.com. The holdings are far from complete: most dossiers for films released between 1913 and 1943 had already been discarded, and Anna Fiaccarini, an archivist at the Bologna facility, confirmed that many of the censored film clippings had likewise been destroyed.

At the Granoff, the roughly nine hundred feet of edited 35 mm film was strung together in a long loop that ran up and down along the open plan gallery walls (fig. 18). On the second floor of the gallery, in a small alcove, the loop was wound through a rear-projection system. The image was visible on a

small screen (16 × 13.5 inches) roughly corresponding to the size of a Moviola viewer.

The work problematizes the viewing of the censored footage. Similar to the first chapter's discussion of the problems associated with viewing China Girls in experimental film, it addresses the manner of seeing itself by presenting two modes by which the censored footage can be viewed. The first is the small rear-projected screen through which the images pass. Here the images can be apprehended in the transparent manner typical of regular film viewing. Additionally, this mode has a historical association, as the Moviola was likely the tool originally used by Italian censors to analyze films. As Radha May has explained, the scale of the projection was limited to keep it consistent with the viewing history of these fragments, which have never before screened publicly.[80] Like the kinetoscope, the viewing device is decidedly small-scale and private.

Meanwhile, in the rest of the gallery, the constantly circulating film effectively turns the space of the gallery into a giant projector. As this is still, in effect, a kind of cinema, the expectation that one will see some kind of moving image remains, even if redirected. Instead of the typical architecture of a cinema, where the viewer trains her attention on the screen in front of her, she additionally sees what is normally kept hidden, which is the mechanism of projection. Beyond the installation practice of placing the projector in the room as in the case of, say, the monumental 35 mm looper in Rosa Barba's *Bending to Earth* (2015), here the projection apparatus surrounds the viewer. She is positioned within it, rather than in front of or beside it. (In Barba's work, the massive platform in the center of the space forces the viewer to walk around it, as it obstructs the view of the gallery walls from most angles.) Watching the act of projection, rather than the result of it, the viewer sees the filmstrip speeding by. It moves too quickly for its own moving image to be viewed. The acetate strip is *visible*, but not *viewable*. In other words, what the viewer sees is *material* rather than *image*.

Here, the task of compiling excised footage is not a simple restoration of visibility to or representation of female figures that have been excluded. As I have argued elsewhere in this book, the revelation of a previously hidden image is usually an inadequate gesture. Following Keeling's critique of the political work that the category of "black lesbian" has been presumed to accomplish, this exposing maneuver often reproduces the problem it seeks to resolve. Were it a mere compilation of censored fragments, the work could easily become itself a fetish object; it would be no different from the Brigitte Bardot tapes that a former archivist allegedly stole and presumably enjoyed for his own pleasure.[81] Instead, *When the Towel Drops* distinguishes itself from

queer and feminist projects that seek to expose the archive's gaps by directing
its attention away from the Gradivan figures that haunt its fringes, focusing
instead on the structures and conditions by which certain images of women
have been fetishized. In terms of Gradiva, and unlike Derrida's theory of the
archive, *The Film of Her*, and even *The Watermelon Woman*, *When the Towel
Drops* does not strive to recover a Zoë. Instead it concentrates on the Gradi-
van materials, the fragmented strips of negative, in terms of their fetishized
invisibility, and addresses the way the act of censorship is itself productive of
the archive. In the case of the Italian censorship archive, this amounts to six
thousand films, and it marks and preserves the logic of gender at the heart
of the archive's structure.

 When the Towel Drops ostensibly produces an image of what has been con-
cealed as in its title. Indeed as Ben Parker has argued, the notion of a cen-
sored subject is itself "an insufficient, approximate, and liberal synonym for
the conceptual work done by ideology."[82] The images of women in this col-
lection are fetishized *because* of censorship, not prior to it. The valorization of
what has been repressed in its mere recovered state can be just as fraught as
the censoring mechanism itself. In this way, censorship is akin to the sorting
work of editing, discussed in chapter 2: it is not only a cutting out but a way
of organizing images according to what is permissible (the official record of
film history), what is desirable (the censorship archive), and what is not worth
consideration. Similar to the escamontage in *Rope*, censorship underscores
the most illicit and therefore most alluring of film images. *When the Towel
Drops* produces a counter-archive, though not to redress gaps in the official
one, as if the latter were merely in need of correction and supplementation.
Instead, the work uses the counter-archive to hold a mirror up to the official
one, reflecting the work of ideology that is most apparent in the censorship
collection. It accomplishes this not by taking the path, offered by Jensen and
declined by Freud and Derrida—where Zoë is revealed and the archive is
subsequently exited—but through its presentation of materiality. With the viewer
placed within this gallery-projector, encouraged to take a reflexive look at this
seeing machine, the view of the film image is obscured in favor of its material
composition.

 For Derrida, the search for Gradiva motivates the construction of the ar-
chive, which is filled with her displaced material remains and haunted by her
image. This Gradivan logic is rehearsed in *The Film of Her*, where the archi-
vist discovers and rescues the Paper Print Collection in his quest for the elu-
sive "her" and, despite the ostensible project to bring marginal figures to
visibility, repeated in *The Watermelon Woman*. With *When the Towel Drops*,
the censored fragments of women are used to make visible the ideological

structure of the archive. Still, none of these films encounter a Zoë. This implies that, for the film archive, there can be no Zoë, no woman's body. Finding her requires looking beyond the archive's walls, past its destruction. Zoë begins where this book ends, and her footsteps lead away from the archive, even away from film. She has gone somewhere else: to life itself.

Afterword

Percy Bysshe Shelley's "On the Medusa of Leonardo Da Vinci in the Florentine Gallery" (1819), discussed in the introduction, contains a missing stanza. Shelley scholar Neville Rogers discovered this extra verse in the notebooks of Mary Shelley and published it with his commentary on the poem in 1961:

> It is a woman's countenance divine
> With everlasting beauty breathing there
> Which from a stormy mountain's peak, supine
> Gazes into the night's trembling air.
> It is a trunkless head, and on its feature
> Death has met life, but there is life in death,
> The blood is frozen—but unconquered Nature
> Seems struggling to the last—without a breath
> The fragment of an uncreated creature.[1]

There is no clear indication of where the stanza would have fit into the poem, though Rogers surmises it belongs at the end. Despite its incomplete status (the blank preceding "night"), he notes that it accords with "what I believe to be the climax intended by Shelley: the idea that out of this monstrous death should come another birth."[2] The "uncreated creature," as Rogers construes it, is a new life that will emerge from her scattered and forgotten remains, perhaps even a Medusa *rediviva*. What form it will take and when it will come are as yet unknown, but Shelley's final lines keep alive the promise of the woman's survival and eventual return.

I hear Adrienne Rich's 1973 poem "Diving into the Wreck" as a faraway response to Shelley's call. It tells of an underwater expedition to a sunken ship

that long ago "held to a course," perhaps heroic in the style of Greek mythology, before inexplicably sinking into the sea. Rich returns to the scene long after the devastation has occurred, when there is no one left to rescue. I read the poem as though she is the one to finally arrive on the scene to find what is left of Medusa, and to witness what she will now become.

Rich states the aims of her quest bluntly:

the thing I came for:
the wreck and not the story of the wreck
the thing itself and not the myth[3]

Once in the ocean's depths, Rich encounters "the thing itself," the ship's rotted hull, its stripped-down contours, its brute material. "I came to see the damage done," she announces, and shortly after she confirms that she has found "the evidence of damage." She does not disclose what happened to sink the ship, or where the vessel was headed. Wherever it might have been going, whoever was onboard, she finds the wreck in a state of permanent interruption. It is "worn by salt and sway," but she, by contrast, holds fast: "This is the place. / And I am here."

Throughout this book I have attempted to dispense with "the story of the wreck," as Rich does, remaining mindful that the story exists for a reason, that someone found it useful in legitimating, explaining, or otherwise affirming a practice—in my examples, those related to film discursive and technical production. In theory, this includes the foundational origins of art via the conquest of the monstrous Medusa and the Gradiva legend as perpetuated by Freud and Derrida; in practice, it is the China Girl's mythologization by lab technicians and the structural films of Land and Fisher, and the ostentatious trick film's version of its own history. These stories, like myths, tend to obscure as much as they represent, and as I have argued, it is very often the bodies of women that are absconded, overlooked, or both. From the discarded mortal "trunk" of Medusa in the introduction, the excluded flesh of the China Girl in chapter 1, the subtly disappeared figures left on the cutting room floor in chapter 2, and the denial of Zoë in chapter 3, I have tracked how the motif of the mostly vanished woman has been woven into film's myths about itself. In each case, this has been illuminated by carefully examining "the thing itself," the material of film. The tools I have used are equivalent to those brought by Rich. They are simple, if imperfect: a knife, a camera, a book of myths.

She dives alone into the dark and airless world. Her movements become strained and unnatural: her feet hampered by flippers, her breathing deliberate. Like Jennifer Montgomery in *Transitional Objects* or Cheryl Dunye in *The*

Watermelon Woman, Rich finds herself a novice, awkward and perhaps a bit afraid. With difficulty, she must find her own way. "I have to learn alone."

She descends still deeper.

Once within the ship's hull, she comes upon "the drowned face always staring/toward the sun." It is Shelley's fragment, both the countenance of Medusa, turned toward Apollonian light, and the unfinished verse, which no one realized was missing until it was discovered.

At this moment of arrival, a powerful shift occurs in Rich's poem. Surveying the scene, she becomes an inclusive "we" where she was previously alone:

We are, I am, you are
by cowardice or courage
the one who find our way
back to this scene
carrying a knife,
a camera
a book of myths
in which
our names do not appear.[4]

Rich couches herself between the "we" and the "you," and becomes the relay between them. The reader—"you"—joins the many women suggested on the horizon of *The Watermelon Woman*, the multiple individuals that comprise the singular identity of Radha May, and all those whose "names do not appear" in the book of myths. We are, she is, you are: Medusa, Mary, Queen of Scots, Lili, Zoë, and all the unnamed and unknown women who have finally returned to the scene of disaster.

Rich's expedition is not a salvage mission. Instead she has brought us to this moment to watch, to witness what happened, and what may yet come. Similarly, *Girl Head*'s purpose was never to retrieve the traces of women who were left out of the book of myths, but to patiently observe the scenes of their disappearance. Rich's tools may be crude, but they allow us to see who was omitted from the record, and who might still be enduringly present like the smiling and unsmiling China Girl model of *Releasing Human Energies*. Just below the surface, we might find many such women, quietly and insistently alive.

Acknowledgments

I am indebted to many individuals who freely gave of their time and expertise in film laboratory work: Steve Blakely, Susan Foster Gallo, Lili Young, Andy Young, Bob Smith, and Irwin Young at DuArt; Janos Pilenyi, Daniel DeVincent, Adam Wangerin, Joey Carducci, and Ullie at Cineric; Vince Roth at Fotokem; Cosgrove, Gail Duncan, Alan Masson, and Rollie Zavada at Kodak; John Galt at Panavision; Peter Symes at the Society of Motion Pictures and Television Engineers; David Corley at DSC Labs; and Si Becker, John Carlson, and David Long at the Rochester Institute of Technology. I am especially thankful for the generosity of Lauren Alberque, Julie Buck, and Anne and Betsy Pytlak.

My work was aided by invaluable archival collections and the guidance of Virginia Dodier, Kathy Connor, Jesse Peers, Ed Stratman, Ben Tucker, and Paolo Usai at the George Eastman Museum; Ross Lipman and Trisha Lendo at the UCLA Film and Television Archive; Liz Coffey and Haden Guest at the Harvard Film Archive; Tim White and Andy Lampert at Anthology Film Archives; Dan Streible at New York University; Becca Hall and Rebecca Lyon at the Chicago Film Society; Ulrich Ruedel at HTW Berlin; and Anna Fiaccarini and Andrea Meneghelli at the Cineteca di Bologna. My research further benefitted from the assistance of Kim Tomadjoglou and Rosemary Hanes at the Library of Congress, Leonard DeGraaf and Karen Sloat-Olsen at the Thomas Edison National Historic Park, and Paul Gordon and Steve Moore at Library and Archives Canada. I thank also Tom Gunning and André Gaudreault for confirming some of the book's early cinema resources.

This book benefited from lively and rigorous exchange at the University of Rochester, which generously hosted me as a Humanities Center fellow in 2016.

I thank especially Almudena Escobar Lopez, Joan Rubin at the Humanities Center and Jane Bryant in the Susan B. Anthony Institute for Gender, Sexuality, and Women's Studies. At the New School, I have been fortunate to receive generous research support and incisive feedback from Dominic Pettman, McKenzie Wark, Deborah Levitt, Carolyn Berman, Inessa Medzhibovskaya, David Bering-Porter, and Stephanie Browner. I am especially indebted to my New School research assistants and students Andrea Avidad, Daryl Meador, Aristea Rellou, Clare Dibella, August Polite, and Olimpia Mosteanu.

I wish to thank the anonymous readers at Fordham University Press, Kari Hensley, and Tom Lay for their incisive and generous comments and suggestions. Tom, especially, excels in the art of guidance, and I learned as much from his feedback as the supportive way he delivered it. Homay King, Hal Foster, Malcolm Turvey, and Dana Polan also read and indelibly shaped this book at different stages of its development. Noah Isenberg has been a tireless advocate and invaluable mentor, and I owe him special thanks for his keen eye and support. At the University of Southern California, I was lucky to learn from Anne Friedberg, David James, and Kara Keeling, all of whom provided inspiration as much as critical insight. Akira Mizuta Lippit believed in this project, and me, from the start, and I have tried to produce the book he envisioned long ago.

Much of this book would have been unthinkable without the rich and complex films of Phil Solomon, Lewis Klahr, Janie Geiser, Michelle Silva, Morgan Fisher, Sandra Gibson and Luis Recoder, Jennifer Montgomery, Mark Toscano, Laida Lertxundi, and Elisa Giardina Papa. I am grateful to these artists for the many illuminating conversations we have shared. I am equally indebted to Sarah Osment, Erica Levin, Tung-Hui Hu, Stefanos Geroulanos, James Cahill, Rembert Hüser, Anjuli Fatima Raza Kolb, Christine Smallwood, Tess Takahashi, Dave Fresko, Feng-Mei Heberer, Matt Moss, David Alworth, Ray Parker, Timothy Bewes, Leon Hilton, and Iván A. Ramos for their incisive feedback and intellectual generosity. I thank especially Pooja Rangan, Josh Guilford, Karen Tongson, Sarah Kessler, Soyoung Yoon, Julie Napolin, Damon R. Young, and Nico Baumbach for being willing to think through this project with me, over the course of years, with humor, brilliance, and love. This book could not have been completed without the childcare workers at Elements Preschool, My Little Village, and our babysitters. I thank my family: Beatrice, Vincent, Patrick, Alice, Natalie, and Eleanor. Ben read every word, in every iteration, of a book that simply couldn't have been written without him. My love for him and for Harriet is best described by the tender words of Herzog's Kaspar Hauser: it feels strong in my heart.

Notes

Introduction: The Body of Medusa

1. Bruce Conner, quoted in Zimmerman and MacDonald, *Flaherty*, 173.

2. Mulvey, "Visual Pleasure and Narrative Cinema," 203.

3. Banks, Joseph, Stamp, and White, "Editors' Introduction," 3.

4. In *Alice Doesn't*, Teresa de Lauretis emphasizes the significance of images of women as "narrative images," in which women are "figures or markers of positions— places and topoi—through which the hero and his story move to their destination and to accomplish meaning" (109). The female position "is the figure of narrative closure, the narrative image in which the film . . . 'comes together'" (140). Though her analysis proceeds from a privileging of cinematic images of women in terms of their narrative significance above their strictly visual expression, the two nevertheless coincide at the level of representation, leaving intact the alignment between film image and gender.

5. Bazin, "Marginal Notes," 170. Damon R. Young, in *Making Sex Public*, discusses a number of seminal film theoreticians (Bazin, Béla Balázs, and Stanley Cavell) who assert that cinema, as technology and as an ontology, is fundamentally organized according to sexual desire.

6. Conner was well aware of the China Girl's existence and included one in his film *Cosmic Ray* (1961). In a related example, his doublesided collage *Untitled* (1954–1961) reveals, on its verso side, an assortment of pinup girl images, among other ephemera, pasted to its back, or as Conner called it, the work's "underbelly." As Kevin Hatch writes, "There is no missing the fact that over time, the dominant image became the seminude female form." Hatch, *Looking for Bruce Conner*, 79.

7. For semiotic approaches, see Linderman, "Uncoded Images," 143–152; Silverman, *Subject of Semiotics*; de Lauretis, *Alice Doesn't*, de Lauretis, *Technologies*

of Gender, and de Lauretis, *Figures of Resistance*. For psychoanalysis, see Doane, *Desire to Desire* and Doane, *Femme Fatales*. For spectatorship and the public sphere, as well as Marxist approaches to film consumption, see hooks, *Black Looks*; Friedberg, *Window Shopping*; Hansen, *Babel and Babylon*; Hansen, " Mass Production of the Senses," 59–77; and Mayne, *Cinema and Spectatorship*.

8. The tendency to use "virtual" to describe digital technologies has resulted in an assumed immateriality of computer-based media. In recent years scholars have pushed back on this idea and affirmed a material dimension to new media, often expressed in the ecological toll. See, for example, Sterne, "Out with the Trash," 16–31; Starosielski, *Undersea Network*; Hu, *Prehistory of the Cloud*; Cubitt, *Finite Media*; and Gaboury, *Image Objects*. Meanwhile, D. N. Rodowick makes a strong case for identifying the virtual with the digital. He describes virtuality as the "basis of all representation," apparent in mathematical notation that reduces all elements to the same language of abstraction. It is this nonspecificity of the virtual that, paradoxically, constitutes the specificity of the digital. See Rodowick, *Virtual Life of Film*, 10.

9. Friedberg, *Virtual Window*, 11. The quotation is from *Webster's Third New International Dictionary Unabridged* (1993), s.v. "virtual," cited on pages 8 and 254.

10. The *Oxford English Dictionary* traces a similar definition to the mid-fifteenth century: "Senses relating to essential, as opposed to physical or actual, existence."

11. Friedberg, *Virtual Window*, 9–10, 140–148. Within film and media theory, Rodowick uses the term *virtual* to articulate the "great paradox of cinema," namely, its dual status as both a "temporal and 'immaterial' as well as spatial medium." Rodowick, *Virtual Life of Film*, 13.

12. Friedberg, *Virtual Window*, 8.

13. Friedberg takes up the question of materiality in relation to representation more directly in her discussion of a common optical theory found in the work of Kepler, Galileo, Descartes, and others. For these thinkers, "*imago*, the image without physical substance" was opposed not to the referent but the "*pictura*, the reflection on the retina." She observes that the "*pictura* had a materiality of its own, but one quite different from that of the object in the world." The tension between *pictura* and *imago* is instructive for thinking the relationship between materiality and the virtual in film. Both pairs invoke, on one side, a concrete physicality (materiality and *pictura*) and, on the other, a weightless image (virtual and *imago*). Granted, these terms do not map perfectly onto each other. As Friedberg notes, the retinal image of *pictura* is closer to painting (also *pictura*) or other mediated forms like a mirror reflection or film and, because *pictura* possesses a "liminal materiality," the difference between *pictura* and *imago* does not quite fit the distinction I am drawing between the materiality of the filmstrip and its immaterial (virtual) image. Both pairs contend with a gap between what is immediately tangible and what is without substance. To bridge this, they bring the field of representation into play, often in tight correspondence. Friedberg, *Virtual Window*, 8.

14. See Peirce, "What Is a Sign?," 4–10.

15. There is a long history in which anxieties over the social status of women's bodies have been displaced onto various forms of material: in philosophy, there is a tradition stemming from Plato that associates the female body with finite and earthly matter, as opposed to the limitless and immaterial soul (a domain mostly occupied by men). Bodies, especially women's bodies, are base material. See Spelman, "Woman as Body," 109–131.

16. Alfred Hitchcock in Truffaut, *Hitchcock*, 257.

17. Kuhn, *Women's Pictures*, 106. See also Kuhn and Wolpe, *Feminism and Materialism*.

18. See the work of the journal *Feminist Media Histories*, including Caetlin Benson-Allott, ed., special issue on "Materialisms"; Benson-Allott, *Killer Tapes and Shattered Screens*; Martin, "*Hello, Central*; Nakamura, *Digitizing Race*; and Nakamura, "Indigenous Circuits," 114–131; Roth, "Looking at Shirley," 111–136; and Roth, "Fade-Out of Shirley," 273–286. Nonfeminist work on the technical and infrastructural history of film includes Whissel, *Spectacular Digital Effects*; Miyao, *Aesthetics of Shadow*; and Jacobson, *Studios Before the System*.

19. The quotation is from Mayer, Banks, and Caldwell, *Production Studies*, 4. On this field, see D'Acci, *Defining Women*; Banks, "Gender Below-the-Line," 87–98; Duffy, *(Not) Getting Paid to Do What You Love*; and Levine, "Toward a Paradigm for Media Production Research," 66–82.

20. See Coole and Frost, *New Materialisms*; Bennett, *Vibrant Matter*; Barad, *Meeting the Universe Halfway*; Hinton and van der Tuin, "Feminist Matters"; Behar, *Object-Oriented Feminism*; and Grosz, *Incorporeal*.

21. Bennett, *Vibrant Matter*, vi.

22. Coole and Frost, *New Materialisms*, 5.

23. Fischer, "The Lady Vanishes," 30–40.

24. Johnston, "Women's Cinema as Counter-Cinema," 26, cited in Gaines, "On Not Narrating," 12.

25. Hennefeld, "Film History," 78.

26. Stamp, "Editor's Introduction," 1–3; cited in Hennefeld, "Film History," 80.

27. Hennefeld, 80.

28. For the most part, Redrobe's case studies describe feats of vanishing organized as acts of prestidigitation, as with the central example, the "Vanishing Lady" act of the late nineteenth-century magic theater and its cinematic progeny. While I share much in common with Redrobe, I part ways with her in my emphasis on sites of material production where gender is not explicitly marked as a foremost concern. I contend that there is tremendous feminist potential in examining these technical sites precisely because they have been mostly ignored, either overlooked in the valuation of representation or dismissed as a technical arena only secondarily touched by social forces.

29. Foster, "Medusa and the Real,"181–190; Foster, *Prosthetic Gods*; Mitchell, *Picture Theory*; and Kracauer, *Theory of Film*. Beyond the three critics I discuss,

Medusa appears in numerous theories of art, including Louis Marin's discussion of Caravaggio's "Head of Medusa" in *To Destroy Painting* (1977); Craig Owens's description of a photographic Medusa in "The Medusa Effect or, The Specular Ruse" (1984); and Lizbeth Goodman's reading of Medusa in performance art in "Who's Looking at Who(m): Re-viewing Medusa" (1996). In *Alice Doesn't*, Teresa De Lauretis suggests that Freud's "Medusa's Head" provides "the definitive theory of pornographic and, some have argued, of cinema *tout court*." De Lauretis, "Medusa in Cinema," 199.

30. Vernant, "Frontality and Monstrosity," 220.

31. Vernant, 210.

32. Foster, "Medusa and the Real," 182.

33. The sexual dimension of the myth is also apparent in the rationale for Perseus's quest, which is motivated by Oedipal rivalry with his mother's suitor Polydectes. Polydectes dares Perseus to bring back the head of Medusa, which the young hero does, and shows it to him, instantly killing him. Regarding the sexual implications of the Cellini *Perseus with the Head of Medusa*, which has a nearly identical stance, it is situated in the Loggia dei Lanzi of the Museo Nazionale Del Bargello, in the midst of two other sculptures depicting scenes of rape: Giambologna's *Rape of the Sabine Women* (1581–1583) and Pio Fedi's *The Rape of Polyxena* (1860–1864).

34. Until 2003, Canova's sculpture stood above the entrance hall to the Metropolitan Museum of Art, architecturally serving as the gateway to the history of art. This image of Perseus holding out the decapitated head of Medusa is one that has had many repetitions: it is figured on countless vases from antiquity, including, at the Louvre Museum, a relief amphora vase from Boeothia, ca. 660 BCE; a tenth-century manuscript of Hyginus's *Fabularum Liber* at the Bibliotheek der Rijksuniversiteit in Leiden, Netherlands; and in many political pamphlets during the French Revolution, where the image of a decapitated Medusa was used to depict the Terror. In contemporary film, the moment of Perseus brandishing Medusa's head is one of climax in the two *Clash of the Titans* films (1981 and its 2010 remake); in music video, Kanye West's *Monster* (2010) depicts him and his featured guests Jay-Z and Nicki Minaj fending off a barrage of female monsters, including a decapitated one that he holds by her hair.

35. See Cavarero, *Horrorism*, 15.

36. Foster, *Prosthetic Gods*, 258.

37. Foster reads a Medusan logic in Lacan's formulation of the image screen, or the surface, often that of a painting or a work of art, on which the look of the viewer meets a malevolent and threatening gaze, the gaze of Medusa. Art tames (Lacan uses the French *dompter* in *The Four Fundamental Concepts of Psychoanalysis*) the gaze, and renders it approachable for the viewer. For Foster, however, this is only a deferral or deflection of the gaze's scotomizing power. See Foster, 272–286. The real, moreover, can never be dispelled from the symbolic.

38. Foster, 260.

39. Foster, 260. Foster downplays the role of gender in his account. Citing Hélène Cixous's critique of Freud, he does acknowledge that the use of Medusa has had the effect of "[leaving] women on the margins, if not headless on the ground" (272), but does not go so far as to locate gender centrally within the myth and Canova's sculpturally staged scene.

40. The victory over Medusa and the appropriation of her head allows Athena to enact her "civilizational function." Foster, "Medusa and the Real," 181. Foster later expands this notion in *Prosthetic Gods*. The Apollonian equation with Perseus and his benefactor Athena is made spatially apparent in Raphael's Vatican Museum fresco *The School of Athens* (1509–1511), which includes two sculptures flanking the hall of the ancient Greek philosophers. On the left stands Apollo with his lyre, and opposite him on the right Athena holds a spear and shield, with Medusa's grimace adorning the latter. The taming and redirection of the gorgoneion presides over the congress of philosophers and their artistic guises (as Raphael modeled several figures after prominent Renaissance artists of his day). Notably, the *Apollo Belvedere* (original bronze sculpture 330–320 BC, marble copy ca. mid-second century) was also the physical model for Antonio Canova's sculpture *Perseus with the Head of Medusa* (also called *Perseus Triumphant*). Both figures, which are housed in adjacent alcoves in the Octagonal Court of the Vatican Museum, stand contrapposto, with left arms extended and draped with cloth. Apollo holds a bow, broken off in the marble version, while Perseus grips Medusa's head.

41. Foster, *Prosthetic Gods*, 260.

42. See Cole, "Cellini's Blood," 215–235.

43. Mitchell, *Picture Theory*, 172.

44. Mitchell, 173.

45. The Flemish Medusa in the Uffizi is, as Mitchell's reading of Shelley suggests, a triumph of indiscernibility. Mostly the painting is very dark. As in the Canova and Cellini Medusas, Medusa's mouth is partly open, in this instance with the suggestion of vapors pouring out. The head lies on a stone floor, surrounded by small snakes, frogs, rats, and insects. No body can be made out on account of the darkness. The direction in which the body might be expected to lay is obscured by a background of "midnight sky" which teems with bats and shapes vaguely suggestive of round stones. Take by contrast Peter Paul Rubens's *Medusa* (1618), which renders Medusa's isolated head in bright and garish light, in the center of a cleared space. The Flemish Medusa has a sort of fecundity, where Rubens imagines the head as a blanched rigidity, vulnerable to decay. The former head is a sort of body on its own, whereas the Rubens head is more like a sculptural bust toppled over. Odd, because Rubens is usually seen as the most corporeal of painters.

46. Mitchell stops short of reconnecting Medusa's gender to the petrifying power of the gorgoneion. He states: "gender is not the unique key to the workings of ekphrasis." Mitchell, *Picture Theory*, 181. In his essay "What Do Pictures *Really* Want?," Mitchell discusses more specifically the conjunction of women and the effect of images as "the Medusa effect." In what amounts to a version of the mirror or

image-screen, Mitchell's (male) viewer is turned "into an image for the gaze of the picture." He observes: "This effect is perhaps the clearest demonstration we have that the power of pictures and of women are modeled on one another and that this is a model of both pictures and women that is abject, mutilated, and castrated. The power they want is manifested as *lack*, not as possession." The image in his formulation is feminized, wounded, and hungry, and correspondingly, the terror it provokes in its viewer is that of consumption, of being wholly engulfed. Mitchell, "What Do Pictures *Really* Want?," 76.

47. Kracauer, *Theory of Film*, 305.

48. This emphasis on reality arises from *Theory of Film*'s concern with film's technical basis as a photographic medium. Like Bazin, with whom he has often been compared, Kracauer argues that film and photography bear a privileged relation to reality owing to the relative automatism of the camera apparatus, freed from the "imaginative rendering" of the artist.

49. Kracauer, 306.

50. Kracauer, 305 and 306.

51. Elsewhere in *Theory of Film*, Kracauer describes the relation between physical reality and its image in gendered language. In elaborating his notion of film's materiality, he uses explicitly maternal terms to discuss the film image: it "denotes a kind of life which is still intimately connected, as if by an umbilical cord, with the material phenomenon from which its emotional and intellectual contents emerge." Kracauer, 306.

52. Kracauer, 306.

53. Lynn Hershman Leeson herself has suggested the work's connection to many of film's origin stories: the photographic gun developed by Etienne Jules-Marey in 1888 and Edison's kinetoscope invented in 1889, a peep-show viewer in which "spectators took pleasure in the process of voyeuristically viewing seductive images of women." Hershman Leeson, "Room of One's Own," 150. The recasting of a woman in the role of the male bandit in *The Great Train Robbery* recalls a similar citation of the iconic film in Gustav Deutsch's *Film ist. a girl & a gun* (2009), and Deutch's own commentary about the shot: "All you need to stop a sexist is a girl with a gun." Interview with MacDonald, "A Conversation with Gustav Deutsch (Part 2)," 159. Cited in Flaig, "Supposing the Archive Is a Woman," 485.

1. China Girls in the Film Laboratory

1. Melville, "The Taratus of Maids," 253.

2. John Pytlak, acceptance speech for the Technical Achievement Award, the Academy for Motion Picture Arts and Sciences, 2001. Though not televised, Pytlak's award was presented by one of the era's most prominent actresses René Zellwegger.

3. See McPherson, "US Operating Systems at Mid-Century," cited in Keeling, "Queer OS," 152–159.

4. The China Girl has analogues in still photography, television, and computer technologies as well. For the "Shirley" image used in still photography, see Roth, "Looking at Shirley," 111–136, and Roth, "The Fade-Out of Shirley," 273–286. A variant in broadcast television is "Test Card F" which features the image of a young girl, Carole Hersee, posing with a clown doll and a game of noughts and crosses. The image debuted during the unscheduled hours of BBC 2 in 1967 and was eventually aired in thirty countries. Hersee, the daughter of engineer George Hersee, is thought to have been on television the longest of any single person, amounting to roughly seventy thousand hours of airtime. See Nikkhah, "Test card girl." I discuss the "Lena" used in JPEG compression algorithms and digital LADs and the "Jennifer in Paradise" image used to develop and demonstrate the Photoshop image editing software later in this chapter.

5. Marx, *Capital*, 1:295.

6. At individual laboratories, the common practice was to use female employees or bring in friends or girlfriends for China Girl shoots. At the film restoration laboratory Cineric, for example, I only met their China Girl by accident because she was still working at the facility. She had little to say about her experience—she protested that "there's nothing to tell" and politely refused to give me her full name—though during our brief conversation it became clear that she had become inured to her own image. Finally, she admitted that, from time to time, clients would remark on seeing her image in their China Girl test strips. For major film manufacturing companies such as Kodak, China Girl test strips were produced and sold with film stocks, and the women were hired from local modeling agencies. David Long, an engineer at Kodak in the 1990s, observes that the names for what are now industry standards, terms like Shirley or Marcie, "stem from the names of Rochester women." Though I searched the Kodak Historical Collection, which was donated to the University of Rochester in 2004, I still have not been able to find documentation associated with the hire of these women. David Long, phone interview with author, May 9, 2017.

7. See Case et al. in "Origins of Chinagirl."

8. See Redrobe, *Vanishing Women*, especially 17–61.

9. The 1958 reference to "a gray lily card" appears in George T. Keene's "A Color Timing Method and Calculator for Subtractive Motion-Picture Printers," which emphasizes the gray patch that makes up part of the China Girl image not only as a common point of analysis but a color value prized for its neutrality, a medium tone that presumably produces the most accuracy. Keene writes: "The only requirement in gray-card timing is that the card image on the print film appear in *all* scenes at a *constant* color and density, not necessarily 'gray.' The choice of this 'gray' for a typical scene is left to the timer, but once it is selected, cards in all subsequent scenes must be matched to this same 'gray.' The original card does not necessarily have to be nonselective, although use of a near-neutral card of medium reflectance will give the highest timing accuracy. . . . There are two techniques in this field involving densitometry of the negative, one integrating the full-frame densities and the other

reading a gray lily card held in the scene key light." Keene, "A Color Timing Method," 404. "Girl-head test" appears in an earlier SMPTE publication from 1950, *Control Techniques in Film Processing*, 54–55.

10. These various objects denote quality control procedures at different stages of film processing. "Test strip" derives from the early developing practice of step printing, whereby different exposures or chemical bath times would be sequentially indicated on a single strip. "Step wedges" used in black-and-white photography are produced by a sensitometer, which creates eleven discrete exposures that are then read with a densitometer to monitor fluctuations in chemistry. See, for example, Bennett, *Handbook of Kinematography*. "The various combinations of "control," "test," "picture," and "print" can be found in numerous sources, including *Control Techniques in Film Processing*; Bomback, *Cine Data Book*; and BKSTS Training, *Image Quality*.

11. "'The Group' at Kodak," advertisement, *Journal of the SMPTE* 76, no. 3 (April 1967): 283; my emphasis.

12. There are few discussions of China Girls in film scholarship, though work has begun to emerge in recent years. See Doane, "Screening the Avant-Garde Face." For a discussion of Gabi Horndasch's *Versteckte Catherine* (1999/2000), see Hüser, "Finding Openings with Opening Credits."

13. According to John Pytlak, "Lily" was associated with Technicolor. Anne Pytlak, email to author, March 1, 2016.

14. Roland Zavada to Susan Foster, email forwarded to author, December 28, 2010. In the same email, Zavada mentions that he used to date one of the Kodak China Girl models in the 1950s.

15. A roll would be four hundred feet of 16 mm film or one thousand feet of 35 mm film.

16. A rare instance of a "China Boy" occurs with the similarly rare Cinemiracle process. Academy Film Archive archivist Andrew Bradburn notes: "Found this while inventorying *Windjammer: The Voyage of the Christian Radich*. . . . It is a bit dark because it is from an IP (interpositive). Most so-called 'girl heads' or 'China girls' are a few frames in the head leader of a negative, used for reference, so the lab manager can make sure the film processing is producing the right color and density on prints. As the above nicknames indicate, they are most often still shots of women in Chinese print dresses or some colorful outfit. This one may be unique in that 1) it is a man, 2) the frame is 6 perforations high (for Cinerama, or in this case, the Cinemiracle process), and 3) as *Windjammer* was the only film ever made in Cinemiracle, this may be the only occurrence of this particular reference still." Bradburn in an email to Mark Toscano, March 15, 2018.

17. Julie Buck, artist and archivist, notes that the earliest China Girl frames she found were from films dated to the late 1920s and early 1930s. Buck, email to author, August 25, 2010.

18. Kodak benefitted, for example, from the formation of the Motion Pictures Patents Company in 1909, signing on as the sole provider for the nine film

producers that made up the Trust: Edison, Biograph, Vitagraph, Essanay, Selig, Lubin, Kalem, Star, and Pathé. Collins, *Story of Kodak*, 142. See also Collins's chapter "Moving Pictures," 136–180.

19. "To Develop Films," *Los Angeles Times*, September 18, 1921, V4.

20. "These resolutions were reported to be pungent and fiery and to have impugned the good faith of the film manufacturers, and to have charged them with planning to absorb the entire laboratory business as an adjunct of the film-making industry." "To Develop Films," *Los Angeles Times*, September 18, 1921, V4.

21. *Los Angeles Times*, September 4, 1921, V2.

22. *Los Angeles Times*, September 4, 1921, V2.

23. Al Young, one of the three founders of DuArt, had previously worked at Erbograph, a chief competitor of Biograph during the 1910s. He left for Los Angeles in the teens to work in the motion picture studios, but returned to New York by the early twenties. Young, interview with author, March 1, 2012.

24. The ACL was founded to address the "considerable variety in the ways we prepare films for printing, in our method of handling, even in the words we used to do business." See Keehn, "Report from the Association of Cinema Laboratories," 383–386.

25. Jenkins, "Chairman's Address," 23.

26. Eastman Kodak Company, *Journey*, 12.

27. Crabtree, "Motion-Picture Laboratory," 13–34.

28. Collins, *Story of Kodak*, 176–177.

29. Increasingly sophisticated film audiences, too, insisted on higher quality prints. While few in the public had any grasp of the darkroom processes of the film industry, the language of film criticism during the first decades of cinema reflects a growing awareness of and attentiveness to photography. In the *New York Times*, for example, a reviewer observes: "Most people, and especially those who have had to wait until Monday for the Kodak prints which the corner drugstore promised them on Saturday, know that when the cameraman turns the crank of his machine in the studio he exposes negative films from which positive prints have to be made before any pictures can be seen in a theater, but there are few who have any more than a vague idea of how the thousands of feet of positive film can be obtained from the milky-white negative that comes out of the camera." "From Camera to Screen," *New York Times*, August 7, 1921, 63. Meanwhile, a 1915 review of Charlie Chaplin's *The Tramp* in *The New York Dramatic Mirror* remarks, "The photography at times might have been a little clearer, and there were instances where working a little closer to the camera would have brought the comedy of his [Chaplin's] expressions out better." Cited in Collins, *Story of Kodak*, 171.

30. Crabtree and Matthews, *Motion Picture Laboratory Practice*, 187. Collins attributes authorship of the book to John Crabtree and Glen Matthews and called it "the motion-picture processors' bible." Collins, *Story of Kodak*, 287.

31. Jones and Crabtree, "A New Sensitometer," 89.

32. Jones and Crabtree, 90.

33. Charles E. K. Mees cited in Jones and Crabtree, 101.

34. Capstaff and Green, "A Motion Picture Densitometer," 154–162.

35. Bomback, *Cine Data Book*, 201–202.

36. Crabtree, "Motion-Picture Laboratory," 23. Earlier, in another publication, Crabtree had affirmed this fact: "The application of sensitometric methods of control to the processing of motion picture film began shortly after the introduction of the sound picture in 1928, but it was not until 1930 that such methods were in general use." Crabtree and Matthews, *Motion Picture Laboratory Practice*, 186.

37. Bennett, *Handbook of Kinematography*, 53.

38. Crabtree and Matthews, *Motion Picture Laboratory Practice*, 7.

39. Crabtree and Matthews, 17.

40. Crabtree and Matthews, 11; my emphasis.

41. Crabtree and Matthews, 189; my emphasis.

42. Crabtree and Matthews, 198.

43. Keene, "Color Timing Method," 404; my emphasis.

44. Mertz, "Exposure Control," 582.

45. Tabernero, "Establishing and Maintaining Printer Light Color Balance," 502.

46. See Basten, *Glorious Technicolor*, 66; cited in Neale, *Cinema and Technology*, 138. For a detailed account of Technicolor's hold over the color industry, see Neale, *Cinema and Technology*, 129–144.

47. Neale, *Cinema and Technology*, 132. In attempts to break up Technicolor's color and Kodak's black-and-white film stock monopolies, antitrust suits were filed against both companies in the mid-1940s (137).

48. Ruedel, "Technicolor Notebooks," 55.

49. Collins, *Story of Kodak*, 206. The suggestion that the Shirley image was named after Mannes and Godowsky's secretary came via John Galt, senior vice president of Panavision Advanced Digital Imaging, and himself the creator of numerous Shirleys. In his email to me from January 26, 2011, however, he notes he has never attempted to confirm this information. My own research in the Kodak Historical Collection at the University of Rochester similarly turned up no clues, though I presume that some of the documents I examined bore her handwriting.

50. David Long, phone interview with author, May 9, 2017.

51. "Flesh tone" is used in Fink, "Color Television vs. Color Motion Pictures," 281–290 and "skin tone" appears in Wright, "Television Studio Practices," 1–6.

52. Bonsignore, "The Art of Color TV," 435.

53. Knight, "The BKSTS Reference Leader Picture," 248/1095. The BKSTS image was manufactured by Studios and Engineering at Thames Television Limited, in collaboration with Technicolor and Rank Film Processing Limited. Additionally, Knight notes that Kodak survey control strips were used to "establish standard conditions" (252/1099).

54. Knight, 252/1099.

55. Knight, 249/1096.

56. Knight, 249/1096.

57. Knight, 249–250/1096–1097; my emphasis.

58. As Brian Pritchard, a film archive consultant wrote, "I believe that the reason to use girls is mainly because of the problems with men's beards which would affect the colour balance as well as such things as sun burn. I assume that there is some tendency for a girl being selected for sexist reasons!" Pritchard, email to the author, January 24, 2011.

59. David Long, phone interview with author, May 9, 2017.

60. "Thus, if a light meter is pointed at a light European face, it will receive about twice as much light as if it had been pointed at the Kodak 18% grey card which is often taken as being the representative 'average' scene. In other words, the face can be thought of as a surface." Corbett, "Characteristics and Exposure of Camera Stocks," 5/8.

61. Taylor and Lent, 76.

62. Taylor and Lent, 76.

63. Taylor and Lent, 76.

64. See also the network television "color girls" discussed in Gross, "Living Test Patterns."

65. Si Becker of the Association of Cinema and Video Laboratories describes the origins of the China Girl as having a "perfect" appearance. In an email to me on February 20, 2012, he writes: "The purpose of the China Girl was to provide a 'perfect' image against which all other (customer) images could be referred. Since there could be little agreement, even among 'experts' as to what a 'perfect' image looked like, Kodak decided to make a reference image that was correctly exposed and processed and, most importantly, could be replicated, so that they could make those images available to film laboratories. I remember visiting the studio in the Kodak facilities in Rochester in which these films were shot. The cinematographer was a man named Earl Cage (I think) and I remember being told how all of the lighting fixtures were cataloged, their exact placement on the studio floor recorded and exact measurements of their brightness and color temperature written down so that they could all be duplicated each time a new batch of China Girls was needed. The specific emulsions on which they were shot (as 16mm Ektachrome Commercial originals or 35mm [and later, 16mm] negatives) were carefully chosen to match those used in previous shootings and they were all processed under matching conditions. The idea was to consistently be able to produce exactly the same images each time they were shot, so that there was at least a fixed 'perfect' image. To a large extent the consistency of the images could be determined by measurement of the grey scales and color chips that were always included in the scene."

66. Jean-Louis Comolli and Paul Narboni, Brian Winston, Lorna Roth, and Richard Dyer have all investigated the racial qua ideological biases within image technology apparatuses that otherwise present themselves to be based on neutral scientific principles. See Comolli and Narboni, "Cinema/Ideology/Criticism," 145–155; Comolli, "Technique and Ideology," 421–443; Winston, "A Whole

Technology of Dyeing," 105–123; Winston, *Technologies of Seeing*; and Roth, "Looking at Shirley."

67. Dyer, *White*, 83.

68. Dyer, *White*, 90.

69. In his study of whiteness and photographic media, Richard Dyer observes an inherent "racial character of technologies" that reveals itself in the use of white skin tone as a measure for others. It is important to note that this "racial character" is not tantamount to racism (e.g., the notion that technologies themselves are or can be racist), but rather are designed according to perceived markers of racial differentiation. Thus, as a racial trait, whiteness may be *ideologically* neutral or invisible, but in color analysis, it nevertheless registers a range of chromatic values. Dyer, *White*, 83.

70. Seshadri-Crooks, *Desiring Whiteness*, 20.

71. Seshadri-Crooks, 20.

72. Dyer, *White*, 45.

73. Dyer, *White*, 94.

74. Dyer, *White*, 95–96.

75. David L. MacAdam cited in Winston, "A Whole Technology of Dyeing," 20.

76. Dyer discusses this embedded photochemical anti-miscegenation in Hollywood films that have had at least one Black and one white lead, including the *Lethal Weapon* series, *In the Heat of the Night*, *Rising Sun*, and *A Few Good Men*. Dyer, *White*, 98–103. The artists Adam Broomberg and Olivier Chanarin have made the racial bias of photochemistry a central issue for their photographic series "To Photograph the Details of a Dark Horse in Low Light" (2012). The artists cite Jean-Luc Godard's refusal to use Kodak film during a 1977 shoot in Mozambique, claiming that the stock was "racist" on account of its preferential exposure of white skin.

77. Long, phone interview with author, May 9, 2017.

78. Dyer reminds us that white is commonly defined both as a color and "colourless" in the 1933 Oxford English Dictionary and the 1992 Collins English Dictionary. Dyer, *White*, 46.

79. Misek, *Chromatic Cinema*, 129.

80. Neale, *Cinema and Technology*, 147.

81. Misek, *Chromatic Cinema*, 37.

82. Kalmus, "Color Consciousness," 142.

83. Kalmus, 147.

84. Some of the techniques used in classical Hollywood cinema to render white women whiter than white included "haloes, backlighting, soft focus, gauzes, retouching, and all the other conventions of feminine lighting. The ethnically loaded evils of shadow and shine can be eliminated." Dyer, *White*, 125.

85. hooks, "Oppositional Gaze," 311.

86. Neale, *Cinema and Technology*, 152.

87. Rogin, *Blackface, White Noise*, 129. Cited in King, *Lost in Translation*, 45.

88. As Homay King and others have argued, ethnic spaces were common sites of spectacle visited in Hollywood films, the Orient chief among them. King writes: "If Asian Americans have been marginalized in Hollywood cinema . . . this marginalization seems at least in part to represent a response to the centrality of the East as a topic of fantasy representation and concern." King, *Lost in Translation*, 45.

89. Galt, *Pretty*, 20.

90. Steve Blakely, laboratory technician at DuArt: "The 21 step strips that were exposed in the lab (on a sensitometer) were more variable from lab to lab and the exposures varied depending upon the exposure the lab did, the stock itself, and the way it was developed. The strip plotted out was a means of determining the gamma/contrast of the processes." Blakely, interview with author, January 4, 2011.

91. John Pytlak: "Developing the Laboratory Aim Density (LAD) control method was one of my first projects at Kodak. It simplifies the control of color and density during film duplication by laboratories, allowing more consistent prints. Working with my long-time technician Al Fleischer, I presented the first technical paper at the SMPTE Conference in Toronto in November 1974. The first paper was published in the October 1976 SMPTE Journal. In 1982, LAD Girl added additional gray and color patches, as well as a photo of a pretty Kodak model to aid labs in setup of the color analyzer. . . . The 'LAD Girl' I developed was photographed in 1982 (I was on the set when we shot the two 400-foot rolls of 5247), and all film supplied since is made from the same original negative, either as a duplicate negative, and now as a digital intermediate." Pytlak, email sent from Anne Pytlak, March 1, 2016.

92. David Long, phone interview with author, May 9, 2017.

93. SMPTE, *Control Techniques in Film Processing*, 54.

94. David Corley, phone interview with author, January 26, 2011.

95. John Pytlak, email from Anne Pytlak, March 1, 2016.

96. David Long, phone interview with author, May 9, 2017.

97. Balázs, *Theory of the Film*, 74.

98. Balázs writes, "[There] are certain regions of the face which are scarcely or not at all under voluntary control and the expression of which is neither deliberate nor conscious and may often betray emotions that contradict the general expression appearing on the rest of the face." Balázs, *Theory of the Film*, 74.

99. Doane, "Screening the Avant-Garde Face," 222.

100. I borrow the term "leader lady" from projectionist and archivist Becca Hall at the Chicago Film Society.

101. "The various absences upon which classic cinema turns, from the excluded real to the hidden camera and tape recorder, are in effect signified *through* woman." Silverman, "Suture," 229.

102. Mulvey, "Visual Pleasure and Narrative Cinema," 199.

103. The China Girl's evocation of a living being (distinct from a mere technical object), along with its replication and technical use, recalls the case of Henrietta Lacks. Lacks, a Black woman from Virginia, died of cervical cancer, but not before

some of her cancerous cells were harvested without Lacks's permission in 1951. The
HeLa (an abbreviation of Lacks's name) immortal cell line was the first group of
cells ever to be mass produced, and it has been foundational to modern biomedical
research. See Skloot, *Immortal Life of Henrietta Lacks*.

104. Bob Smith, interview with author, January 4, 2011. Smith also noted that he
first heard about the China Girl in 1949 while developing film in the Air Force
Reconnaissance School in Denver, Colorado.

105. China Girls appear in the following experimental films: *Cosmic Ray* (Bruce
Conner, 1961), *White Heart* (Dan Barnett, 1975), *New Improved Institutional Quality*
(Owen Land [George Landow], 1976), *Black Cat White Cat It's a Good Cat If It
Catches the Mouse* (David Rimmer, 1989), *The Vyrotonin Decision* (Matt McCormick,
2000), *Nadja* (Brian Frye, 2000), *Versteckte Catherine* (Gabi Horndasch, 1999/2000),
MM (Timoleon Wilkins, 1996), *To the Happy Few* (Thomas Draschen and Stella
Friedrichs, 2003), *China Girls* (Michelle Silva, 2006), *Hot Under the Collar* (Jason
Britski, 2007), *Movie Tote* (Ephraim Asili, 2007), *Girls on Film* (Julie Buck and
Karin Segal, 2008), *Broken Tongue* (Monica Savirón, 2013), and *Second Sighted*
(Deborah Stratman, 2014). China Girls also feature prominently in the end credits
of *Death Proof* (Quentin Tarantino, 2007). For a list of films that feature leader
footage, see Matt Soar and Jackie Gallant, "Lost Leaders: Found Footage and
the Metadata of Film (2011–)." http://www.lostleaders.ca/references/." In the domain of
visual art, China Girls, Shirleys, and test images have become increasingly prominent.
To cite a few examples, Christopher Williams's *Kodak Three Point Reflection Guide
© 1968 Eastman Kodak Company, 1968 (Meiko Laughing), Vancouver, B.C., April 6,
2005* (2005) staged photographs of Kodak test images, and two versions of this series
were used on a 2006 cover of *Artforum*. (Incidentally, Williams was a teaching
assistant for Morgan Fisher during his time as a graduate student at CalArts.)
Candice Breitz's *Extra!*, a photographic series shot in the South African Broadcasting
Corporation (SABC) studios, references the history of apartheid in the studio designs
as they were later repurposed for the shooting of the soap opera *Generations* (2012).
In this work, Breitz examines the racial legacy of apartheid in the white-oriented
China Girl test cards, still used despite *Generations* lacking a single white cast
member. Amanda Ross-Ho's *The Character and Shape of Illuminated Things* (July 23,
2013–May 4, 2014), commissioned for the Plaza Project for the MCA Chicago, features
a large sculpture of a model's head in front of a board of color swatches. Adam
Broomberg and Olivier Chanarin's 2012 exhibition at Paradise Row in London, *To
Photograph the Details of a Dark Horse in Low Light*, features, among various test
strips, an array of Shirley reference images. In a later installation of the exhibition at
Gallery TWP in Toronto from April 29 to June 2, 2013, several Shirleys were blown
up, mounted, and publicly displayed on billboards.

106. James Benning, phone interview with author, October 21, 2010.

107. Sitney, *Visionary Film*, 364.

108. "I discovered that five of my films contain bimbos; it seems to be a recurrent
theme. *The Film in Which* has the so-called China Girl; *Bardo Follies*, the southern

belle waving to the boat; *Institutional Quality*, the girl who demonstrates the projector; *Thank You Jesus for the Eternal Present* has the 'booth bimbo'; *New Improved Institutional Quality* has the 3D version of the 'China Girl.' So that's some useless information." Owen Land, unpublished portion of an interview by Mark Webber, July 3, 2004.

109. James, *Allegories of Cinema*, 246.

110. Doane, "Screening the Avant-Garde Face," 223–224.

111. As David E. James observes, *Standard Gauge* was made after the heyday of structural film and bears a sense of melancholy not present in earlier works by Hollis Frampton or Paul Sharits. The China Girl, then, is emblematic not only of film, but marks a point of nostalgia at which film history and Fisher's own autobiography converge. The way Fisher speaks is not unlike the wistful tenor of the older laboratory technicians I interviewed. See James, *Most Typical Avant-Garde*, 54–57.

112. "*China Girls*," *Canyon Cinema Catalog*, accessed June 12, 2012, http://canyoncinema.com/catalog/film/?i=4116.

113. Lippit has called Freud's dream of Irma's injection, analogous to the X-ray image, a "repressed corporeality." Lippit, *Atomic Light*, 39.

114. Minh-ha, "World as Foreign Land," 187.

115. Take, for example, code: computer code determines the appearance of images on a computer screen indirectly and algorithmically, so that, in digital media, there is no direct correlation between the technical infrastructure and the images that manifest onscreen. In a similar way, the China Girl, and the LAD patch with which it's closely associated, could be considered a form of cinematic encoding. By applying a logic borrowed from digital technologies, the China Girl can be considered an instrument used to determine the appearance of film images without having a direct visual correlation to them. Again, China Girls are most often evaluated against themselves; in film processing, a technician may never even look at the film to which a China Girl is attached.

116. See Hutchinson, "Culture," 1 and 5–7. A related example is the "Jennifer in Paradise" image used by Photoshop creator John Knoll to demonstrate his new software. He took the photograph himself in 1987 of his then girlfriend while on vacation in Bora Bora. See Comstock, "Jennifer in Paradise."

117. James, *Allegories of Cinema*, 245. James's use of the word "phantom" recalls Deleuze's formulation of the close-up as "the book of phantoms," an inscrutable void present within the face.

118. Parikka, *What Is Media Archaeology?*, 84.

119. Toscano was the one to bring my attention to the China Girl when, during a workshop on moving images organized by Tom Gunning at the Getty Research Institute in 2009, he showed a 16 mm camera original reel of China Girl footage that had been donated to the Academy Film Archive in Los Angeles. Toscano later used this same footage for *Releasing Human Energies*.

120. Among the television analogues for China Girls, Patty Painter understood her work as a model as crucial to the development of color television broadcast. At a

certain point, she had ambitions of hosting her own television show, suggesting the degree to which behind-the-scenes work might have been seen as continuous with the credited labor in front of the camera. See Gross, "Living Test Patterns."

2. Gone Girls of Escamontage

1. Kracauer, *Theory of Film*, 57.

2. Musser, *Emergence of Cinema*, 87.

3. Karen Redrobe identifies a quality of trickery and theft, as well as the deftness of juggling, in the French term *escamotage*. Redrobe, *Vanishing Women*, 49. Patrick Saffar, meanwhile, defines escamontage as the translation of theatrical to cinematic forms of magic. See Saffer, "Forever Méliès."

4. Musser, *Emergence of Cinema*, 180, 231; Higgins, "Silent Screen," 23.

5. Aumont, *Montage*, 32.

6. Scott Higgins, meanwhile, asserts that editing "emerged in late 1896," then in the next paragraph he sees "editing ongoing action within a single space" in the earlier (1895) cut in *Mary, Queen of Scots*. Higgins, "Silent Screen," 23.

7. Seymour, "Case Study."

8. Gunning, "'Primitive' Cinema," 98–99.

9. Gunning, "Cinema of Attractions," 56–62. Gunning writes: "Cinema itself was an attraction," one of many dazzling visual devices to draw in fairground and vaudeville audiences (53). *Mary, Queen of Scots*'s status as a kinetoscope film additionally marks it as among the cinema of attractions.

10. Gunning does acknowledge that these splices were used far more frequently than film historians previously assumed. The historical irony is that they went entirely unnoticed for decades. Gunning, "'Primitive' Cinema," 97. He cites Jacques Malthête's confirmation that, in Méliès's films, "every appearance, disappearance or substitution was of course enacted during shooting, but re-cut in the laboratory on the negative for a simple reason: this trick . . . cannot support a break in rhythm [of the film during projection]." Malthête, "Méliès, Technicien du Collage," 171, 174. Translated and cited in Cahill, "How It Feels to Be Run Over," 303. Gunning notes that Malthête confirmed John Frazer's observations that all of Méliès's trick films contained cuts. See Frazer, *Artificially Arranged Scenes*, 74–75, referenced in Gunning, "'Primitive' Cinema," 97–98.

11. Gunning, "'Primitive' Cinema," 97.

12. Gunning, 97.

13. Stephen Bottomore characterizes Méliès's work as being translated from the magic stage. He writes: "Ultimately . . . the technique of the magician/film-maker derives from the theatre: his multi-scene films are merely multi-scene theatre that has been filmed. Almost every shot is taken from the front, reproducing the viewpoint of someone in the theatre audience, and one shot is normally one scene." For Bottomore this reliance on theater disqualifies Méliès as developing cinematographic language. Bottomore, "Shots in the Dark," 105. Elsewhere he observes the innovation

of skipping time, first by a camera stoppage and second by a splice, was invented by actuality filmmakers. Though he refrains from calling these early splices editing, choosing instead "jump cut," his implication is clear: these clean-up cuts pave the way to later continuity editing. This, however, leaves escamontage still unaccounted for. See also Bottomore, "Shots in the Dark," 107–108.

14. Dudley Andrew expresses the view that cinema, contrary to the position that champions its capacity to create fantastical effects, maintains the "aim to discover, to encounter, to confront, and to reveal." Andrew, *What Cinema Is*, xviii.

15. Rees, "Projecting Back," 63.

16. Clark, cited by Withington, "Golden Jubilee Anniversary," 573. Withington, a secretary of Edison Pioneers, confirms this account through direct correspondence with Clark.

17. The splice in *Joan of Arc* was confirmed by Senior Film Conservator Paul Gordon at Library Archives Canada. It occurs after the actor is mounted onto the stake, and, in a manner similar to *The Execution of Mary, Queen of Scots*, it is used to replace the actor with a dummy that is then burned. Gordon, email to author, August 18, 2017. *Joan of Arc* was presumed lost until the late 1990s, when Ray Phillips located a single copy of the film, titled simply as *Death Scene*, in Library Archives Canada.

18. See Admin, "Bootleg Files."

19. David Levy cites "a weak ontological frontier" between fiction and actuality footage that viewers readily trampled. Levy, "Reconstituted Newsreels," 249.

20. Kinetoscope subjects were derived from the vaudeville stage, and they featured similar genres: scenes of violence as seen in *Mary, Queen of Scots, Joan of Arc, Indian Scalping Scene* (1895), and *Corbett and Courtney Before the Kinetograph* (1894); erotic spectacle as in *Dolorita's Passion Dance* (1896); studies of the body in films depicting body builders, contortionists, or *danses du ventre* (belly dances); facial expressions films such as *The Kiss* (with May Erwin and John C. Rice, 1896) and *Layman, The Man of 1000 Faces* (1894); boxing matches and cockfights; ethnographic displays such as *Sioux Ghost Dance* (1894) or *Imperial Japanese Dance* (1894); and demonstrations of quotidian scenes such as *Horse Shoeing* (1894) and *Barber Shop* (1894).

21. Charles Musser has observed that the kinetoscope in particular enabled "the absence of presence," making it possible for spectators to view sights that would not otherwise have been accessible—prize fights, for instance, were often banned in major cities—and to provide female viewers access to spaces normally coded as male, namely in the audiences of cock fights and burlesque shows. Musser, *Edison Motion Pictures*, 36–37.

22. Edison advertised kinetoscope reels at fifty feet in length, running at 46 frames per second, though as Ray Phillips has noted, the actual length of these reels tended more often to forty-two feet. Fifty feet may reflect the length of film used in shooting, with some footage lost in its development, printing, and mounting onto a kinetoscope reel. See Phillips, *Edison's Kinetoscope*, 17, 18, and 59.

23. At the time of the release of *Mary, Queen of Scots,* the historical queen was already a figure of fascination in popular visual culture. The tercentenary of her death occurred in 1887, and the occasion was marked with services at Petersborough, the cathedral where she was first buried, and Fortheringay Castle, the site of her execution. In 1889 the British Museum mounted a display of Stuart relics. In the late 1880s, controversy on both sides of the Atlantic surrounding Mary once again stirred over the question of her candidacy for sainthood; in 1896, the Westminster Diocese approved the proposed canonization of Mary, Queen of Scots, though after much debate, the case of her martyrdom was never resolved and remains contested to this day. Waxwork replicas of the scene of Mary's execution, meanwhile, remained popular entertainments among eighteenth and nineteenth century audiences.

24. *Mary Stuart* is lost, though its description in the *Kinetogram* reads: "In all history there is no more pathetic figure than beautiful Mary Stuart, the lovely Queen of France and Scotland, whom fate seems to have marked from childhood as a victory of its cruelty. Her hopeless struggle, in the relentless power of the great Queen Elizabeth, the plots and intrigues of the followers of both queens, form one of the most romantic and exciting series of incidents outside of fiction." *Edison Kinetogram* 8, no. 9 (June 1, 1913), advertisement on back cover.

25. For the primacy of the trick film for the cinema of attractions thesis, see Christie, "The Visible and the Invisible," 106–112.

26. Talbot, "Trick Pictures," 211–215.

27. Méliès, "Cinematographic Views" (1907), 30.

28. For a discussion of the discovery of the trick film as accident, see Cahill, "How It Feels to Be Run Over," 289–316. For recent scholarship that attributes the stop-motion technique to trick filmmakers, see Solomon, "Up-to-Date Magic," 595–615.

29. See Ezra, *Georges Méliès,* 28, cited in Hanaway, "Laughing Matter," 21n37.

30. Cook, "Humours of 'Living Picture' Making," 94–95.

31. Gardette, "Some Tricks of the Moving Picture Maker," 53–56; Hulfish, *Cyclopedia of Motion-Picture Work,* 93; Jones, *How to Make and Operate Motion Pictures,* 189.

32. Jenkins and Depue, *Handbook for Motion Picture and Stereopticon Operators,* 93.

33. Another is Frederick Talbot: "When the pieces of film are connected to form a complete band, the continuity in action is so perfect that the public is unable to detect the points where the sequence was interrupted." Talbot, "Trick Pictures," 211.

34. Bennett, *Handbook of Kinematography,* 85.

35. Bennett, 227.

36. Bennett, 229.

37. Redrobe, *Vanishing Women,* 49. In this connection, Redrobe notes an important correction made by Linda Williams, responding to Lucy Fischer's "The Lady Vanishes: Women, Magic and the Movies." Fischer contends the

"commonplace" of trick films involving male magicians performing often gruesome acts on female bodies. Williams points out that male bodies were also subject to the genre's "drama of morcellation and restoration" as frequently as those of women. While Williams takes issue with Fischer's emphasis on the primacy of female bodies in trick films, she agrees with the governing assertion of patriarchal power in such films. Williams writes: "More important than the vanishing act, more important than the imitation of procreative powers, is the construction of a scenario which gives the magician-filmmaker power over *all* the bodies in his domain." Williams, "Film Body," 526, 527. See also Noam Elcott's account of the differences between male and female dismemberment in *Artificial Darkness.*

38. Redrobe, *Vanishing Women,* 8–9.

39. In early cinema, the alterity of women extends to racialized and lower-class figures as well. Alice Maurice affirms Redrobe's view when she connects the racialized body to the film apparatus in her examination of early film genres. These include the "credulous rube" films, dance films, and ethnographic spectacle in which "the reciprocal relation whereby the motion picture represents particular kinds of bodies/subjects while those bodies/subjects represent or dramatize the power of the motion picture apparatus." Maurice, *Cinema and Its Shadow,* 27–28.

40. Gaudreault, "Theatricality, Narrativity and 'Trickality,'" 118; cited in Gunning, "'Primitive' Cinema," 98.

41. See Bielik, *"Children of Men."*

42. Hitchcock, "My Most Exciting Picture" (1948), 275.

43. Miller, "Anal Rope," 114–133; see 133n18 for a list of the five hidden and five unhidden shots.

44. Arthur Laurents, interview in *Rope Unleashed* (Laurent Bouzereau, 2001).

45. "To pick up on the 'back' of jackets would have required from the projectionists a precision that could not be regularly counted on in practice. For this reason, every 600 meters—approximately, since the length of shot-sequences is unequal—we have a classic reverse shot." Rohmer and Chabrol, *Hitchcock,* 90–91, cited in Miller, "Hitchcock's Understyle," 15.

46. The visibility of the "hidden" cut is exacerbated by shifts in the pace of acting, imperfect blackout effects, and "poor narrative motivation" (to suddenly zoom, for example, to a man's backside). Miller, "Hitchcock's Understyle," 16. Miller cites V. F. Perkins and Philippe Mather in their observations that the "hidden" cuts are too visible, whether because they are poorly concealed or masked in the wrong way. Miller summarizes such a view as such: "by masking them badly, [Hitchcock seems] to be arranging their display." See Miller, "Hitchcock's Understyle," 16.

47. Hitchcock's films are famously riddled with the gaps left by bodies that have disappeared, and in *Rope, The Lady Vanishes, Foreign Correspondent* (1940), *Spellbound* (1945), *The Man Who Knew Too Much* (1956), *The Trouble with Harry* (in this case a gap produced by a corpse that has unexpectedly appeared), and *Family Plot* (1976), these absences structure the events that follow. Some bodies, often those of women, not only disappear but are surreptitiously replaced: the local woman's corpse that

substitutes for Mrs. de Winter in *Rebecca*, the real Madeline Ulster in *Vertigo* (perhaps the unidentified woman in the opening credits?), the ventriloquized Mrs. Thorwald in *Rear Window*, and Mrs. Bates in *Psycho*.

48. On "morcellated men," see Williams, "Film Body," 526.

49. There are at least two additional moments of escamontage in *Rope*. Following the publication of "Anal Rope," Miller discovered two "jump cuts" that occur toward the end of the film. One occurs "in the open" as the camera moves autonomously to a doorway, before a character enters the frame from the opposite direction. The other is a slight jump in the image during a line of dialogue, likely the compromise of bringing together two different takes without producing a synchronization mismatch. Miller calls this latter cut "a post-production tear mended with a splice." These two cuts are even deeper instances of escamontage because they occur outside of the play of visibility orchestrated for the five famous "hidden" cuts. See Miller, "Hitchcock's Understyle," 3–24.

50. Miller, *Hidden Hitchcock*, 72.

51. Miller, 72.

52. Miller, 72.

53. Modleski, "Remastering the Master," 153.

54. Hitchcock discusses the complex blocking for the film in "My Most Exciting Picture": "Every piece of furniture on the stage—every table, chair, plate, dish, and drinking glass—had to be moved on cue."

55. Melanie Williams writes: "Indeed, continuity is a job that hinges on invisibility, noticed only if it is not done properly via continuity errors which render visible the processes of film-making that should ordinarily be invisible. It is thus very similar to the way that housework was conceptualised by feminists, as work that must be done but is noticed only in the breach rather than the observance." Williams, "Continuity Girl," 608.

56. Amy's, or rather Fincher's, idea of "Nancy" is a blunt "white trash" stereotype. Fincher is something of an elitist, and never passes up an opportunity to scorn the working class (see the "gluttony" murder in *Seven* [1995]). His films are generally occupied by the malaise and decadence of the wealthy, especially in *Fight Club* (1999), *The Game* (1997), and *Panic Room* (2002). Even when the rich are devious, as in *The Girl with a Dragon Tattoo* (2011) or *The Social Network* (2010), Fincher still makes room to admire their impeccable taste.

57. The enlarged area of "post" or "VFX" has so transformed these categories that new terminology is required to describe them. Chief among these is "workflow," a new paradigm for motion picture assembly where the traditionally delineated areas of cinematography and editing (along with art direction, set design, costuming, hair, and makeup) blend in computer assembly. Ignatiy Vishnevetsky describes the term as a process by which digital information is organized, first as material to be edited, later manipulated, and finally projected. Vishnevetsky, "What Is the 21st Century."

58. Kirk Baxter cited in Meagan Keane, "'Gone Girl' Marks Yet Another Milestone for Adobe Premiere Pro CC." Despite the prevailing association of visual effects with lavish, big-budget spectacle and computer-generated imagery (CGI), the vast majority of effects work is functionally invisible. As digital imaging technician Justin Paul Warren has said, "99 percent of the VFX you saw [in any film] is the VFX you never knew you saw." Cited in Lucca, "Cleaning Crew." See also Prince, *Digital Visual Effects in Cinema* for a fuller discussion of the surreptitious quality of most contemporary visual effects.

59. David Heyman quoted in "GRAVITY 'From Script to Screen' Making-Of Featurette," accessed December 12, 2018, https://www.youtube.com/watch?v =uJEkPq1WA3g.

60. Baxter, "Editors on Editing."

61. Baxter, "Behind the Scenes."

62. Baxter, "Behind the Scenes."

63. Tyler Nelson in Ian Blair, "Where Is She?" (2014), accessed September 14, 2019, https://www.hdvideopro.com/film-and-tv/feature-films/where-is-she/3/.

64. Brue, "Gone Girl Goes from Raw 6K Footage to Hollywood Thriller."

65. One such example of escamontage that does not rely on the cut is the Fluid Morph feature in Avid Media Composer, the offline editing software. Introduced in 2005, and followed by Adobe Premiere's Morph Cut function, these programs digitally average the differences between two shots. When used with a minor jump cut, as in different takes from the same camera set-up, a fluid morph creates the appearance of a single, uninterrupted shot. The space of transition is exceedingly small, often no more than several frames. This feature is often used in talking head interviews, as it allows editors to trim out unwanted footage (such as extra time or verbal tics) or to splice together nonsequential moments. Where in a previous era, editors would use cutaways, a staple of continuity editing, to condense time or resequence footage, the fluid morph can convey the same meaning by using escamontage instead. Not all dissolves, however, are escamontage. It is only in the case where the before and after clips maintain the same framing that it would count, because of escamontage's overarching concealing function. The origin of such a technique, unsurprisingly, occurs with Méliès: Stephen Bottomore observes that he commonly used a magic lantern to dissolve between cuts in order to smooth them out. See Bottomore, "Shots in the Dark," 105.

66. Rodowick argues that the film is a "montage work" because it is interrupted by more than thirty thousand "digital events," or computer interventions that might, for example, add computer-generated snow to one scene or remove a piece of rigging in another. Such events are unified under the practice of compositing, which Rodowick defines as "a process wherein a number of different digitized elements, whether captured, synthesized, or applied as algorithmic filters, are assembled from a variety of sources and combined ideally into a perpetually seamless artifact." Rodowick, *Virtual Life of Film*, 165, 167. Aumont, meanwhile, argues against the view that takes *Russian Ark* to be a single shot "because we all

spontaneously sense that describing this film as containing a single shot, or even to see it as an especially long and complex sequence shot, is inadequate." For him, shots cannot be of any length, but must "depict a reasonable length of time, one still measurable by the yard-stick of the film of which they are a part." Aumont, *Montage*, 49, 50.

67. Kuleshov, "Art of the Cinema," 53. Cited in Gunning, "Desire and Pursuit," 265.

68. On the casting of Rosamund Pike in the role of Amy, Fincher has remarked: "Rosamund was someone that I had seen in four or five different movies over 10 years, and I never got a bead on her," said Fincher, who was pleased that Pike was an only child, like Amy. "I never got a sense of who she was. And I pride myself on being able to watch actors and sort of know instinctivly [*sic*] what their utility belt is, and I don't have that with Rosamund. I didn't know what she was building off of. There was an opacity there and it was interesting." David Fincher, in Labrecque, "Gone Girl."

69. The motif of cutting up women is present, more or less replicating the association with editing made in *Psycho*, in countless films including the slasher films of the 1970s, where women, and the racialized others they sometimes stand in for, are gruesomely cut through and cut up. Race can be thought of as the dialectical underside to the logic of gender I have laid out. In American cinema especially, racial difference has been foundational. In early and silent film, see especially Maurice, *Cinema and Its Shadow*, and Stewart, *Migrating to the Movies*.

70. In *Rear Window*, Richard Allen observes multiple female bodies that are cut up—actually (Mrs. Thorwald), figuratively (the partial view of Miss Torso in the window), and imaginatively (Lisa, when she is assaulted by Thorwald). See Allen, *Hitchcock's Romantic Irony*, 34.

71. Kaja Silverman uses *Psycho* to expand the concept of cinematic suture. She takes its basic premise as a psychological principle that guides the shot-by-shot construction of a film in order to cover spatial gaps (that arise between shots) that might otherwise threaten the implied male viewer's sense of his own omniscience. Hence the rules of continuity editing affirm the smooth procedures of suture, filling out the space of the diegesis in, for example, the relay between shot and reverse shot. The "wound of castration" that reminds the viewer that he is not, in fact, in the picture, and therefore not in a position of mastery over it, is covered over by various devices including his identification with the protagonist as well as the brisk progression of narrative. For Silverman, however, suture can extend beyond specific shot formations and be exploited for other ends, as Hitchcock does with *Psycho*. The film heightens the viewer's anxiety, and thereby ratchets up the desire to seek relief, by "foreground[ing] the voyeuristic dimensions of the cinematic experience, making constant references to the speaking subject, and forcing the viewer into oblique and uncomfortable positions *vis-à-vis* both the cinematic apparatuses and the spectacle which they produce." The shower scene is all the more disturbing because, at its conclusion, it places the viewer in the subject position of the murderer. Silverman's

reading of *Psycho* in terms of the exploded possibilities of suture demonstrates how the cinematic apparatus, and particularly the operation of the cut, can both settle and disturb the viewer's subject position. The cut comes to be the juncture by which cinematic spectacle—the brutal slashing of Marion—is enacted *despite its absence*, and, further, the cut can be made to implicate the viewer in this imagined violence as well. As with *Rope, Psycho* involves a complicated editing scheme that troubles the coherence of viewer perception in the process. Silverman, *Structure of Semiotics*, 204.

72. Clover, *Men, Women, and Chain Saws*, 41.

73. Alfred Hitchcock quoted by Spoto, *Dark Side of Genius*, 431; cited in Clover, *Men, Women, and Chain Saws*, 52.

74. Robert Samuels writes: "This connection between murder and representation becomes clear in the famous shower scene where each stab at Marion's body is matched with a cut of the film and camera angle. In other terms, the film editor and director are the ones that are cutting up the female body by breaking down her image into separate angles and views. Through the analysis of the ethics of representation, we learn that film feeds on the feminine body, but it can only represent it by cutting and ultimately killing it." Samuels, "Epilogue," 154.

75. See Thomson, *Moment of Psycho*, 55–56.

76. For a historical overview of female film editors, see Hatch, "Cutting Women." Not all film industries follow the pattern of Hollywood; in France, for example, the percentage of female editors began to increase in the 1930s. In all contexts, however, it appears that women tended toward work deemed unskilled or technical. See Reynolds, "Face on the Cutting Room Floor," 66–82. Two databases dedicated to the recovery of female film industry workers are especially worth noting here: Jane Gaines, Radha Vatsal, and Monica Dall'Asta's *Women Film Pioneers Project*, begun by Gaines in 1993, and Su Friedrich's *Edited By* project, launched in 2019, that, on its home page, declares itself "A survey of one hundred and thirty-nine editors who invented, developed, fine-tuned and revolutionized the art of film editing." http://womenfilmeditors.princeton.edu. Accessed June 1, 2019.

77. Field, "Women Film Editors from Silent to Sound," 210–211.

78. *Transitional Objects* was shown at the Hyde Park Art Center in December 2008. Berlant's remarks are noted in Wang, "Guest Editorial."

3. Gradivan Footsteps in the Film Archive

1. Much of the commentary on *Archive Fever* centers on metaphors of absence and destruction: see Baer, "Deep in the Archive," 54–59, esp. 58; Enwezor, *Archive Fever*; and Fossati, *From Grain to Pixel*, esp. 259. Archivists themselves have contended with the practical implications of Derrida's metaphorical account of the archive, as in Stoler, "Colonial Archives and the Arts of Governance," 87–109; Kaplan, "Many Paths to Partial Truth," 209–200; Burton, "Thinking Beyond the Boundaries," 60–71; and Cook, "Archive(s) Is a Foreign Country," 600–632. Carolyn Steedman insists,

meanwhile, that it is a book less about archives per se than an exploration of the "relationship between memory and writing." Steedman, *Dust*, 5. Derrida's theorization of the archive has been particularly influential within film and media studies. *Archive Fever* has been taken up in works by Mary Ann Doane (who reads *Gradiva*, via Derrida's interpretation, as Freud's "fascination with the limits of indexicality"); Akira Mizuta Lippit (who explores Derrida's notion of a secret archive through Freud's *Moses and Monotheism* [1939] and Tanizaki Jun'ichirō's *In Praise of Shadows* [1933]); and Domietta Torlasco (who envisions archiving, in a cross between phenomenological and psychoanalytic approaches, "as a mode of writing that occurs in and through perception"). Apart from Doane, few film scholars have linked Derrida's purported theory of the archive, such that it exists, to the figure of Gradiva. See Doane, *Emergence of Cinematic Time*, 220 (see also 220 and 221 for a discussion of Gradiva's footstep); Lippit, *Atomic Light*; and Torlasco, *Heretical Archive*, xvi. See also Dragan Kujundzic's discussion of *Archive Fever* in view of the contradictory impulses of the archive—to remember by forgetting—as interpreted in Theo Angelopoulos's *Ulysses' Gaze* (1996), in "Archigraphia," 166–188.

2. Gradiva has been an enduring figure for many artists, especially among Surrealists André Masson, Salvador Dalí, and Paul Éluard. More recently the figure of Gradiva has appeared in work by Sophie Calle, and the story is the basis for Alain Robbe-Grillet's 2006 film *Gradiva* (*C'est Gradiva qui vous appellée*). Freud's reading of Gradiva has been seen as a major development within the history of psychoanalysis, as evident in Gilles Deleuze and Félix Guattari, *Anti-Oedipus*. It has also been significant to literary analysis and theory as in the work of Kofman, *Childhood of Art*; and Hake, "Saxa Ioquutur," 146–173.

3. See Combe, *Forbidden Archives*. Cited Derrida, *Archive Fever*, 4.

4. Redrobe, *Vanishing Women*, 66. See also Alice Maurice on the vexed relation between the material body in space and the immaterial image in her discussions of *Hooligan Assists the Magician* (Edison, 1900) and *Uncle Josh at the Moving Picture Show* (Edison, 1902), where male spectators naively venture "too close" to the images onscreen. Maurice, *Cinema and Its Shadow*, 27.

5. Kaplan, "Working in the Archives," 103 and 107.

6. Kaplan, 104. See also Dever, "Greta Garbo's Foot," 163–173; and Gilliland and Caswell, "Records and their Imaginaries," 53–75. Gilliand and Caswell affirm this view of the archive when they assert: "the records as imagined or anticipated can inspire all sorts of narratives, suppositions, aspirations, longings, fears and distrust that, as Dever notes, become 'forces that shape archives'" (54–55).

7. For feminist archive studies, see Lerner, *Creation of Feminist Consciousness*; and Smith, *Gender of History*. Lerner's *The Creation of Feminist Consciousness* includes a chapter that discusses the way women have attempted to intervene in history by addressing archival practices, namely in the collecting and description of records. See also Lerner, *Creation of Patriarchy*; Eisler, *Chalice and The Blade*; and Voss-Hubbard, "No Documents—No History"; Zapperi, "Woman's Reappearance"; Buss and Kidar, *Working in Women's Archives*. For postcolonial and critique of

empire approaches, see Arondekar, *For the Record*, 6; Arondekar, "Without a Trace"; and Arondekar, "In the Absence of Reliable Ghosts." See also Richards, *Imperial Archive*; Stoler, *Along the Archival Grain*; and Gilliland and Caswell, "Records and Their Imaginaries."

8. See Cvetkovich, *Archive of Feelings*; Halberstam, *In a Queer Time and Place* (see especially Halberstam's discussion of "the Brandon archive" in chapter 2); and Kumbier, *Ephemeral Material*. See also Taylor, *Archive and the Repertoire*; Bly and Wooten, *Make Your Own History*; Eichhorn, *Archival Turn in Feminism*; and Marshall, Murphy, and Tortorici, "Queering Archives."

9. Jensen, *Gradiva*, 47.

10. Freud, *Delusions and Dreams*, 9. In his historiography of Freud's preoccupation with *Gradiva*, Mayer observes a letter from Wilhelm Stekel that disputes this account. See Mayer, "Gradiva's Gait," 558n12.

11. Derrida, *Archive Fever*, 64.

12. Jensen, *Gradiva*, 5.

13. Jensen, 47.

14. Freud, *Delusions and Dreams*, 89.

15. Andreas Mayer observes the significance of a work of fiction serving as the model Freud develops for psychoanalysis in "Gradiva's Gait," 554–578, see especially 575.

16. Mayer notes that many of Freud's students also hung copies of the Gradiva relief in their own offices. See Mayer, "Gradiva's Gait," 556. Joan Copjec observes the placement of the Gradiva relief in Freud's office next to a reproduction of an Ingres painting, *Oedipus Interrogating the Sphinx*. "In this configuration at least she is clearly a symbol of healing, of the answer at the end of the analytic search." See Copjec, "Transference," 85.

17. Freud, *Delusions and Dreams*, 62.

18. Freud, 48 and 58.

19. Freud, 37. Here Freud cites Jensen directly and later remarks: "We had already guessed that the Greek origin of the imaginary Gradiva was an obscure result of the Greek name 'Zoe'; but we had not ventured to approach the name 'Gradiva' itself, and had let it pass as the untrammelled creation of Norbert Hanold's imagination. But, lo and behold! that very name now turns out to have been a derivative—indeed a translation of the repressed surname of the girl he had loved in the childhood which he was supposed to have forgotten" (38).

20. Freud, 49.

21. See Mayer, "Gradiva's Gait," 576; Willis, "She Who Steps Along," 229; and Copjec, "Transference," 90. After their second encounter in Pompeii, during which time Zoë reveals her name, Hanold refers to her as Zoë-Gradiva. From this point onward, Gradiva generally refers to the phantasmatic being that he remembers from his dream or imagines, and Zoë-Gradiva the person he meets with every day at noon, though there remains significant ambiguity between the two. When, for example, he meets with her on the third day, he reverts to calling her Gradiva. It is only when

she gives the name of her father does he switch to calling her Miss Zoë Bertgang or just Miss Zoë. Jensen, *Gradiva*, 106.

22. Freud, *Delusions and Dreams*, 70.

23. Freud, 89.

24. Jensen, *Gradiva*, 118.

25. Freud, *Delusions and Dreams*, 84.

26. Copjec, "Transference," 63.

27. Copjec, 90.

28. Copjec, 87.

29. Copjec, 66.

30. Derrida, *Archive Fever*, 97.

31. Derrida, 91.

32. Derrida, 90.

33. Jensen, *Gradiva*, 75.

34. Doubtless the preserving volcano at Pompeii was linked in Freud's imagination with the volcano that he posits as the Midianite god adopted by the Jews in their exodus. Freud, *Moses and Monotheism*, 48.

35. See Yerushalmi, *Freud's Moses*, 73; cited in Derrida, *Archive Fever*, 23. *Archive Fever* is much more concerned with circumcision than its title or most critical literature would suggest.

36. Again, owing to the operation of deconstruction, Derrida contends that the contradiction is productive in the sense that it gets to the heart of the (or at least his) concept of the archive: "it modulates and conditions the formation of the concept of the archive and of the concept in general—right where they bear the contradiction" (*Archive Fever*, 90).

37. Derrida, 97.

38. Derrida, 99.

39. Derrida, 85. The phrase is used by Jensen throughout *Gradiva*.

40. Derrida, 97.

41. Derrida, 94.

42. Derrida, 100.

43. Lippit writes that the secret of the archive, its ash, is "constituted as secret on the occasion of the archive's destruction. A secret that precedes the archive and serves as its condition of possibility and impossibility." Lippit, *Atomic Light*, 9.

44. Derrida, *Archive Fever*, 101.

45. Derrida writes: "Hanold has come to search for these traces in the literal sense (*im wörtlichen Sinne*)," *Archive Fever*, 98.

46. All 35 mm films were produced on nitrate before 1951; after that year, they were made on triacetate. 16 mm and 8 mm film stocks, however, were never produced with a nitrate base. See Reilly, *IPI Storage Guide for Acetate Film*, 21–22.

47. Regarding vinegar syndrome, see Reilly, *IPI Storage Guide for Acetate Film*, *passim*. The issue of digitization has, for the past two decades, been of paramount concern for all archives. In the film archive, practices associated with digitization—

restoration, conversion from film, and preservation—are hotly debated and have caused many archives to revisit their missions, particularly as it concerns public access. Among film archivists, though digitization is regarded as inevitable, film stocks are still regarded as the more durable, if still vulnerable, format, whereas digital files are prone to corruption and data loss. Hence most archives practice redundancy where they can afford it: making digital as well as analog copies. See Fossati, *From Grain to Pixel*; Usai, *Death of Cinema*; and Usai, "Conservation of Moving Images."

48. See "Visual Decay Guide," accessed January 16, 2017, www.filmcare.org//visual_decay.

49. Elsaesser continues: "The major film archives . . . owe their existence to the fact that, with the coming of sound, a whole world of cinema was going to disappear, but also the gradual realization of what an extraordinary treasure of factual, historical, social, and material information lay buried in the moving image." Elsaesser, "Archives and Archaeologies," 29.

50. Prior to its founding in 1938, the International Federation of Film Archives (FIAF) referred to its member organizations as "romantic pirates, working secretly and in isolation." Daudelin, "Introduction," 8. For a chronology of major events and archives in FIAF history, see Daudelin, 26–37.

51. Paolo Cherchi Usai notes that the number for silent films is unofficially estimated by members of the International Federation of Film Archives. See Usai, "Conservation of Moving Images," 250. See also Habib, "Ruin, Archive and the Time of Cinema"; and Gianvito, "Remembrance of Films Lost."

52. Usai, *Death of Cinema*, 18.

53. Usai, 121.

54. Jeffrey Skoller suggests that the interest in film archives and archival footage among experimental filmmakers at the end of the twentieth century is due to the relatively recent availability of archival materials themselves. He writes: "For the first time in the history of the art form, filmmakers have an archive to sift through, analyze, and appropriate, allowing them to create their own metahistories. The history of world film culture has been a short but dense one that has permeated the consciousness of much of the planet, allowing cinema to become—like literature—a way of apprehending the world itself." Skoller, *Shadows, Specters, Shards*, xxix. This development in experimental film dovetails with the "archival impulse," dubbed by Hal Foster in 2004, in contemporary art. He argues that such artworks are characterized by the following: an interest in making "historical information, often lost or displaced, physically present"; that they are distinguished from art that is organized around institutional critique; and that they are as involved in using archival materials as they are in producing their own. Foster, "An Archival Impulse," 4. Foster notes a somewhat nostalgic strain among these works, which could also be said of archivally minded experimental films, especially of the Gradivan sort I examine: "the archives at issue here . . . are recalcitrantly material, fragmentary rather than fungible, and as such they call out for human interpretation, not machinic reprocessing" (5).

55. The potential of *The Watermelon Woman* for thinking the significance of archives within queer, feminist, and Black histories is discussed at length in Kumbier, *Ephemeral Material*; Cvetkovitch, *Archive of Feelings*; Juhasz, *Women of Vision*; and Richardson, "Our Stories Have Never Been Told."

56. Gunning borrows the sense of "minor" from Deleuze and Guattari's reading of Kafka, where "minor literature remains exiled from a major literature. . . . [It] remains aware of, and celebrates, its marginal identity, fashioning from it a revolutionary consciousness." Gunning, "Toward a Minor Cinema," 2.

57. Usai, *Death of Cinema*, 89.

58. Niver, *Early Motion Pictures*.

59. Morrison describes being drawn to the young woman in the stag film for her particular gaze: "I thought it contained this awareness of the camera that made you think, "Who is this actress who looks directly into the camera? It is an incredibly amateurish production, but the carnality had to do with the physicality of the film as much as how old it was." Morrison, Le Cain, and Ronan, "Trajectories of Decay."

60. Morrison confirms the fictionalized aspect of the film: "In *The Film of Her*, there was never a porn star who inspired an archivist to rediscover an early film collection. . . . The fact of the matter is I was looking for a plot point that would have some passion in it, because the reasons he has given me in the real-life interviews weren't adding up; he was just wondering what was down there." Morrison, Le Cain, and Ronan, "Trajectories of Decay."

61. Jensen's description of the artistic rendering of Gradiva is nearly photographic in its logic of capture: "In her was embodied something humanly commonplace—not in a bad sense—to a degree a sense of present time, as if the artist, instead of making a pencil sketch of her on a sheet of paper, as is done in our day, had fixed her in a clay model quickly, from life, as she passed on the street." Jensen, *Gradiva*, 3–4.

62. Flaig, "Supposing the Archive Is a Woman," 453.

63. Flaig, 445.

64. Flaig, 441.

65. Flaig, 445 and 447.

66. Flaig, 456.

67. "Out of the two hours you spend in a movie theater, you spend one of them in the dark. It's this nocturnal portion that stays with us, that fixes our memory of a film in a different way than the same film seen on television or on a monitor." *Film Comment*, "Marker Direct." Doane estimates that 40 percent of the time is spent in darkness. Doane, *Emergence of Cinematic Time*, 172.

68. A similar trade-off occurs in Adolfo Bioy Casares's *The Invention of Morel*. In the novella, the unnamed narrator has arrived at an island, and falls in love with Faustine, a mysterious woman who seems not to see him and whose every action and word repeat, as if on a loop, at the end of each week. Eventually he discovers that she is not, in fact, present, but that what he has been seeing is the result of a fantastical machine by Dr. Morel, another one of the island's inhabitants. Faustine, along with a small group of people, had been recorded by this machine sometime in

the past, and what the narrator witnesses is their multidimensional replica produced by what is essentially a cinematic device. (Bioy Casares famously modeled Faustine on Louise Brooks.) Testing the machine on himself, the narrator burns his hand, and he realizes that the machine also caused the deaths of those it recorded. Despite this, and despite the knowledge that Faustine, however fully realized she may appear, is not actually there, he chooses to record himself into the image. He thereby joins his beloved in the only way available to him—as an illusion, and with the consequence of his own death.

69. See, for example, Sullivan, "Chasing Fae"; Winokur, "Body and Soul"; Blaetz, *Women's Experimental Cinema*; and Rich, *New Queer Cinema*.

70. Dunye says, "While the Lesbian Herstory Archive was filled with juicy material from African American lesbian life, including the Ira Jeffries archive (she appears in the film), it had no material on African American women in Hollywood. The Library of Congress, on the other hand, had some material from African American women in Hollywood, but none on African American lesbians." Dunye in Bryan-Wilson and Dunye, "Imaginary Archives," 83.

71. For example, as Robert F. Reid-Pharr has argued, while "both 'the black' and 'the lesbian' have been seen regularly within American cinema, most often [they have been regarded] as demeaned, degraded, or silenced figures." Reid-Pharr, "Makes Me Feel Mighty Real," 133.

72. For discussions of the archival procedures in *The Watermelon Woman*, see Kumbier, *Ephemeral Material* and Cvetkovich, *Archive of Feelings*.

73. Kara Keeling notes that, in assuming the mantle of Black lesbian filmmaking (speaking for "our" stories), Cheryl claims a vision of Fae that legitimates her own practice: both Fae and Cheryl like "movies and women." Keeling observes that the film is also suggestive of another kind of Black lesbian figure, "one that remains hostile to the world Cheryl claims as hers because it is inassimilable into that world's logic." Keeling, "Joining the Lesbians," 224.

74. For Keeling, this "other" Fae represents all that is not possible in Cheryl's account of herself, which is the plurality of experiences suggested by "black" and "lesbian," or what Keeling describes as the "multifarious 'we.'" Keeling, "Joining the Lesbians," 216 and *passim*.

75. Radha May is made up of three artists: Nupur Mathur, from India; Bathsheba Okwenje, from Uganda; and Elisa Giardina Papa, from Italy. Together they adopt the guise of the singular artist persona Radha May. The first volume of *When the Towel Drops*, which treats film censorship in Italy, was led by Giardina Papa. The collective plans for later versions to address censorship in the Indian and South African film industries.

76. The wikistorm component is part of a practice devised by the feminist network FemTechNet that aims to "engender a set of digital practices among women and girls, to teach and encourage their participation in writing the techno-cultural histories of the future by becoming active participants in the creation of global digital archives." See Ulrich, "Eye of the Wikistorm." To wikistorm is to alter and insert the perspective

of women into the collaboratively authored online encyclopedia Wikipedia, either by editing existing entries or creating new ones. To date, the wikistorm has resulted in eighteen edited pages and four new entries, all searchable under the username Radha May. A typical wikistorm intervention includes a new section on censorship in which the Italian censorship documents are cited and the offending content is described.

77. Document 30589 in Radha May, *When the Towel Drops, Vol. 1, Italy,* zine, March 12, 2015, n.p.

78. For more information pertaining to state and Catholic censorship practices in Italy, see Lichtner, *Fascism in Italian Cinema Since 1945*; and Biltereyst and Gennari, *Moralizing Cinema.* For most of the twentieth century and into the twenty-first, the censorship committee functioned by requiring visas for any film to be distributed and exhibited in Italy, including both domestic and foreign releases. A fanciful picture of Catholic censorship in Italy can be found in the 1988 film *Cinema Paradiso,* directed by Giuseppe Tornatore.

79. The dialogue for *Breathless* (1960), for example, was altered in the scene where Michel (Jean-Paul Belmondo) says to Patricia (Jean Seberg), "All right, we are good friends, so we should sleep together!" The Italian version was changed to: "All right, we are good friends, so we should get married!" Mathur, Okwenje, and Papa, "Interview with the Artist Radha May," 180.

80. The idea for the loop was also meant to evoke the censors' mode of viewing. Radha May notes: "The inspiration for the projected loops of the scenes came from reading the censorship document on Antonioni's *Zabriskie Point* [1970]. The document describes how the committee had to watch the scene over and over again while deciding if it was acceptable or not." Radha May, email to author, August 18, 2016.

81. This anecdote, of apocryphal origin, was told to me by Elisa Giardina Papa of Radha May. During her research at the Bologna archive, she found several shots of Bardot in a VHS tape of highlights from the censorship collection, but when she went into the vaults to retrieve the corresponding film negative, they were missing. Nobody at the archive knew why, though they joked that a previous archivist, known to be an ardent Bardot fan, might be storing the footage at his home. Papa, Skype interview with author, July 28, 2016. This story, however, was rejected by archivist Anna Fiaccarini when I spoke to her in Bologna in July 2017.

82. Ben Parker, "Censorship and Ideology," unpublished manuscript.

Afterword

1. Percy Bysshe Shelley, *The Bodleian Shelley,* 97, 100. Cited in Rogers, "Shelley and the Visual Arts," 10.

2. Rogers, "Shelley and the Visual Arts," 17.

3. Rich, "Diving Into the Wreck," 23.

4. Rich, "Diving Into the Wreck," 24.

Bibliography

Allen, Richard. *Hitchcock's Romantic Irony.* New York: Columbia University Press, 2007.

Andrew, Dudley. *What Cinema Is! Bazin's Quest and its Charge.* New York: Wiley-Blackwell, 2010.

Arondekar, Anjali. *For the Record: On Sexuality and the Colonial Archive in India.* Durham, NC: Duke University Press, 2009.

———. "In the Absence of Reliable Ghosts: Sexuality, Historiography, South Asia." *differences* 25, no. 3 (2015): 98–122.

———. "Without a Trace: Sexuality and the Colonial Archive." *Journal of the History of Sexuality* 14, nos. 1–2 (2005): 10–27.

Aumont, Jacques. *Montage.* Montreal: Caboose, 2014 [2013].

Baer, Ulrich. "Deep in the Archive." *Aperture,* no. 193 (2008): 54–59.

Balázs, Béla. *Theory of the Film: Character and Growth of a New Art.* Translated by Edith Bone. New York: Dover, 1970.

Banks, Miranda. "Gender Below-the-Line: Defining Feminist Production Studies." In *Production Studies: Cultural Studies of Media Industries,* edited by Vicki Mayer, Miranda J. Banks and John Caldwell, 87–98. New York: Routledge, 2009.

Banks, Miranda, Ralina L. Joseph, Selley Stamp, and Michele White, "Editors' Introduction: Genealogies of Feminist Media Studies." *Feminist Media Histories* 4, no. 2 (2018): 1–11.

Barad, Karen. *Meeting the Universe Halfway: Quantum Physics and the Entanglement of Matter and Meaning.* Durham, NC: Duke University Press, 2007.

Basten, Fred E. *Glorious Technicolor: The Movies' Magic Rainbow.* New York: A. S. Barnes and Company, 1980.

Baxter, Kirk. "Behind the Scenes on *Gone Girl*: Adobe Creative Cloud." Accessed April 15, 2016. https://www.youtube.com/watch?v=6DMw8nvRu9Q.

———. "Editors on Editing: Kirk Baxter, Gone Girl." Interview with Glen Garland. Accessed April 15, 2016. https://www.youtube.com/watch?v=xBD03O5Dcdo.

Bazin, André. "Marginal Notes on *Eroticism in the Cinema*." In *What Is Cinema?*, vol. 2, translated by Hugh Gray, 169–175. Berkeley: University of California Press, 2005 [1971].

Behar, Katherine, ed. *Object-Oriented Feminism*. Minneapolis: University of Minnesota Press, 2016.

Bennett, Colin N. *The Handbook of Kinematography: The History, Theory, and Practice of Motion Photography and Projection*. London: Kinematograph Weekly, 1911.

Bennett, Jane. *Vibrant Matter: A Political Ecology of Things*. Durham, NC: Duke University Press, 2010.

Benson-Allott, Caetlin. *Killer Tapes and Shattered Screens: Video Spectatorship from VHS to File Sharing*. Berkeley: University of California Press, 2013.

———, ed. "Materialisms." Special issue, *Feminist Media Histories* 1, no. 3 (Summer 2015).

Bielik, Alain. "*Children of Men*: Invisible VFX for a Future in Decay." Animation World Network. December 27, 2006. Accessed August 15, 2017. https://www.awn.com/vfxworld/children-men-invisible-vfx-future-decay.

Biltereyst, Daniel, and Daniela Treveri Gennari, eds. *Moralizing Cinema: Film, Catholicism and Power*. New York: Routledge, 2015.

Bioy Casares, Adolfo. *The Invention of Morel*. Translated by Ruth L. C. Simms. New York: New York Review Books Classics, 2003 [1940].

BKSTS Training. *Image Quality and Control of Motion Picture and Television Film*. London: British Kinematograph Sound and Television Society Education and Training Committee, 1971.

Blaetz, Robin. *Women's Experimental Cinema: Critical Frameworks*. Durham, NC: Duke University Press, 2007.

Bly, Lyz, and Kelly Wooten. *Make Your Own History: Documenting Feminist and Queer Activism in the 21st Century*. Sacramento, CA: Litwin Books, 2012.

Bomback, Richard H. *Cine Data Book: The Comprehensive Reference Book for All Cine Workers*. London: Fountain Press, 1950.

Bonsignore, Salvatore J. "The Art of Color TV." *Journal of the SMPTE* 65, no. 8 (1956): 435–436.

Bottomore, Stephen. "Shots in the Dark: The Real Origins of Film Editing." In Elsaesser, *Early Cinema*, 104–113.

Brue, Jeff. "Gone Girl goes from raw 6K footage to Hollywood thriller with the power of Adobe Premiere Pro CC." Accessed April 15, 2016. https://www.youtube.com/watch?v=2o6pjd2AU9c.

Bryan-Wilson, Julia, and Cheryl Dunye. "Imaginary Archives: A Dialogue." *Art Journal* 72, no. 2 (Summer 2013): 82–89.

Burton, Antoinette. "Thinking Beyond the Boundaries: Empire, Feminism and the Domains of History." *Social History* 26, no. 1 (2001): 60–71.

Buss, Helen M., and Marlene Kidar, eds. *Working in Women's Archives: Researching Women's Private Literature and Archival Documents.* Waterloo, Ontario: Wilfrid Laurier University Press, 2001.

Cahill, James Leo. "How It Feels to Be Run Over: Early Film Accidents." *Discourse* 30, no. 3 (Fall 2008): 289–316.

Capstaff, J. G., and N. B. Green. "A Motion Picture Densitometer." *Transactions of the Society of Motion Picture Engineers* 7, no. 17 (1923): 154–162.

Case, Dominic, et al. "Origins of China girl." Cinematography Information and Discussion board. August 24, 2004. Accessed February 15, 2012. http://web.archive .org/web/20090610193017/http://www.cinematography.net/OriginsOfChinagirl .htm.

Cavarero, Adriana. *Horrorism: Naming Contemporary Violence.* New York: Columbia University Press, 2009.

Christie, Ian. "The Visible and the Invisible: From 'Tricks' to 'Effects.'" *Early Popular Visual Culture* 13, no. 2 (2015): 106–112.

Clover, Carol. *Men, Women, and Chain Saws: Gender in the Modern Horror Film.* Princeton, NJ: Princeton University Press, 1992.

Cole, Michael. "Cellini's Blood." *Art Bulletin* 81, no. 2 (1999): 215–235.

Collins, Douglas. *The Story of Kodak.* New York: Harry N. Abrams, 1990.

Combe, Sonia. *Archives interdites: Les peurs françaises face à l'histoire contemporaine.* [Forbidden archives: Fears facing contemporary history.] Paris: Albin Michel, 1994.

Comolli, Jean-Louis. "Technique and Ideology: Camera, Perspective, Depth of Field." Translated by Diana Matias. In Rosen, *Narrative, Apparatus, Ideology,* 421–443.

Comolli, Jean-Louis, and Paul Narboni. "Cinema/Ideology/Criticism." Translated by Susan Bennett. *Screen* 12, no. 1 (1971): 145–155.

Comstock, Gordon. "Jennifer in Paradise: The Story of the First Photoshopped Image." *Guardian.* June 13, 2014. Accessed July 10, 2018. https://www.theguardian .com/artanddesign/photography-blog/2014/jun/13/photoshop-first-image-jennifer -in-paradise-photography-artefact-knoll-dullaart.

Cook, Terry. "The Archive(s) Is a Foreign Country: Historians, Archivists, and the Changing Landscape." *American Archivist* 74, no. 2 (Fall–Winter 2011): 600–632.

Cook, Victor W. "The Humours of 'Living Picture' Making." *Chambers's Journal* 3, no. 135 (1900): 486–490. Reprinted in *In the Kingdom of Shadows: A Companion to Early Cinema,* edited by Colin Harding and Simon Popple, 94–95. London: Cyngus Arts, 1996.

Coole, Diana, and Samantha Frost, eds. *New Materialisms: Ontology, Agency, and Politics.* Durham, NC: Duke University Press, 2010.

Copjec, Joan. "'Transference: Letters from an Unknown Woman." Discipleship: A Special Issue on Psychoanalysis. *October* 28 (Spring 1984): 60–90.

Corbett, John. "Characteristics and Exposure of Camera Stocks." In BKSTS Training, *Image Quality and Control of Motion Picture and Television Film,* 5–8.

Crabtree, J. I. "The Motion-Picture Laboratory." *SMPTE Journal* 64, no. 1 (January 1955): 13–34.

Crabtree, John, and Glen Matthews, *Motion Picture Laboratory Practice and Characteristics of Eastman Motion Picture Films.* Rochester, NY: Eastman Kodak Company, 1936.

Cubitt, Sean. *Finite Media: Environmental Implications of Digital Technologies.* Durham, NC: Duke University Press, 2017.

Cvetkovich, Ann. *An Archive of Feelings: Trauma, Sexuality, and Lesbian Public Cultures.* Durham, NC: Duke University Press, 2003.

D'Acci, Julie. *Defining Women: Television and the Case of Cagney and Lacey.* Chapel Hill: University of North Carolina Press, 1994.

Daudelin, Robert. "Introduction." In *50 Years of Film Archives,* 8–9. Brussels: FIAF, 1988.

De Lauretis, Teresa. *Alice Doesn't: Feminism, Semiotics, Cinema.* Bloomington: Indiana University Press, 1984.

———. *Figures of Resistance: Essays in Feminist Theory.* Urbana: University of Illinois Press, 2007.

———, "Medusa in Cinema." In *The Medusa Reader,* edited by Marjorie B. Garber, and Nancy J. Vickers, 198–200. New York: Routledge, 2003.

———. *Technologies of Gender: Essays on Theory, Film, and Fiction.* Bloomington: Indiana University Press, 1987.

Derrida, Jacques. *Archive Fever: A Freudian Impression.* Translated by Eric Prenowitz. Chicago: University of Chicago Press, 1996 [1995].

Dever, Maryanne. "Greta Garbo's Foot, or Sex, Socks and Letters." *Australian Feminist Studies* 25, no. 64 (2010): 163–173.

Doane, Mary Ann. *The Desire to Desire: The Woman's Film of the 1940s.* Bloomington: Indiana University Press, 1987.

———. *The Emergence of Cinematic Time: Modernity, Contingency, the Archive.* Cambridge, MA: Harvard University Press, 2002.

———. *Femme Fatales: Feminism, Film Theory, Psychoanalysis.* New York: Routledge, 1991.

———. "Screening the Avant-Garde Face." In *The Question of Gender: Joan W. Scott's Critical Feminism,* edited by Judith Butler and Elizabeth Weed, 206–229. Indianapolis: Indiana University Press, 2011.

Duffy, Brooke Erin. *(Not) Getting Paid to Do What You Love: Gender, Social Media, and Aspirational Work.* New Haven, CT: Yale University Press, 2017.

Dyer, Richard. *White.* New York: Routledge, 2017.

Eastman Kodak Company. *Journey: 75 Years of Kodak Research.* Rochester, NY: Eastman Kodak Company, 1989.

Eichhorn, Kate. *The Archival Turn in Feminism: Outrage in Order.* Philadelphia: Temple University Press, 2013.

Eisler, Riane. *The Chalice and The Blade: Our History, Our Future.* San Francisco: HarperOne, 1988.

Elcott, Noam. *Artificial Darkness: An Obscure History of Modern Art and Media.* Chicago: University of Chicago Press, 2016.

Elsaesser, Thomas. "Archives and Archaeologies: The Place of Non-Fiction Film in Contemporary Media." In *Films That Work: Industrial Film and the Productivity of Media,* edited by Vinzenz Hediger and Patrick Vonderau, 19–34. Amsterdam: Amsterdam University Press, 2009.

Thomas Elsaesser, ed. *Early Cinema: Space, Frame, Narrative.* London: BFI Publishing, 1990.

Enwezor, Okwui. *Archive Fever: Uses of the Document in Contemporary Art.* New York: International Center of Photography, 2008.

Ezra, Elizabeth. *Georges Méliès: The Birth of the Auteur.* Manchester: Manchester University Press, 2008.

Field, Tania. "Women Film Editors from Silent to Sound." In *Silent Women: Pioneers of Cinema,* edited by Melody Bridges and Cheryl Robson, 201–227. Twickenham, UK: Supernova Books, 2016.

Film Comment. "Marker Direct: An Interview with Chris Marker." *Film Comment* (May–June 2003). Accessed August 20, 2019. https://www.filmcomment.com /article/marker-direct-an-interview-with-chris-marker/.

Fink, Donald G. "Color Television vs. Color Motion Pictures." *SMPTE Journal* 64, no. 6 (June 1955): 281–290.

Fischer, Lucy. "The Lady Vanishes: Women, Magic and the Movies." *Film Quarterly* 33, no. 1 (Autumn 1979): 30–40.

Flaig, Paul. "Supposing the Archive Is a Woman." In *New Silent Cinema,* edited by Paul Flaig and Katherine Groo, 441–488. New York: Routledge, 2016.

Fossati, Giovanna. *From Grain to Pixel: The Archival Life of Film.* Amsterdam: Amsterdam University Press, 2009.

Foster, Hal. "An Archival Impulse." *October* 110 (Autumn 2004): 3–22.

——. "Medusa and the Real." *RES: Anthropology and Aesthetics* 44 (Autumn 2003): 181–190.

——. *Prosthetic Gods.* Cambridge, MA: MIT Press, 2006.

Frazer, John. *Artificially Arranged Scenes: The Films of Georges Méliès.* Boston: G. K. Hall, 1979.

Freud, Sigmund. *Delusions and Dreams in Jensen's* Gradiva (1907 [1906]). In *The Standard Edition of the Complete Psychological Works of Sigmund Freud.* Vol. 9, *Jensen's "Gradiva" and Other Works (1906–1908).* Translated by James Strachey. London: Hogarth Press and the Institute of Psychoanalysis, 1959.

——. *Moses and Monotheism.* Translated by Katherine Jones. New York: Knopf, 1949.

Friedberg, Anne. *The Virtual Window: From Alberti to Microsoft.* Cambridge, MA: MIT Press, 2006.

——. *Window Shopping: Cinema and the Postmodern.* Berkeley: University of California Press, 1993.

Gaboury, Jacob. *Image Objects.* Cambridge, MA: MIT Press, 2021.

Gaines, Jane. "On Not Narrating the History of Feminism and Film." *Feminist Media Histories* 2, no. 2 (2016): 6–31.

Galt, Rosalind. *Pretty: Film and the Decorative Image.* New York: Columbia University Press, 2011.

Gardette, L. "Some Tricks of the Moving Picture Maker." *Scientific American* 100 (1909): 476–477.

Gaudreault, André. "Theatricality, Narrativity and 'Trickality': Reevaluating the Cinema of Georges Méliès." *Journal of Popular Film and Television* 15, no. 3 (1987): 110–119.

Gianvito, John. "Remembrance of Films Lost." *Film Quarterly* 53, no. 2 (Winter 1999–2000): 39–42.

Gilliland, Anne J., and Michelle Caswell. "Records and Their Imaginaries: Imagining the Impossible, Making Possible the Imagined." *Archival Science* 16, no. 1 (2016): 53–75.

Goodman, Lizbeth. "Who's Looking at Who(m)?: Reviewing Medusa." *Modern Drama* 39, no. 1 (1996): 190–210.

Gross, Benjamin. "Living Test Patterns: The Models Who Calibrated Color TV." *Atlantic.* June 28, 2015. Accessed September 19, 2015. http://www.theatlantic.com /technology/archive/2015/06/miss-color-tv/396266/.

Grosz, Elizabeth. *The Incorporeal: Ontology, Ethics, and the Limits of Materialism.* New York: Columbia University Press, 2017.

Gunning, Tom. "The Cinema of Attractions: Early Film, its Spectator and the Avant-Garde." In Elsaesser, *Early Cinema,* 56–62.

———. "The Desire and Pursuit of the Hole: Cinema's Obscure Object of Desire." In *Erotikon: Essays on Eros, Ancient and Modern,* edited by Shadi Bartsch and Thomas Bartscherer, 261–277. Chicago: University of Chicago Press, 2005.

———. "'Primitive' Cinema: A Frame-up? Or The Trick's on Us." In Elsaesser, *Early Cinema,* 95–103.

———. "Toward a Minor Cinema: Fonoroff, Herwitz, Ahwesh, Klahr, Lapore and Solomon." *Motion Picture* 3, nos. 1–2 (1989–1990): 2–5.

Habib, André. "Ruin, Archive and the Time of Cinema: Peter Delpeut's 'Lyrical Nitrate.'" *SubStance* 35, no. 2: (2006): 120–139.

Hake, Sabine. "Saxa Ioquuntur: Freud's Archaeology of the Text." *boundary 2* 20, no. 1 (Spring 1993): 146–173.

Halberstam, Jack. *In a Queer Time and Place: Transgender Bodies, Subcultural Lives.* New York: New York University Press, 2005.

Hanaway, Cleo. "Laughing Matter: Phenomenological Takes on the Mind/Body Problem in Ulysses and Early Cinema." *Literature and History* 21, no. 1 (Spring 2012): 6–23.

Hansen, Miriam. *Babel and Babylon: Spectatorship in American Silent Film.* Cambridge, MA: Harvard University Press, 1994.

———. "The Mass Production of the Senses: Classical Cinema as Vernacular Modernism." *Modernism/Modernity* 6, no. 2 (April 1999): 59–77.

Hatch, Kevin. *Looking for Bruce Conner.* Cambridge, MA: MIT Press, 2012.

Hatch, Kristen. "Cutting Women: Margaret Booth and Hollywood's Pioneering Female Film Editors." Women Film Pioneers Project. Accessed July 5, 2016. https://wfpp.cdrs.columbia.edu/essay/cutting-women/.

Hennefeld, Maggie. "Film History." *Feminist Media Histories* 4, no. 2 (2018): 77–83.

Hershman Leeson, Lynn. "Room of One's Own: Slightly Behind the Scenes." In *Iterations: The New Image,* edited by Timothy Druckrey, 150–155. New York: International Center of Photography, 1993.

Higgins, Scott. "The Silent Screen, 1895–1927: Editing." In *Editing and Special/ Visual Effects,* edited by Charlie Keil and Kristen Whissel, 22–36. New Brunswick, NJ: Rutgers University Press, 2016.

Hinton, Peta, and Iris van der Tuin, eds. "Feminist Matters: The Politics of New Materialism." Special issue. *Women: A Cultural Review* 25, no. 1 (2014): 1–122.

Hitchcock, Alfred. "My Most Exciting Picture" (1948). In *Hitchcock on Hitchcock: Selected Writings and Interviews,* edited by Sidney Gottlieb, 275–284. Berkeley: University of California Press, 1997.

hooks, bell. *Black Looks: Race and Representation.* New York: South End Press, 1992.

——. "The Oppositional Gaze." In *Feminist Film Theory: A Reader,* edited by Sue Thornton, 307–320. New York: New York University Press, 1999.

Hu, Tung-Hui. *A Prehistory of the Cloud.* Cambridge, MA: MIT Press, 2016.

Hulfish, David S. *Cyclopedia of Motion-picture Work: A General Reference Work.* Vol. 2. Chicago: American Technical Society, 1914.

Hüser, Rembert. "Finding Openings with Opening Credits." In *Media, Culture, and Mediality: New Insights into the Current State of Research,* edited by Ludwig Jäger, Erika Linz, and Irmela Schneider, 307–332. Bielefeld, Germany: Transcript Verlag, 2010.

Hutchinson, Jamie. "Culture, Communication, and an Information Age Madonna." *IEEE Professional Communication Society Newsletter* 45, no. 3 (May–June 2001): 1, 5–7.

Jacobson, Brian R. *Studios Before the System: Architecture, Technology, and the Emergence of Cinematic Space.* New York: Columbia University Press, 2015.

James, David E. *Allegories of Cinema: American Film in the Sixties.* Princeton, NJ: Princeton University Press, 1989.

——. *The Most Typical Avant-Garde: History and Geography of Minor Cinemas in Los Angeles.* Berkeley: University of California Press, 2005.

Jenkins, Charles Francis. "Chairman's Address." *Transactions of the Society of Motion Picture Engineers* 2 (1916): 23.

Jenkins, Charles Francis, and Oscar B. Depue. *Handbook for Motion Picture and Stereopticon Operators.* Washington, DC: Knega Company, 1908.

Jensen, Wilhelm. *Gradiva: A Pompeiian Fancy.* Translated by Helen M. Downey. New York: Moffat, Yard and Company, 1918 [1903].

Johnston, Claire. "Women's Cinema as Counter-Cinema." In *Notes on Women's Cinema*, edited by Claire Johnston, 24–31. London: Society for Education in Film and Television, 1973.

Jones, A., and J. I. Crabtree. "A New Sensitometer for the Determination of Exposure in Positive Printing." *Transactions of the Society of Motion Picture Engineers* 6, no. 15 (1922): 89–101.

Jones, Bernard E. *How to Make and Operate Moving Pictures: A Complete Practical Guide to the Taking and Projecting of Cinematograph Pictures*. New York: Funk and Wagnalls, 1916.

Juhasz, Alexandra. *Women of Vision: Histories In Feminist Film and Video*. Minneapolis: University of Minnesota Press, 2001.

Kalmus, Natalie M. "Color Consciousness." *Journal of the Society of Motion Picture Engineers* 25, no. 2 (1935): 139–147.

Kaplan, Alice Yaeger. "Working in the Archives." *Yale French Studies*, no. 77 (1990): 103–116.

Kaplan, Elisabeth. "'Many Paths to Partial Truth': Archives, Anthropology, and the Power of Representation." *Archival Science* 2 (2002): 209–200.

Keane, Meagan. "'Gone Girl' Marks Yet Another Milestone for Adobe Premiere Pro CC." October 3, 2014. Accessed August 1, 2019. https://blogs.adobe.com/creativecloud/gone-girl-marks-yet-another-milestone-for-adobe-premiere-pro-cc/

Keehn, Neal. "A Report from the Association of Cinema Laboratories." *SMPTE Journal* 64, no. 7 (1955): 383–386.

Keeling, Kara. "'Joining the Lesbians': Cinematic Regimes of Black Lesbian Visibility." In *Black Queer Studies: A Critical Anthology*, edited by E. Patrick Johnson and Mae G. Henderson, 213–227. Durham, NC: Duke University Press, 2005.

———. "Queer OS." *Cinema Journal* 53, no. 2 (Winter 2014): 152–159.

Keene, George T. "A Color Timing Method and Calculator for Subtractive Motion-Picture Printers." *Journal of the SMPTE* 67, no. 6 (June 1958): 404–408.

King, Homay. *Lost in Translation: Orientalism, Cinema, and the Enigmatic Signifier*. Durham, NC: Duke University Press, 2010.

Knight, Ray E. "The BKSTS Reference Leader Picture." *British Kinematography Sound and Television* (September 1970): 248/1095–252/1099.

Kofman, Sarah. *The Childhood of Art: An Interpretation of Freud's Aesthetics*. New York: Columbia University Press, 1988.

Kracauer, Siegfried. *Theory of Film: The Redemption of Physical Reality*. Princeton, NJ: Princeton University Press, 1997 [1960]).

Kuhn, Annette. *Women's Pictures: Feminism and Cinema*. 2nd ed. New York: Verso, 1994 [1982].

Kuhn, Annette, and Annmarie Wolpe, eds. *Feminism and Materialism*. London: Routledge and Kegan Paul, 1978.

Kujundzic, Dragan. "Archigraphia: On the Future of Testimony and the Archive to Come." *Discourse* 25, no. 1 (2003): 166–188.

Kuleshov, Lev. "Art of the Cinema." In *Kuleshov on Film*, 41–124. Berkeley: University of California Press, 1974.

Kumbier, Alana. *Ephemeral Material: Queering the Archive*. Sacramento: Litwin Books, 2014.

Lacan, Jacques. "The Four Fundamental Concepts of Psychoanalysis." *Essaim* 2 (2008): 135–148.

Land, Owen. Interview by Mark Webber, unpublished portion of "Interview with Owen Land." In *Two Films By Owen Land*, ed. Mark Webber, 101–112. London and Vienna: LUX and Österreichisches Filmmuseum, 2005.

Lerner, Gerda. *The Creation of Feminist Consciousness: From the Middle Ages to Eighteen-Seventy*. New York: Oxford University Press, 1993.

———. *The Creation of Patriarchy*. Vol. 1, *Women and History*. New York: Oxford University Press, 1986.

Levine, Elana. "Toward a Paradigm for Media Production Research: Behind the Scenes at *General Hospital*." *Critical Studies in Media Communication* 18, no. 1 (2001): 66–82.

Levy, David. "Reconstituted Newsreels, Re-Enactments and the American Narrative Film." In *Cinema 1900 | 1906: An Analytic Study by the National Film Archive (London) and the International Federation of Film Archives*, edited by Roger Holman, 243–258. Brussels: Féderation Internationale des Archives du Film, 1982.

Lichtner, Giacomo. *Fascism in Italian Cinema Since 1945: The Politics and Aesthetics of Memory*. London: Palgrave, 2013.

Linderman, Deborah. "Uncoded Images in the Heterogeneous Text." In Rosen, *Narrative, Apparatus, Ideology*, 143–152.

Lippit, Akira Mizuta. *Atomic Light (Shadow Optics)*. Minneapolis: University of Minnesota Press, 2005.

Lucca, Violet. "The Cleaning Crew." *Film Comment* (November/December 2016). Accessed November 15, 2016. http://www.filmcomment.com/article/the-cleaning -crew-vfx/.

MacDonald, Scott. "A Conversation with Gustav Deutsch (Part 2)." In *Gustav Deutsch*, edited by Wilbirg Brainin-Donenberg and Michael Loebenstein, 145–162. Vienna: Austrian Film Museum, 2009.

Malthête, Jacques. "Méliès, Technicien du Collage." In *Méliès et La Naissance du Spectacle Cinématographique*, edited by Madeleine Malthête-Méliès, 169–184. Paris: Klincksieck, 1984.

Marin, Louis. *To Destroy Painting*. Translated by Mette Hjort. Chicago: University of Chicago Press, 1995.

Marshall, Daniel, Kevin P. Murphy, and Zeb Tortorici, eds. "Queering Archives: A Roundtable Discussion with Anjali Arondekar, Ann Cvetkovich, Christina B. Hanhardt, Regina Kunzel, Tavia Nyong'o, Juana María Rodríguez, and Susan Stryker." *Radical History Review* 122 (May 2015): 211–231.

Martin, Michèle. *"Hello, Central?": Gender, Technology, and Culture in the Formation of Telephone Systems*. Montreal: McGill-Queen's University Press, 1991.

Marx, Karl. *Capital*. Vol. 1. Translated by Ben Fowkes. New York: Vintage, 1977.

Mathur, Nupur, Bathsheba Okwenje, and Elisa Giardina Papa, "An Interview with the Artist Radha May: A Global Collective with a Single Identity." *Camera Obscura* 31, no. 3 (2016): 176–183.

Maurice, Alice. *The Cinema and Its Shadow: Race and Technology in Early Cinema*. Minneapolis: University of Minnesota Press, 2013.

Mayer, Andreas. "Gradiva's Gait: Tracing the Figure of a Walking Woman." *Critical Inquiry* 38, no. 3 (Spring 2012): 554–578.

Mayer, Vicki, Miranda J. Banks, and John Caldwell, eds. *Production Studies: Cultural Studies of Media Industries*. New York: Routledge, 2009.

Mayne, Judith. *Cinema and Spectatorship*. New York: Routledge, 1993.

McPherson, Tara. "US Operating Systems at Mid-Century: The Intertwining of Race and UNIX." In *Race after the Internet*, edited by Lisa Nakamura and Peter Chow-White, 27–43. New York: Routledge, 2011.

Méliès, Georges, "Cinematographic Views." Translated by Stuart Liebman. *October* 29 (1984): 23–22.

Melville, Herman. "The Taratus of Maids." In *The Works of Herman Melville*. Standard Edition, vol. 13. Edited by Michael Sadleir. London: Constable and Company, 1924.

Mertz, Pierre. "Exposure Control." *Journal of the SMPTE* 74, no. 7 (July 1965): 577–593.

Miller, D. A. "Anal Rope." *Representations*, no. 32 (Fall 1990): 114–133.

———. *Hidden Hitchcock*. Chicago: University of Chicago Press, 2016.

———. "Hitchcock's Understyle: A Too-Close View of *Rope*." *Representations*, no. 121 (Winter 2013): 1–30.

Misek, Richard. *Chromatic Cinema: A History of Screen Color*. West Sussex, UK: Wiley-Blackwell, 2010.

Mitchell, W. J. T. *Picture Theory*. Chicago: University of Chicago Press, 1994.

———. "What Do Pictures *Really* Want?" *October* 77 (Summer 1996): 71–82.

Miyao, Daisuke. *The Aesthetics of Shadow: Lighting and Japanese Cinema*. Durham, NC: Duke University Press, 2013.

Modleski, Tania. "Remastering the Master: Hitchcock after Feminism." *New Literary History* 47, no. 1 (Winter 2016): 135–158.

Morrison, Bill, Maximilian Le Cain, and Barry Ronan. "Trajectories of Decay: An Interview with Bill Morrison." *Senses of Cinema*, no. 41 (November 2006). Accessed May 30, 2017. http://sensesofcinema.com/2006/the-films-of-bill -morrison/bill-morrison-interview/.

Mulvey, Laura. "Visual Pleasure and Narrative Cinema." In Rosen, *Narrative, Apparatus, Ideology*, 198–209.

Musser, Charles. *Edison Motion Pictures, 1890–1900: An Annotated Filmography*. Washington, DC: Smithsonian Institution Press, 1997.

———. *The Emergence of Cinema: The American Screen to 1907*. History of the American Cinema. Berkeley: University of California Press, 1990.

Nakamura, Lisa. *Digitizing Race: Visual Cultures of the Internet.* Minneapolis: University of Minnesota Press, 2008.

———. "Indigenous Circuits: Navajo Women and the Racialization of Early Electronic Manufacture." In *New Media, Old Media: A History and Theory Reader,* edited by Wendy Hui Kyong Chun and Thomas Keenan, 114–131. New York: Routledge, 2015.

Neale, Steve. *Cinema and Technology: Image, Sound, Colour.* Bloomington: Indiana University Press, 1985.

Nikkhah, Roya. "Test Card Girl 'Bemused' by Her Return to British Television." *Telegraph.* January 10, 2009. Accessed September 1, 2013. http://www.telegraph .co.uk/news/uknews/4214042/Test-card-girl-bemused-by-her-return-to-British -television.html.

Niver, Kemp. *Early Motion Pictures: The Paper Print Collection in the Library of Congress.* Washington, DC: Library of Congress, 1985.

Owens, Craig. "The Medusa Effect or, The Specular Ruse." In *The Medusa Reader,* edited by Marjorie Garber and Nancy J. Vickers, 203–209. New York: Routledge, 2003.

Parikka, Jussi. *What Is Media Archaeology?* Cambridge, UK: Polity, 2012.

Peirce, Charles Sanders. "What Is a Sign?" [1894]. In *The Essential Peirce: Selected Philosophical Writings.* Vol. 2, *(1893–1913),* edited by Nathan Houser and Christian Kloesel, 4–10. Indianapolis: Indiana University Press, 1998.

Phillips, Ray. *Edison's Kinetoscope and Its Films: A History to 1896.* Westport, CT: Greenwood Press, 1997.

Prince, Stephen. *Digital Visual Effects in Cinema: The Seduction of Reality.* Newark, NJ: Rutgers University Press, 2012.

Redrobe (Beckman), Karen. *Vanishing Women: Magic, Film, and Feminism.* Durham, NC: Duke University Press, 2003.

Rees, A. L. "Projecting Back: UK Film and Video Installation in the 1970s." *Millennium Film Journal,* no. 52 (2010): 54–70.

Reid-Pharr, Robert F. "Makes Me Feel Mighty Real: *The Watermelon Woman* and the Critique of Black Visuality." In *F is for Phony: Fake Documentary and Truth's Undoing,* edited by Alexandra Juhasz and Jesse Lerner, 130–140. Minneapolis: University of Minnesota Press, 2006.

Reilly, James M. *IPI Storage Guide for Acetate Film: Instructions for Using the Wheel, Graphs, and Tables.* Rochester, NY: Image Permanence Institute, Rochester Institute of Technology, 1993.

Reynolds, Siân. "The Face on the Cutting Room Floor: Women Editors in the French Cinema of the 1930s." *Labor History Review* 63, no. 1 (Spring 1998): 66–82.

Rich, Adrienne. "Diving into the Wreck." In *Diving Into the Wreck: Poems 1971– 1972.* New York: W. W. Norton, 2013.

Rich, B. Ruby. *New Queer Cinema: The Director's Cut.* Durham, NC: Duke University Press, 2013.

Richards, Thomas. *The Imperial Archive: Knowledge and the Fantasy of Empire*. New York: Verso, 1993.

Richardson, Matt. "Our Stories Have Never Been Told: Preliminary Thoughts on Black Lesbian Cultural Production as Historiography in *The Watermelon Woman*." Special Issue: Beyond Normative: Sexuality and Eroticism in Black Film, Cinema, and Video. *Black Camera* 2 no. 2 (Spring 2011): 100–113.

Rodowick, D. N. *The Virtual Life of Film*. Cambridge, MA: Harvard University Press, 2007.

Rogers, Neville. "Shelley and the Visual Arts." *Keats-Shelley Memorial Bulletin* 12 (1961): 9–17.

Rogin, Michael. *Blackface, White Noise: Jewish Immigrants in the Hollywood Melting Pot*. Berkeley: University of California Press, 1998.

Rohmer, Eric, and Claude Chabrol. *Hitchcock: The First Forty-Four Films*. Translated by Stanley Hochman. New York: Ungar, 1988.

Rosen, Philip, ed. *Narrative, Apparatus, Ideology: A Film Theory Reader*. New York: Columbia University Press, 1986.

Roth, Lorna. "The Fade-Out of Shirley, a Once-Ultimate Norm. In *The Melanin Millennium*, edited by Ronald E. Hall, 273–286. Dordrecht: Springer, 2013.

———. "Looking at Shirley, the Ultimate Norm: Colour Balance, Image Technologies, and Cognitive Equity." *Canadian Journal of Communication* 34, no. 1 (2009): 111–136.

Ruedel, Ulrich. "The Technicolor Notebooks at the George Eastman House." *Film History* 21, no. 1 (2009): 47–60.

Saffar, Patrick. "Forever Méliès." *Revue jeune cinema*, no. 279 (December 2002). Accessed May 25, 2019. http://www.jeunecinema.fr/spip.php?article154.

Samuels, Robert. "Epilogue: Psycho and the Horror of the Bi-Textual Unconscious." In *Alfred Hitchcock's Psycho: A Casebook*, edited by Robert Kolker, 140–162. New York: Oxford University Press, 2004.

Seshadri-Crooks, Kalpana. *Desiring Whiteness: A Lacanian Analysis of Race*. Feminism for Today series. New York: Routledge, 2000.

Seymour, Mike. "Case Study: How to Make a Captain America Wimp." *fxguide*, July 25, 2011. Accessed May 1, 2019. https://www.fxguide.com/fxfeatured/case -study-how-to-make-a-captain-america-wimp/.

Shelley, Percy Bysshe. *The Bodleian Shelley Manuscripts. Vol. 2: Bodleian MS. Shelley Adds. d.7.* Edited by Irving Massey. New York: Routledge, 1987.

———. "On the Medusa of Leonardo Da Vinci in the Florentine Gallery." In *The Complete Poems of Percy Bysshe Shelley*. New York: Modern Library, 1994 [1819].

Silverman, Kaja. *The Subject of Semiotics*. New York: Oxford University Press, 1983.

———. "Suture." In Rosen, *Narrative, Apparatus, Ideology*, 219–235.

Sitney, P. Adams. *Visionary Film: The American Avant-Garde, 1943–2000*. 3rd ed. New York: Oxford University Press, 2002.

Skloot, Rebecca. *The Immortal Life of Henrietta Lacks*. New York: Crown, 2010.

Skoller, Jeffrey. *Shadows, Specters, Shards: Making History in Avant-Garde Film.* Minneapolis: University of Minnesota Press, 2005.

Smith, Bonnie G. *The Gender of History: Men, Women, and Historical Practice.* Cambridge, MA: Harvard University Press, 1998.

Society of Motion Picture and Television Engineers, Laboratory Practice Committee. *Control Techniques in Film Processing.* New York: Society of Motion Picture and Television Engineers, 1960.

Solomon, Matthew. "Up-to-Date Magic: Theatrical Conjuring and the Trick Film." *Theatre Journal* 58, no. 4 (December 2006): 595–615.

Spelman, Elizabeth V. "Woman as Body: Ancient and Contemporary Views." *Feminist Studies* 8, no. 1 (Spring 1982): 109–131.

Spoto, Donald. *The Dark Side of Genius: The Life of Alfred Hitchcock.* New York: Ballantine, 1983.

Stamp, Shelley. "Editor's Introduction." *Feminist Media Histories* 1, no. 1 (Winter 2015): 1–3.

Starosielski, Nicole. *The Undersea Network.* Durham, NC: Duke University Press, 2015.

Steedman, Carolyn. *Dust: The Archive and Cultural History.* New Brunswick, NJ: Rutgers University Press, 2002.

Sterne, Jonathan. "Out with the Trash: On the Future of New Media." In *Residual Media*, edited by Charles Acland, 16–31. Minneapolis: University of Minnesota Press, 2007.

Stewart, Jacqueline Najuma. *Migrating to the Movies: Cinema and Black Urban Modernity.* Berkeley: University of California Press, 2005.

Stoler, Ann Laura. *Along the Archival Grain: Epistemic Anxieties and Colonial Common Sense.* Princeton, NJ: Princeton University Press, 2010.

———. "Colonial Archives and the Arts of Governance." *Archival Science* 2 (2002): 87–109.

Sullivan, Laura L. "Chasing Fae: *The Watermelon Woman* and Black Lesbian Possibility." *Callaloo* 23, no. 1 (2000): 448–460.

Tabernero, Pablo. "Establishing and Maintaining Printer Light Color Balance in Additive Color Printing by a System of Controlled Chance." *Journal of the SMPTE* 70, no. 7 (July 1961): 502–508.

Talbot, Frederick. "Trick Pictures and How They are Produced." In *Moving Pictures: How They Are Made and Worked*, 211–215. London: Heinemann, 1912.

Taylor, Diana. *The Archive and the Repertoire: Performing Cultural Memory in the Americas.* Durham, NC: Duke University Press, 2003.

Taylor, E. W. and S. J. Lent. "BBC Test Card No. 61 (Flesh Tone Reference): Colorimetric and other Optical Considerations." *SMPTE Journal* 87, no. 2 (February 1978): 76–78.

Thomson, David. *The Moment of Psycho: How Alfred Hitchcock Taught America to Love Murder.* New York: Basic Books, 2009.

Torlasco, Domietta. *The Heretical Archive: Digital Memory at the End of Film.* Minneapolis: University of Minnesota Press, 2013.

Trinh T. Minh-ha, "The World as Foreign Land." In *When the Moon Waxes Red: Representation, Gender and Cultural Politics*, 185–200. London: Routledge, 1991.

Truffaut, François, Alfred Hitchcock, and Helen G. Scott. *Hitchcock*. New York: Simon and Schuster, 1984 [1983].

Ulrich, Jade. "The Eye of the Wikistorm." FemTechNet. December 3, 2013. Accessed July 28, 2016. https://femtechnet.org/2013/12/the-eye-of-the-wikistorm/.

Usai, Paolo Cherchi. "The Conservation of Moving Images." *Studies in Conservation* 55, no. 4 (2010): 250–257.

———. *The Death of Cinema: History, Cultural Memory and the Digital Dark Age*. London: BFI Publishing, 2001.

Vernant, Jean-Pierre. "Frontality and Monstrosity." In *The Medusa Reader*, edited by Marjorie B. Garber, and Nancy J. Vickers, 210–231. New York: Routledge, 2003.

Vishnavetsky, Ignatiy. "What Is the 21st Century: Revising the Dictionary." Mubi. February 1, 2013. Accessed March 1, 2016. https://mubi.com/notebook/posts/what-is-the-21st-century-revising-the-dictionary.

Voss-Hubbard, Anke. "'No Documents—No History': Mary Ritter Beard and the Early History of Women's Archives." *American Archivist* 58, no. 1 (Winter 1995): 16–30.

Wang, Dan S. "Guest Editorial: Transitionals." Mark Rigney (website). December 12, 2008. Accessed July 1, 2016. http://www.markrigney.net/Blog/F4669D1B-298F-45B3-9195-5FE1A336F8F5.html.

Whissel, Kristen. *Spectacular Digital Effects: CGI and Contemporary Cinema*. Durham, NC: Duke University Press, 2014.

Williams, Linda. "Film Body: An Implantation of Perversions." In Rosen, *Narrative, Apparatus, Ideology*, 507–534.

Williams, Melanie. "The Continuity Girl: Ice in the Middle of Fire." *Journal of British Cinema and Television* 10, no. 3 (2013): 603–617.

Willis, Ika. "'She Who Steps Along': Gradiva, Telecommunications, History." *Helios* 34, no. 2 (Fall 2007): 223–242.

Winokur, Mark. "Body and Soul: Identifying (with) the Black Lesbian Body in Cheryl Dunye's *Watermelon Woman*." In *Recovering the Black Female Body: Self-Representations by African American Women*, edited by Michael Bennett and Vanessa D. Dickerson, 231–252. New Brunswick, NJ: Rutgers University Press, 2001.

Winston, Brian. *Technologies of Seeing: Photography, Cinematography and Television*. London: British Film Institute, 1996.

———. "A Whole Technology of Dyeing: A Note on Ideology and the Apparatus of the Chromatic Moving Image." *Daedalus* 114, no. 4 (Fall 1985): 105–123.

Withington, Chester Merrill. "Golden Jubilee Anniversary of the Motion Picture Industry." *Journal of the Society of Motion Picture Engineers* 30, no. 5 (1938): 570–576.

Wright, Harold. "Television Studio Practices Relative to Kinescope Recording." *Journal of the SMPTE* 65, no. 1 (1956): 1–6.

Yerushalmi, Yosef Hayim. *Freud's Moses: Judaism Terminable and Interminable.* New Haven, CT: Yale University Press, 1991.

Young, Damon R. *Making Sex Public and Other Cinematic Fantasies.* Durham, NC: Duke University Press, 2018.

Zapperi, Giovanna. "Woman's Reappearance: Rethinking the Archive in the Contemporary Art—Feminist Perspectives." *Feminist Review* 105, no. 1 (2013): 21–47.

Zimmerman, Patricia, and Scott MacDonald. *The Flaherty.* Indianapolis: Indiana University Press, 2017.

Index

Page numbers in italics refer to figures.

GENEVIEVE YUE is an assistant professor of in the Department of Culture and Media and director of the Screen Studies program at Eugene Lang College, the New School. Her essays and criticism have been published in *October, Grey Room, The Times Literary Supplement, Reverse Shot, Artforum.com, Film Comment,* and *Film Quarterly.* She is also an independent film programmer and serves on the Board of Trustees for the Flaherty Film Seminar.